STEP INTO CROCHET

>>>

CROCHETED SOCK TECHNIQUES FROM **BASIC** TO **BEYOND**!

ROHN STRONG

a content + ecommerce company

www.fwcommunity.com

21 20 19 18 17 5 4 3 2 1

Distributed in Canada by Fraser Direct
100 Armstrong Avenue
Georgetown, ON, Canada L7G 5S4
Tel: (905) 877-4411

Distributed in the U.K. and Europe by
F&W MEDIA INTERNATIONAL
Pynes Hill Court, Pynes Hill, Rydon Lane
Exeter, EX2 5AZ, United Kingdom
Tel: (+44) 1392 797680
E-mail: enquiries@fwmedia.com

SRN: 16CR10
ISBN-13: 978-1-63250-478-4

Editors:
Leslie T. O'Neill
Kerry Bogert

Technical Editors:
Charles Voth
Susanna Tobias
Lisa Espinosa

Designer:
Alanna DiLiddo

Illustrator:
Kathie Kelleher

Photographer:
Deana Travers

Model:
Rebecca Tonelli
Alanna DiLiddo

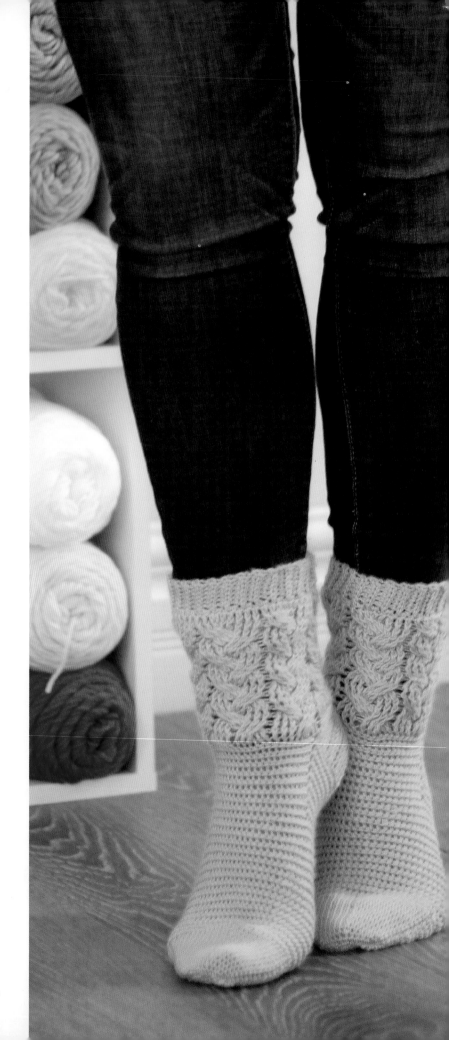

CONTENTS

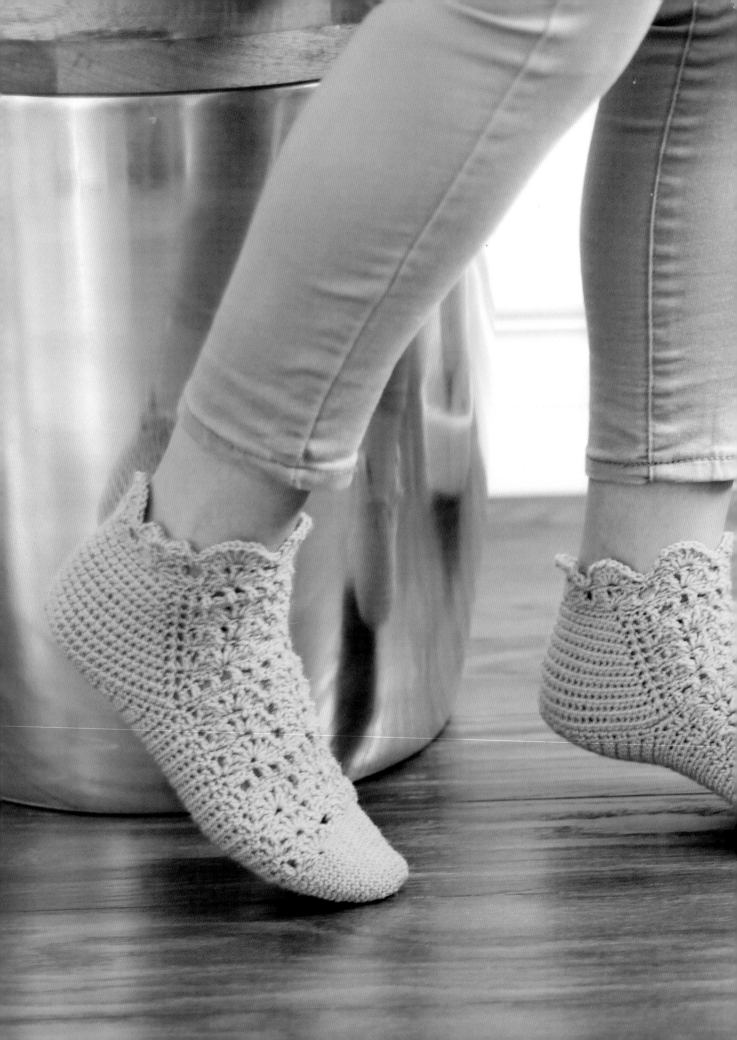

INTRODUCTION

Ask most crocheters if they've ever crocheted a sock and most of them will tell you one of two things:

1. "Yes, but they never fit, so I gave up."

or...

2. "No, but I've always wanted to!"

These answers inspired me to write this book. While crocheters have loved crocheting socks for years, and many have done so successfully, an equal number have found the process challenging and frustrating. I was one of those people.

The very first pair of crochet socks I whipped up didn't fit. I didn't know what I did. I bought the exact yarn, worked the pattern just as written, even made a gauge swatch. The problem?

The pattern wasn't written with someone with thick ankles in mind. It was written for the "average crocheter." I'm anything but average — which meant I needed to adjust the pattern to fit me.

But I just didn't find what I needed anywhere. So, I made it up. Tried a few things, and they worked. The result was my very first published sock pattern, called Dowding Socks, which is still popular to this day.

Step into Crochet was born out of this ingenuity. It is written to help you crochet socks that fit you by teaching you all there is to know about crocheted socks. From proper measurement and stitch construction to yarn and customization options, I've taken the guesswork out of the equation.

This book includes 18 patterns, each designed to be unique and interesting while including room for modification. I didn't skimp on the details, either. You'll find cables, colorwork, and lace!

I also wrote four basic patterns that use the two recommended stitches for well-fitting socks, two toe-up patterns and two cuff-down patterns. These are perfect for getting your feet wet and customizing to your heart's content.

I wrote *Step into Crochet* for one reason: I want you to be able to create custom socks that fit your feet and are comfortable. The information in this book will make sure you can do that.

Crochet on!

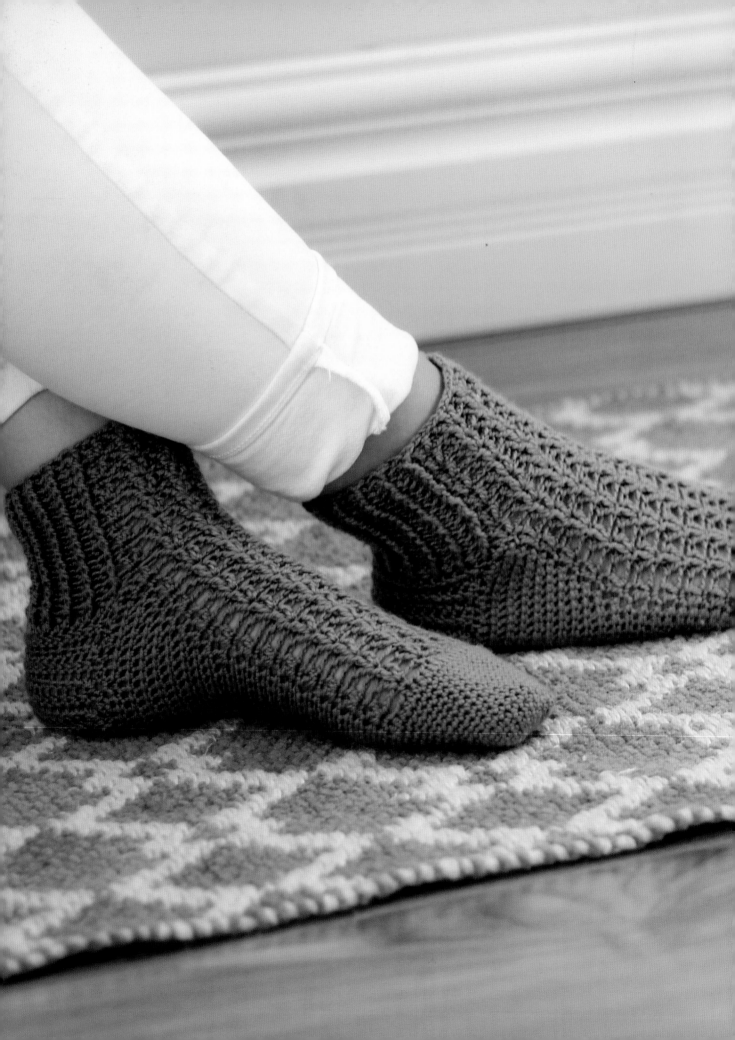

CHAPTER 1

CROCHETING SOCKS THAT FIT

Crocheting socks is simple once you know the secrets to well-fitting socks. From measuring your foot to choosing your yarn, many factors go into creating custom-fit crochet socks.

NOT TOO LOOSE, NOT TOO TIGHT—SOCKS THAT ARE JUST RIGHT

The number one question asked by new sock crocheters is "How can I make my socks fit?"

The answer to that question is long and varied. To understand how to make a sock fit, you need to know the different parts of a crocheted sock, the many measurements of your foot, and how to adjust a sock pattern to accommodate your actual feet.

>>>

MEASURING FOR THE PERFECT SIZE

When reading sock patterns, you'll notice that they almost always give two finished values: the foot circumference and the ankle circumference. Although an average fit can be achieved using these measurements, a custom fit can in no way be guaranteed. Other patterns completely reject the finished measurements and include only the standard small, medium, large, and extra large labels. If no final measurements are given, you should approach these patterns with caution.

Some designers may have a different view as to what these standard sizes are. If a pattern is written to crochet "to fit" and doesn't give you the actual finished measurements of the sock, you should skip it. These measurements are given for you to correctly choose the perfect size for your feet.

The best way to determine your sock size is to measure your foot. You need specific measurements if you want the sock to fit your foot perfectly. Socks should be worked with negative ease—they should be crocheted a bit smaller than your actual foot size.

Most designers use four standard measurements to determine size: the circumferences of the foot, ankle, and gusset plus the length of the foot. They also include three more measurements for people with shapely legs or non-average feet: the circumference of the calf, the heel diagonal, and the length of the toes.

A. Foot circumference: the circumference around the ball of the foot.

B. Ankle circumference: the circumference around the narrowest part of the ankle.

C. Gusset circumference: the circumference around the arch of the foot, just in front of the heel.

D. Foot length: the length of the foot, from the tip of the longest toe to the back of the heel.

E. Low calf circumference: the circumference of the leg, measured 6 inches (15 cm) up from the ground.

F. Heel diagonal: the circumference of the diagonal from the top of the foot at the front of the ankle to the back of the heel, at the floor.

G. Toe length: the length of the longest toe.

STRETCH FOR FIT

Socks are meant to stretch. If you were to grab your favorite pair of store-bought socks from your sock drawer, you would undoubtedly discover that these socks are quite a bit smaller around than your actual foot circumference. Manufactured socks are usually composed of a cotton/polyester blend with a stretch material such as latex rubber or elastic. This allows the sock to stretch to fit a wide variety of feet, enabling manufacturers to make a limited number of sizes that work for nearly all customers.

Choosing a sock pattern based on such a sock will often, if not always, lead you to crocheting a sock that neither fits nor feels good. So, our socks must be crocheted to a size that is closer to our actual foot measurements. While commercial socks may have negative ease around 30 percent—that is, 30 percent smaller than your foot measurement—crocheted socks need to stay within 5 percent negative ease, or 5 percent smaller than your foot measurement.

For the optimal fit, feel, and function, a sock needs to measure 5 percent, or ½" (1.3 cm), less than the finished foot circumference. The foot length should measure 10 percent, or 1" (2.5 cm), less than the finished foot length. This is due to crochet's tendency to stretch vertically but not horizontally. This is also assuming that the sole is constructed out of a solid fabric.

TAKING MEASUREMENTS

Because your foot is unique, you need to take your own measurements. Use the chart below to record your actual foot measurements.

The measuring process takes less than just five minutes. All you need is a simple, flexible cloth tape measure, a new or rarely used one preferably. This will help ensure that your measurements are accurate.

FOOT CIRCUMFERENCE

Find the widest part of your foot (avoiding any bunions or corns) and measure the circumference of your foot. This is usually the area right behind the toes often referred to as the "ball" of the foot.

When choosing a size, you will need to look for a finished sock circumference that is ½" to 1" (1.3 to 2.5 cm) smaller, depending on the pattern. While the rule I stated above says about 5 percent, this isn't always an option. If you reside outside of that 5 percent, choosing a size within the 5 to 10 percent range will result in a sock that fits well but isn't too tight.

ANKLE CIRCUMFERENCE

Locate your anklebone (the rounded bones on either side of your foot) and wrap the tape measuring around your ankle. This measurement is needed to ensure a fit that keeps the sock up. Crochet socks often tend to bag around the ankle because many crochet patterns assume the ankle-to-foot circumference ratio is the same; this is not always the case, however.

Your ankle circumference tends to be larger than your foot circumference. This is where crocheters have issues getting their socks to fit. If your ankle and foot circumferences are similar, you can simply choose a size that is 5 percent smaller than the larger measurement. However, if either of the measurements is more than ½" (1.3 cm) wide, plan to customize the sock when you crochet it.

For example, if your ankle is 9½" (24 cm) around and your foot is 8½" (21.5 cm) around, you could work the leg following the directions for a sock one size larger and the foot one size smaller, decreasing the stitches at the gusset. Or, if your foot measures more than your ankle, simply work a foot from a size larger and the leg a size smaller. This will ensure the finished sock fits your measurements perfectly.

GUSSET CIRCUMFERENCE

Locate the area just in front of your heel. Measure the circumference around the arch of the foot. This measurement is taken to ensure the gusset will

ACTUAL FOOT MEASURMENTS	LEFT FOOT	RIGHT FOOT
(A) Foot circumference		
(B) Ankle circumference		
(C) Gusset circumference		
(D) Foot length		
(E) Leg circumference		
(F) Heel diagonal		
(G) Toe length		

fit correctly. The gusset is already a tricky part of the sock, and by adding a bit of fabric on either side of the foot by picking up stitches, you change the fit of the sock. This can either create a baggy area in the sock or an area that is too tight. By staggering or rushing the decreases/increases, you can alter the fit of the sock.

I recommend working the sock to the gusset and trying the sock on after the gusset is complete. Although a small amount of bagginess or pull is fine, a significant amount needs to be dealt with immediately.

FOOT LENGTH

Standing with your feet flat on the ground, measure from the back of your heel to the tip of your longest toe.

Foot length is one of the two main sizes a pattern offers at the beginning. Most of the time, though, this measurement is completely controlled by you. You can choose to work the sock into any length you like simply by working more or fewer rounds.

A sock should be worked to 3" (7.5 cm) less than the foot length measurement. If your foot is 10" (25.5 cm) long, work the sock (either from the back of the heel or from the tip of the toe) to just 7" (18 cm). You'll have 2" (5 cm) to work either the heel or toe, leaving 1" (2.5 cm) that accounts for 10 percent of negative ease.

If a sock pattern does not offer your finished foot length needs, never fear; just stop working the foot where it makes sense in the pattern (such as after a pattern repeat), and begin working the heel or toe as directed in the pattern.

LEG CIRCUMFERENCE

Take the leg circumference measurement directly above where you took your ankle circumference. This measurement will be used to gather the number of cuff stitches needed. This number should be greater than your ankle circumference measurement.

If this is a rather large measurement, you may have to decrease or increase stitches in the leg section, depending on the direction of the work. A larger-than-average calf will need more stitches to accommodate the sock and ensure it stays up. A sock will not stay up on the leg if it is too small or too large. By working increases or decreases at the back of the leg, you can make a tidy sock that fits perfectly.

HEEL DIAGONAL

Measure your heel diagonal by wrapping the tape around the circumference of your ankle beginning at the bottom of the heel, wrapping around the top of your foot, and ending at the bottom of your heel again. Then divide this number in half to get your heel diagonal. This will be the largest of your numbers.

The heel diagonal is used to ensure your sock stretches to accommodate the full width of your heel and ankle. Although this measurement isn't always used in patterns, I find it especially helpful to have after completing the heel section. The sock can be measured while it's lying flat, giving letting you check if you are on target for proper fit.

This tends to be an area of struggle because the measurement can vary greatly between crocheters. Because of this, crocheters will finish a sock that in theory fits the "important" measurements designers provide, but the sock still doesn't fit their feet. Most of the time the issue has to do with the heel diagonal measurement.

While it is an easy fit, just requiring a bit of increasing before or after the heel shaping, it can prove pretty painful if this measurement is not taken into consideration.

TOE LENGTH

Standing with your feet flat on the ground, measure the length of your longest toe. This measurement is almost always within the 1½" to 2" (3.8 to 5 cm) range and doesn't change that much from pattern to pattern. Still, it is important to take stock of, especially if the toe box is quite short or quite long. This will determine the rate of increases or decreases worked within the toe.

A shorter toe box will often mean working the decreases/increases every round instead of every other round, whereas a longer toe box will mean working the decreases/increases every three rounds instead of every other round.

A Note on Leg Length: While this measurement may seem necessary, it is in fact personal and holds little bearing on most patterns. Patterns are usually sized at 7" (18 cm), 5" (12.5 cm), and 2" (5 cm), depending on the length of leg desired.

Taking these measurements will ultimately lead to one thing—a perfect-fitting sock. We have proven over the years is that while crochet sock patterns may come in a set number of sizes, crocheters do not. These measurements will help you see where you need to make modifications.

USING SOCK SIZING TABLES

The secret to well-fitting socks is applying your actual measurements to your socks. There are cases where you may not have the wearer with you—still, you can crochet socks that fit well.

You need to know the wearer's shoe size or foot circumference. These are nowhere near as accurate as actual foot measurements, but in a pinch they will suffice. Use these standard sock size charts when crocheting gifts or if you aren't concerned with an exact fit.

However, let me reiterate, following these charts will not guarantee fit. Wearers may have larger calves, thicker ankles, longer feet, or even longer toes—all of which can make a sock fit differently than these charts indicate. The standards given were taken from the Craft Yarn Council's standards on sock sizing.

Differing shoe sizes from different areas around the world can make using this measurement a bit tricky, so use with care. Sock circumference and sock length measurements are presented with the negative ease needed for a finished sock. Therefore, they are smaller than the estimated or actual measurements of a foot given.

All measurements are rounded to the nearest ¼" (6 mm). If your measurements don't match the chart exactly, round down. Erring on the small side will ensure a tighter fit.

The foot circumference in the chart has ½" (1.3 cm) of negative ease already applied. This will give you the correct fit needed on an adult sock. However, the child's socks are close to actual foot measurements, due to the smaller amount of negative ease traditionally applied to a child's sock.

Foot length is presented in the chart with 1" (2.5 cm) of negative ease. So, the finished foot length of the adult sock will be 1" (2.5 cm) shorter than that of the actual foot to accommodate the vertical stretch of crochet stitches. In a child's sock, the general rule is to give the foot length ½" (1.3 cm) of negative ease.

I have also included a chart based on the leg lengths of socks. This is the total length of the leg minus the heel. The heel should not be added as an indicator of sock height.

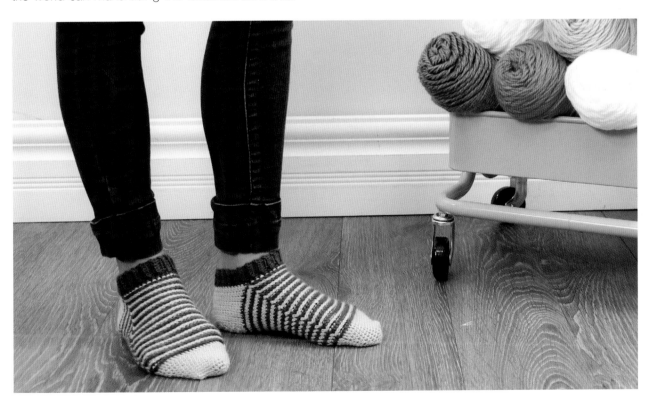

INFANT/CHILD	U.S./CANADIAN SHOE SIZE	AGE	TOTAL FOOT LENGTH
	0	6–12 mo.	4" (10 cm)
	2	6–12 mo.	4" (10 cm)
	4	1–3 y.	5" (12.5 cm)
	6	1–3 y.	5" (12.5 cm)
	8	3–5 y.	6" (15 cm)
	10	3–5 y.	7$\frac{1}{2}$" (19 cm)
	2	5–9 y.	7$\frac{3}{4}$" (19.5 cm)
	4	7–13 y.	8" (20.5 cm)
	6	7–13 y.	8$\frac{1}{2}$" (21.5 cm)

WOMEN	U.S./CANADIAN SHOE SIZE	TOTAL FOOT LENGTH	TOTAL FOOT CIRCUMFERENCE
	3	9" (23 cm)	8" (20.5 cm)
	4	9$\frac{1}{4}$" (23.5 cm)	8$\frac{1}{4}$" (21 cm)
	5	9$\frac{1}{2}$" (24 cm)	8$\frac{1}{2}$" (21.5 cm)
	6	9$\frac{3}{4}$" (25 cm)	8$\frac{3}{4}$" (22 cm)
	7	10" (25.5 cm)	9" (23 cm)
	8	10$\frac{1}{4}$" (26 cm)	9$\frac{1}{4}$" (23.5 cm)
	9	10$\frac{1}{2}$" (26.5 cm)	9$\frac{1}{2}$" (24 cm)
	10	10$\frac{3}{4}$" (27.5 cm)	9$\frac{3}{4}$" (25 cm)
	11	11" (28 cm)	10" (25.5 cm)
	12	11$\frac{1}{4}$" (28.5 cm)	10$\frac{1}{4}$" (26 cm)

MEN	U.S./CANADIAN SHOE SIZE	TOTAL FOOT LENGTH	TOTAL FOOT CIRCUMFERENCE
	6	9$\frac{1}{2}$" (24 cm)	7" (18 cm)
	7	9$\frac{3}{4}$" (25 cm)	7$\frac{1}{2}$" (19 cm)
	8	10" (25.5 cm)	7$\frac{3}{4}$" (19.5 cm)
	8.5	10$\frac{1}{2}$" (26.5 cm)	8" (20.5 cm)
	9	10$\frac{3}{4}$" (27.5 cm)	8$\frac{1}{2}$" (21.5 cm)
	10	10$\frac{3}{4}$" (27.5 cm)	8$\frac{3}{4}$" (22 cm)
	10.5	11" (28 cm)	9" (23 cm)
	11	11$\frac{1}{4}$" (28.5 cm)	9$\frac{1}{2}$" (24 cm)
	12	11$\frac{1}{2}$" (29 cm)	9$\frac{3}{4}$" (25 cm)
	12.5	11$\frac{1}{2}$" (29 cm)	10" (25.5 cm)
	13	11$\frac{3}{4}$" (30 cm)	10$\frac{1}{2}$" (26.5 cm)
	14	11$\frac{3}{4}$" (30 cm)	10$\frac{3}{4}$" (27.5 cm)

USING YOUR FOOT MEASUREMENTS

In this section, we are going to explore how to use your actual measurements from your feet to find your "to-fit" foot measurements. Working a bit of math to find your to-fit measurements will make all the difference in choosing the proper size sock.

Actual Foot Measurements: the measurements of your foot.

To-fit Measurements: the measurement of your foot after ease has been deducted. This will be the size of the finished sock.

As an example, look at the sample chart of actual foot measurements from one of my students.

FOOT, GUSSET, ANKLE, AND LEG CIRCUMFERENCE

Start with measurements for A, B, and C. Because they are circumference measurements, they require applying 5 percent negative ease. The easiest way to figure this out, as long as you have a gauge within a range of 6 to 7 extended single crochet stitches (exsc) per 1" (2.5 cm), is to subtract ½" (1.3 cm).

Note: If you are making a sock at a different gauge, multiply your actual foot measurement by 0.95. This will automatically give you a finished number that is 5 percent less than that of your actual measurement.

In our example, we begin with the following measurements:

A) 8½" (21.5 cm)
B) 9¼" (23.5 cm)
C) 9¼" (23.5 cm)
E) 11¾" (30 cm)
F) 11½" (29 cm)

Subtracting ½" (1.3 cm) gives us these measurements:

A) 8" (20.5 cm)
B) 8¾" (22 cm)
C) 8¾" (22 cm)
E) 11¼" (28.5 cm)
F) 11" (28 cm)

This gives us clean and easy numbers to use as our to-fit measurements.

Alternatively, we could apply our equation to get the negative-ease measurements:

A) 8.5 x 0.95 = 8.075
B) 9.25 x 0.95 = 8.787
C) 9.25 x 0.95 = 8.787
E) 11.25 x 0.95 = 11.162
F) 11.5 x 0.95 = 10.925

Round down to the nearest ¼" (6 mm) to get the to-fit measurements:

A) 8" (20.5 cm)
B) 8¾" (22 cm)
C) 8¾" (22 cm)
E) 11" (28 cm)
F) 10¾" (27.5 cm)

Measurements A, B, and C are the same as simply subtracting ½" (1.3 cm). However, measurements E and F are actually about ¼" (6 mm) less than if we were to multiply by 0.95.

Although, in the long run, the ¼" (6 mm) difference may not affect the overall fit of the sock an incredible amount, the smaller the foot, the more problems you may run into. Either way, however, you'll finish with to-fit measurements that create a custom-fit sock.

If a sock pattern does not feature the exact size of your to-fit measurement, simply choose a size that is nearest while still smaller than your actual foot measurements. For example, if a sock pattern only offers sizes 8" and (20.5 and 21.5 cm) and your to-fit measurements are 8¾" (22 cm), choose the 8½" (21.5 cm) size. Never choose a size that is more than 1" (2.5 cm) less than your actual foot measurements; the sock will not stretch over all the areas needed.

Measurement F (the heel diagonal) is not crucial to the overall structure of the sock. It is used to create a gusset that ensures the sock will stretch over the ankle.

Because this is a tricky measurement, I often have students try on the sock as they are working through the gusset to see if any changes need to be made throughout the area. If so, then reducing or increasing the gusset stitches can provide a more comfortable fit.

But, if you're crocheting a gift sock, you need to check this area without trying it on. Test by stretching the sock horizontally while holding the heel and top of the foot. If it stretches to half the actual foot measurement, then it is safe to wear. If you don't have that measurement, rest assured, the sock should still fit, barring no extensive measurement differences within the foot.

FOOT LENGTH

When working the foot length of the sock, subtract 1" (2.5 cm) to get the to-fit measurement instead of 1/2" (1.3 cm). Also, instead of multiplying the actual foot measurement by 0.95, multiply by 0.90. This gives us a finished measurement that is 10 percent less than our actual measurement.

For foot length, the only two measurements that need to be factored in are D and G. Measurement G is already factored into D, but we need to look at G especially if it has a difference of 2" (5 cm).

Using our same student's foot, subtracting 1" (2.5 cm) gives us this measurement:

D) 7 1/4" (18.5 cm)

This clean, easy number to work from includes the heel, toe, and foot.

Alternatively, if we applied our equation, we would work:

D) 8.25 x 0.90 = 7.425

After rounding down to the nearest 1/4" (6 mm), our to-fit measurement would be:

D) 7 1/4" (18.5 cm)

While our to-fit measurement includes the toe measurement, sometimes a pattern does not take the toe into account. You may read a pattern that states, "Work in pattern stitch until foot measures 5 1/4" (13.5 cm) from back of heel, begin toe."

This assumes a 2" (5 cm) toe. For the measurements in the chart above, you'll notice my student has a toe length of only 1 1/4" (3.2 cm). What should she do?

The simple answer is to ignore the pattern directions. In this case, work until the foot measures 1 1/4" (3.2 cm) less than the student's desired to-fit measurement. So, she would work until the foot of her sock measures 6" (15 cm) from the back of the heel, then work the toe 1 1/4" (3.2 cm), giving her a finished sock that measures 7 1/4" (18.5 cm)—a great fit for her 8 1/4" (21 cm)—long foot.

SAMPLE ACTUAL FOOT MEASUREMENTS	LEFT FOOT	RIGHT FOOT
(A) Foot circumference	8 1/2" (21.5 cm)	8 1/2" (21.5 cm)
(B) Ankle circumference	9 1/4" (23.5 cm)	9 1/4" (23.5 cm)
(C) Gusset circumference	9 1/4" (23.5 cm)	9 1/4" (23.5 cm)
(D) Foot length	8 1/4" (21 cm)	8 1/4" (21 cm)
(E) Leg circumference	11 3/4" (30 cm)	11 3/4" (30 cm)
(F) Heel diagonal	11 1/2" (29 cm)	11 1/2" (29 cm)
(G) Toe length	1 1/4" (3.2 cm)	1 1/4" (3.2 cm)

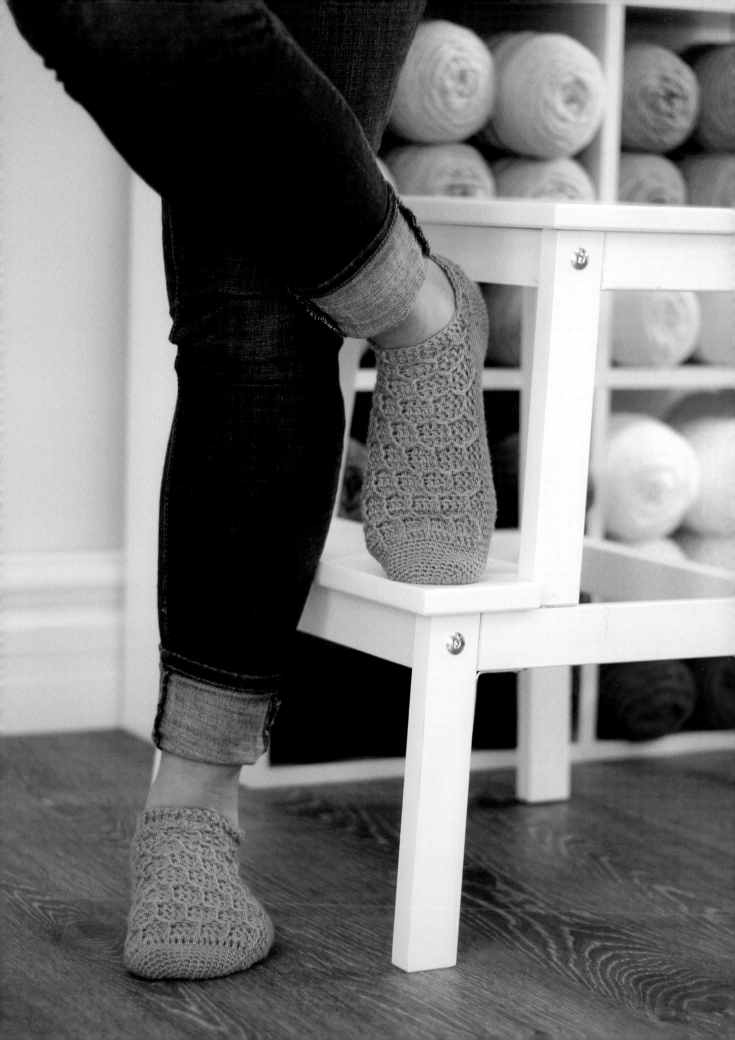

CHAPTER 2

CHOOSING THE RIGHT YARN

The right yarn can make or break a sock. Understanding all that goes into a sock yarn will help make it easier to make the right choice for your socks.

NOT ALL YARNS ARE SOCK YARNS

Crocheters have a unique relationship with yarn. Most of us learn by using what we find in the big-box stores—usually a worsted-weight (sometimes called a "number 4 yarn") acrylic yarn. This will never work for socks.

For socks, you must use sock yarn. That is, fingering-weight yarn specifically customized for socks. This is an elastic, wicking, strong, and (more often than not) wool or wool-blend yarn.

When choosing yarn, I always recommend experimenting with different yarns. Buy five different sock yarns and try them out—one is bound to work for you. Lastly, remember, sock yarn doesn't have to cost an arm and a leg. Some of our favorite chain craft stores sell wool and wool-blend sock yarns that are just as good as those expensive alternatives.

>>

THE IDEAL SOCK YARN

A good sock yarn has what I call the "Holy Trinity of Socks:" elasticity, strength, and absorbency.

ELASTICITY

Elasticity is the capability of stretching over the foot but springing back to stay up after an entire day's worth of wear. It also refers to sock yarn bouncing back into shape after washing.

STRENGTH

Socks have to be strong. The stronger the better, and the stronger the yarn, the more plies you'll find. Several plies need a tighter twist, both of which will make an incredibly strong yarn that will last for years.

ABSORBENCY

Your feet sweat, and some people's feet sweat a lot. Sock yarn should be able to absorb or wick that moisture. Wool is a great wicking agent that keeps your feet dry and comfortable, which reduces odor and blisters. It also keeps your socks from wearing out quickly by reducing wetness, which, along with friction, will cause felting.

FIBER

Wool is the best option for crochet socks, so each of the patterns in this book features a wool yarn. Wool is thought of as scratchy and coarse, but most modern wools are completely the opposite. Still, it's important to note that the even the softest of wools are not always the best for crochet socks.

A wool-blend yarn is often a great choice for crochet socks. Bamboo is a great addition to sock yarn because it adds strength but keeps the yarn soft.

Most sock yarns include at least a small amount of nylon. While this is a great addition for crochet socks, it is not absolutely required. The nature of crochet fabric makes it dense and therefore strong, which means your socks will last longer.

Still tempted by that skein of acrylic yarn? Put it down, back away. It won't breathe, as wool does, so you'll end up with damp and uncomfortable feet.

PLIES

Plies are the single strands of yarn that are spun together to make the final yarn. The individual strands can be spun very thin (and often are in sock yarn).

I like to say, "two is good, but four is best" when it comes to my sock yarn. The number of plies in a yarn determines its strength as well as how well it performs as a sock.

Okay Better

The more plies, the stronger the yarn will be. Often, a greater number of plies also means a higher twist in the yarn; the higher the twist, the more bounce and energy the yarn will have. A tight twist also makes a tougher yarn, but it can make the yarn feel rough and dense, good qualities in sock yarns. Our feet are not as sensitive as our hands or our heads, so an extremely soft yarn isn't needed.

READING LABELS

Sock yarn labels include some great information, which will help you choose the hook size you'll begin with to achieve gauge. They also include the fiber content, amount of yarn included in the skein, weight of the skein, recommended stitch gauge, recommended needle and hook sizes, colorway name or number, and washing instructions.

It is important to note that weight and yardage of yarns often vary; 100 grams of one sock yarn may contain 435 yds (398 m), while 100 grams of another sock yarn may contain 385 yds (352 m). Choosing a sock yarn simply on weight is never a good idea, so choose a pattern that gives an approximate yardage needed and purchase about 25 percent more yarn than recommended in the pattern. This will ensure you have enough yarn to complete your project.

Yarn amounts vary greatly from sock pattern to sock pattern. Cabled crochet socks may take more yarn than lace socks do, whereas simple socks require a yardage amount somewhere in between.

The chart offers a guideline for yarn amounts based on gauge and foot circumference, which can help determine the amount of yarn you'll need to crochet a pair of socks. In general, the larger the sock size, the more yarn you will need.

COST VS QUALITY

The cost of sock yarn is a point of concern for many crocheters. Crochet socks tend to take more yarn than knitted socks, so multiple skeins may have to be purchased. When the skeins cost $25 to $30 a piece, that can add up quickly. However, cost is not an indicator of quality. Some of the most expensive sock yarns wear out the quickest.

Some yarns, including those chosen for this book, are both affordable and cost-effective. The larger the sock or finer the gauge, the more yarn you will need, which means a higher cost overall.

A number of (non-acrylic!), cost-effective sock yarns are available at most local craft stores. This lower price tag doesn't necessarily mean a lower quality. They're simply produced at a larger quantity, which trickles down to the crocheter at a lower price.

Yarn choice is completely personal. It depends on a variety of factors and should be chosen based on what works for you. Ultimately, your favorite wool sock yarn is the best one for your socks.

WASHING AND BLOCKING

Blocking is simply the process of washing your socks to allow the fibers to realign and settle back into place where they should be. With wear, crochet socks tend to stretch out, and blocking them ensures your socks will spring into shape and last longer. Socks also need to be washed more often than other crochet garments because we wear them more often!

Although most sock yarns can be thrown in the wash and machine dried, I prefer to handwash all of my crochet socks. This helps ease wear and prevents accidental felting.

Handwashing socks is a very simple task and can be completed in an assembly-line fashion. Fill a large sink with warm water and a small amount of wool wash or a mild dishwashing detergent. Submerge your socks and squeeze to saturate with water. Allow your socks to soak for up to 20 minutes.

Remove your socks and squeeze as much water out of them as you can. Do not wring or pull on your socks while wet. Roll your socks in a towel to remove any extra moisture or throw them in the washer set to the spin cycle. You can even place them in a heavy-duty salad spinner! Then either lay flat to dry, hang to dry, or use sock blockers and follow the directions given with those. When the socks are dry, you're all set to wear your freshly laundered socks.

SOCK CIRCUMFERENCE	GAUGE (sts/1" [2.5 cm])					
	4	5	5.5	6	6.5	7
8" (20.5 cm)	320 yd (293 m)	350 yd (320 m)	380 yd (347.5 m)	410 yd (375 m)	440 yd (402 m)	470 yd (430 m)
8½" (21.5 cm)	330 yd (302 m)	370 yd (338 m)	410 yd (375 m)	450 yd (411.5 m)	490 yd (448 m)	530 yd (485 m)
9" (23 cm)	340 yd (311 m)	390 yd (357 m)	440 yd (402 m)	490 yd (485 m)	540 yd (494 m)	590 yd (539.5 m)
9½" (24 cm)	350 yd (320 m)	410 yd (375 m)	470 yd (430 m)	530 yd (485 m)	590 yd (539.5 m)	650 yd (594 m)
10" (25.5 cm)	360 yd (329 m)	430 yd (393 m)	500 yd (457 m)	570 yd (521 m)	640 yd (585 m)	710 yd (649 m)
10½" (26.5)	370 yd (338 m)	450 yd (411.5 m)	530 yd (485 m)	610 yd (558 m)	690 yd (448 m)	770 yd (704 m)

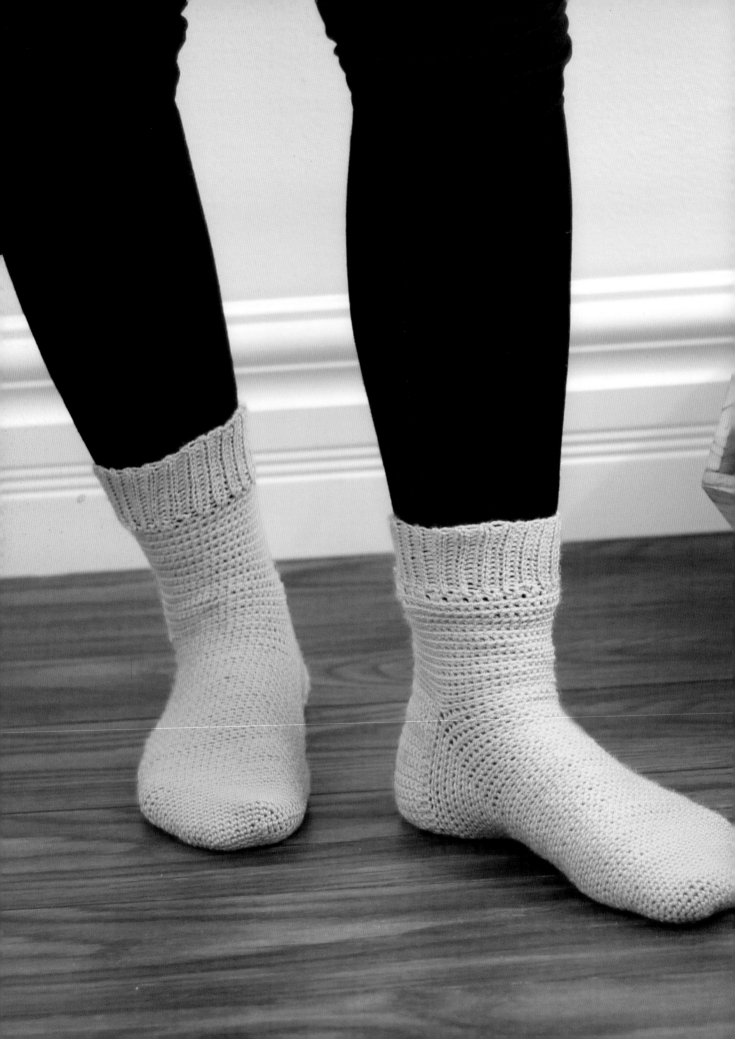

CHAPTER 3

BASIC SOCK CONSTRUCTION

You have the right tools and the right yarn, and now you need the right skills to make socks that fit your feet. Basic sock construction includes knowing the parts of the sock as well as the stitches to crochet them.

BUILDING A SOCK—TOE UP OR CUFF DOWN

Well-fitting socks need stretch, and the amount of stretch is based on the fabric you create. When crocheting socks, it's important to take into account the nature of crochet stitches.

Crochet fabric is constructed of a series of knots built upon each other. Each stitch is independent in both construction and stretch. With each stitch being constructed with knots, this greatly minimizes the amount of horizontal stretch. However, because the stitches are stacked vertically as the work progresses, the vertical stretch is quite impressive.

The patterns in this book are written to counter these problems. Because the fabric of crochet tends to lean toward just a small amount of stretch, the use of certain stitches, such as extended or linked crochet stitches, can drastically alter the amount of stretch in the finished sock. My patterns, whether crocheted from the toe up or from the cuff down, use stitch patterns that provide both horizontal stretch and support, as well as create a solid fabric that eases the soles of your feet.

>>>

BASIC STITCHES

My favorite stitch for my crochet sock designs is the linked half double crochet stitch (lhds; **figure 1,** see Techniques for instructions to work the stitch). The lhdc is a marvelous stitch that astounds me every single time I use it—it is incredibly stretchy. The linked nature of the stitch ensures even stretch across the stitches, it joins the work much like knitting, and it creates a solid fabric, unlike traditional half double crochet (hdc; see Techniques).

Crocheting lhdc takes a bit longer than working a standard hdc, but the resulting fabric is like no other. It creates a fabric that is comfortable to wear, strong, and stretchy.

The lhdc stitch is worked similarly to the hdc stitch, except that each lhdc stitch is joined to the previous stitch by working into the horizontal bar of the previous stitch.

Another stitch that can be used for socks is the extended single crochet stitch (exsc). It provides a good amount of stretch, but it can be felt on the feet more than the linked stitches. The extra chain that occurs near the bottom of the stitch adds a small base to each stitch and allows the stitch to stretch vertically and horizontally. While the stretch isn't anywhere near that of a commercial sock, it does help with fit. Many crocheters find this an adequate solution to their sock-crocheting issues.

With these stitches, we often run into problems adapting stitch patterns. The lack of horizontal stretch can be a bigger issue if using techniques such as

colorwork or lace. Most crochet stitches aren't meant to be horizontally stretched, and lace or colorwork don't take into consideration negative ease. That means that some crochet sock designs aren't made to fit every foot. However, crocheted cables have a great deal of stretch to them, making them a great fit for crochet socks.

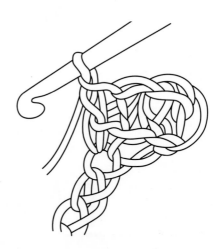

Figure 1

>> GAUGING FOR SUCCESS <<

Gauge is simply the number of stitches and rows or rounds in an inch of finished crochet fabric. When you crochet to the stitch and the row gauges given in a pattern, you can achieve the correct size sock.

Surprisingly, gauge is more difficult to achieve in crochet than in knitting. Crocheters have to account for not just the width of stitches but also the height of stitches—and that can depend on yarn choice, hook choice, and even the way you hold your yarn. The stitches are not determined by a set needle circumference but instead more so by the individual crocheter.

Crocheting socks in particular complicates getting the correct gauge. Crochet socks should always be worked at a tighter-than-average density; a denser fabric will create a more durable sock. A stitch gauge of 6 to 7 stitches per 1" (2.5 cm) is perfect for crochet socks. Anything denser than that will reduce stretch and make the socks uncomfortable.

Although stitch gauge and row gauge are both critical for success, stitch gauge is more important. No matter the pattern, stitch gauge should remain constant. Trying to adjust for incorrect gauge by decreasing or increasing stitches in the middle of the sock will change the fit of the sock. Your row gauge matters most when it comes to lace and cable patterns, but the length of the sock can always be adjusted as you work through the pattern.

MAKING A GAUGE SWATCH
A gauge swatch should be worked in the round using the pattern stitch of the sock. You want to know your true gauge, or the actual gauge, of the finished sock.

Crochet a swatch that is at least 4" (10 cm) tall and 4" (10 cm) wide with your sock yarn of choice and the hook size recommended in the pattern. I suggest working a swatch that is 30 stitches around for 4" to 5" (10 to 12.5 cm). Complete the swatch in the pattern stitch, then block it.

Place a ruler over the stitches in the center of your swatch, taking care not to press the ruler into the fabric (which will distort the measurement). Take two or three measurements from different areas of the swatch. Count the full and partial stitches, which will add up if you don't account for them, within the width given in the pattern.

For example, the gauge for the Beltline Toe-Up Socks is 28 stitches and 24 rows in a 4" (10 cm) swatch worked in linked half double crochet (lhdc) in the round. If you have more than 28 stitches in your swatch, you're crocheting too tightly; try going up in hook size. But if you have fewer stitches, you're crocheting too loosely; trying going down in hook size.

HOOKS
Hook choice is critical to successful crochet socks. The material, grip, and shaft size of a hook affect gauge in a big way.

Crochet hooks come in wood, metal, and plastic. Metal is clearly the most popular. Personally, I have a tendency to crochet loosely if using a wooden hook, whereas a metal hook gets my gauge just where it needs to be. If you are having difficulty getting the right gauge, changing the material of your hook may help.

GRIP
Many crochet hooks feature soft grips that keep your hand in an ergonomic position and comfortable for hours of crocheting. These are great, but they can also change how you hold your hook and your gauge. I use hooks with large grips for finely crocheted items such as socks. They keep my hand well rested, but my gauge loosens up considerably; so, I have to go down a hook size.

SHAFT SIZE
The shaft, which is just below the hooked end of your crochet hook, is what determines the size of the stitches. It controls the circumference of the loops worked in each stitch. The length of the shaft can also have a small impact on the gauge. If I use a hook with a longer shaft, which gives it more room to move through the stitch, then I go up a hook size. After years of trial and error, I've found that I crochet more tightly with hooks with longer shafts.

Recommended Hook Size for Gauge

3.5 mm = 6 sts/1" (2.5 cm)

3.25 mm = 6.5 sts/1" (2.5 cm)

3.0 mm = 7 to 7.5 sts/1" (2.5 cm)

2.75 mm = 7.5 sts/1" (2.5 cm)

THE ANATOMY OF A SOCK

Every sock, whether it is crocheted toe up or cuff down (**Figure 2**), is composed of a cuff, leg, heel, foot (which is the instep and sole), and toe. Most socks also have a gusset, which is sometimes omitted in toe-up socks. Each part has a specific purpose.

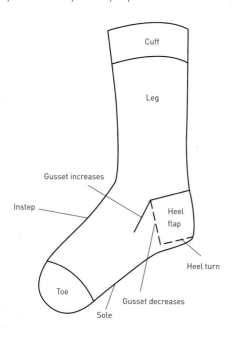

Figure 2

THE CUFF

The cuff is a stretchy type of ribbing whose sole purpose is to keep the sock up. Side-to-side ribbings, such as the two used throughout this book, offer attractive and practical alternatives to traditional ribbing. The side-to-side nature of the ribbing takes advantage of crochet's vertical stretch and creates a cuff that holds its elasticity throughout the day.

THE LEG

The leg is a straight tube that must be elastic enough to accommodate the difference in size between the ankle and the calf. The linked half double crochet and extended single crochet stitches easily stretch enough to accommodate any leg. However, if the leg features a pattern, such as lace, that does not include at least a small amount of stretch, you'll need to compare the stretch with your cuff and ankle circumference to ensure a proper fit.

THE HEEL AND GUSSET

The heel is composed of a few different parts. The heel itself is at the back of the foot and usually measures about 2½" (6.5 cm) long with a width that measures half of the finished circumference of the sock. The gusset is worked either before the heel flap (if working toe up) or after the heel flap (if working cuff down). The gusset is a small triangle of fabric on either side of the foot that allows for extra space. This small amount of extra fabric gives the sock a custom fit.

THE FOOT

Like the leg, the foot is a straight tube. It connects the heel to the toe. The instep is the part that sits on the top of your foot, and the sole is the bottom. The instep can be patterned, but the sole of the sock should always be worked in a solid stitch for maximum durability.

THE TOE

The toe is the hardest-working part of the sock. It's stuck in the shoe all the time, taking the brunt of each step. We move our toes in our shoes all day long, and our toes have nails. It is no wonder that sock toes need some special care. The toe should be worked in single crochet (sc), the strongest of the crochet stitches. If you happen to be extra hard on your toes (as I am), a reinforcing thread of nylon can be carried along with the yarn to add another layer of strength.

CUFF-DOWN CONSTRUCTION

Cuff-down socks are where most crocheters start out, and it's no wonder. They're simple to start, and with very little preparation, you can begin crocheting socks that will fit well. It's easy to customize a cuff-down sock as you work.

Cuff-down socks begin at the cuff and are worked in the following order:

Cuff > leg > heel > heel turn > gusset > foot > toe

This is a traditional, tried-and-true method for working socks. The cuff is completed, then stitches are picked up around the finished ribbing. The leg is worked from these stitches to the heel, the heel is worked back and forth in rows, and then the heel turn is completed. Stitches are picked up around the heel flap and the bottom of the foot, gusset decreases are then worked, followed by the foot (instep and sole), and then the toe is worked to finish the sock. The Gorman Street Cuff-Down Sock is a great example of this construction method.

TOE-UP CONSTRUCTION

A new, exciting way to crochet socks is by starting with the toe. The new combinations of toe and heel methods being developed by talented designers around the world continue to inspire crocheters and offer alternatives to the standards.

The method of construction is simply the reverse of the cuff-down sock:

Toe > foot > gusset > heel turn > heel > leg > cuff

Working socks from the toe up changes the direction of the stitches and provides a different fit from working socks cuff down. Increases, instead of decreases, are worked in the gusset. The heel is worked back and forth with a heel turn, but with a twist; it is worked in the reverse order beginning with the turn and then the flap is worked in a join-as-you-go method. The cuff is worked in a side-to-side, join-as-you-go method, which provides the same stretch and feel as the cuff-down version. The Beltline Toe-Up Sock is a great example of this construction technique.

Note: One of the great advantages to toe-up socks is being able to manage yarn amounts. If you are afraid of running out of yarn, work both socks at the same time from toe to cuff until you run out of yarn. When you're done, break the yarn, and you have two matching socks made with a single skein!

GUSSETS

Gussets are simply small areas of fabric that are inserted into different areas of clothing that are under stress, such as the side of the foot (**Figure 3**). For crocheters, gussets are especially helpful when it comes to proper fit.

Looking at your foot measurements, you'll see that the gusset circumference is a bit larger than your foot circumference. Crochet socks often don't stretch enough to accommodate the widest part of the foot, especially the area that includes the heel and ankle. Adding gussets on either side of the foot comfortably solves this problem.

You can also add a gusset at the back of the sock leg to accommodate larger calf sizes. Simply add the amount of stitches needed for the larger calf measurements, remembering your stitches per 1" (2.5) from your gauge swatch, and decrease the stitches as the calf measurement decreases (if it does). This will accommodate a larger, shapelier calf while keeping the pattern intact.

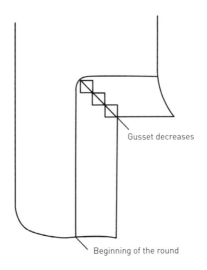

Gusset decreases

Beginning of the round

Figure 3

MAKING YOUR SOCKS PRETTY

Most crocheters want their socks to be pretty, of course, whether that is through the yarn or the stitch pattern. Beyond how the sock should fit and what heel or toe you choose, it needs to look good enough to proudly wear. After all, why make a sock that looks like something you can buy in the store?

The great thing about crochet socks is that they are extremely unique. You get to show them off, knowing the chances of another crafter having the exact same pair is quite rare.

The best way to add character to your socks is to switch up the stitch patterns. Adding cables, lace, or texture will create unique socks that fit well and feel even better. While each has its distinct advantages, you'll find that adding stitch patterns will enhance your socks and really give you the best of both function and beauty.

CABLES

Cables have come a long way in crochet. The use of post stitches (see Techniques) to work cables gives fabric shape and drape while using crochet's stability to its best advantage. Personally, cables and I have a love-hate relationship. I love the plump look and feel of cables, but I don't like the bulk they often add to fabric.

Post stitches, which are often used to crochet cables, are called that because they are worked around the post of a double crochet or similarly high stitch. These stitches generally don't work well on sc or half double crochet (hdc). The stitch is wrapped around the post from the previous row, forcing the stitch to the front (front post) or back (back post) of the work.

This creates a very textural stitch and a fabric that is quite stretchy, but it will not retain its stretch. Post stitches should be used in conjunction with other stitches such as sc, hdc, or double crochet (dc). This will give the sock stability and support while allowing it to retain the stretch it needs. Overall, post stitches should be used sparingly on socks. Rarely should post stitches, especially large plump cables, be carried down to the foot. This will make the sock ill fitting inside the shoe.

LACE

Lace is my favorite addition to crochet socks. The stitch patterns translate beautifully and look great when stretched open over the leg and top of the foot. However, crochet lace is not as stretchy as you might think. The lace is composed of chains and groups of stitches; chains have a tendency to be a bit tighter than other stitches and can create an uncomfortable fit, especially on the ankle.

So, I usually recommend lace only on the leg when just beginning to crochet socks. As you become more comfortable customizing crochet socks, you can carry the lace down the front of the foot with confidence it will fit.

The easiest way to customize lace is to add an extra chain whenever there are large chain spaces. This will alter the overall stitch count, but this is a necessary modification to account for the lack of stretch. Doing so will contribute a small amount of stretch over the whole sock without altering the over-all stitch count. The stitches should be ignored on the following rows and where the lace pattern is not worked, such as the sole of the foot, heel, toe, or cuff; it is imperative to keep the stitch count that of what the gauge denotes.

COLORWORK

Colorwork is a great way to use up scraps and small amounts of yarn, such as partial skeins. It is also a wonderful way to add a pop of color to your socks. Traditional stranded colorwork takes almost all the stretch out of socks. But you can add color without compromising stretch using different methods of colorwork or by switching colors within a pattern. The key to successful colorwork is maintaining even tension through all the different yarns.

INTENTIONAL STRIPES

Stripes that you create (as opposed to using self-striping yarn) within a fun and textured stitch pattern can add a new layer of color.

Some sock patterns offer unique stitch patterns that vary in height and overall stitch count, such as lace or cables. By changing yarns colors every other row, you can dramatically change the overall look and feel of the sock without altering the finished design aesthetic.

INTARSIA

Intarsia is a way of working colorwork without compromising stretch. It is an advanced method that requires juggling more than one yarn simultaneously. It can be a bit complicated, but the overall finished appearance is well worth the effort.

The biggest worry of colorwork is making sure it stretches over the heel. Check this by working the swatch in the proposed colorwork pattern and in the stitch count for your size. Test the swatch to ensure your sock will stretch to fit over your heel.

If using a stranded colorwork technique such as Fair Isle crochet or tapestry crochet, your gauge will almost always be tighter than standard crochet stitches in the same yarn with the same hook. Take time to measure your gauge in the colorwork pattern before beginning your socks.

>> TOP FIVE WAYS TO ADJUST PATTERNS FOR A CUSTOM FIT <<

An average foot is the one that socks are designed for. However, feet, just like people, are unique, and many need adjustments here and there. For example, I have very large, muscular calves and am over 6½" (198 cm) tall. So, I need to adjust crochet socks to fit my calves while also lengthening the leg of my sock for a proportional fit.

Sock crocheters often ask the same questions when figuring out how to adjust their socks to best fit their feet. These are the top five most-often-asked questions—and simple solutions:

1. MY SOCKS WON'T STAY UP ON MY LEG. WHAT AM I DOING WRONG?

Chances are the socks are just too large. You may need to adjust the amount of ease in the sock so that it properly stretches over the smaller areas.

On your next pair of crochet socks, check your measurements and work from new numbers. If it is a chronic problem, try making the leg of the sock one size smaller and finishing the sock in your standard size by working only enough gusset decreases or increases (depending on construction) to achieve the proper stitch count.

2. EVERY SINGLE TIME I MAKE SOCKS, THEY NEVER STRETCH OVER MY HEEL! WHAT AM I DOING WRONG?

This is a common problem. If I'm being honest, it has happened to me a few times. Make the leg of your sock in the required number of stitches and work to the beginning of the heel on a top-down sock (if working a toe up, make a tube of stitches in the same stitch count) and try it on, stretching it over your heel. Remember, this shouldn't be a loose fit, but it should slide easily over your heel to your calf. If this isn't working, you may need to go up a size and make your sock leg a bit larger or try a stitch with more stretch.

3. I HAVE SHAPELY LEGS, SO I ALWAYS MAKE ANKLE SOCKS. IS THERE ANYTHING I CAN DO TO MAKE CROCHET SOCKS FIT MY CALVES?

Try working the gusset method of adding stitches at the back of the leg, then decreasing stitches down to the ankle. This will provide a customized fit and allow your foot to fit perfectly in the sock. Tailor the sock to fit your measurements perfectly.

4. MY FEET ARE MUCH WIDER THAN MY ANKLE, SO SOCKS FEEL TOO TIGHT. IS THERE ANYTHING I CAN DO?

Here's a simple solution! Work a few extra decrease rounds at the gusset to get the sock circumference to the needed measurement, taking negative ease into consideration. Alternatively, try decreasing to the next smallest size of sock.

5. THE FOOT OF MY SOCK IS TOO SHORT (OR TOO LONG). WHAT DID I DO WRONG?

You might have figured too much negative ease in the sock length, or you simply forgot to include that measurement. Either way, simply work the sock until the foot is about 2" (5 cm) less than your desired sock length, then work the toe.

CHAPTER 4

HEELS, TOES, AND CUFFS

Heels, toes, and cuffs are the three major areas of a sock. You don't have to settle for just one construction method to crochet them. With a variety of options in your skill set, you can customize your socks to your specific needs.

HEEL AND TOE CONSTRUCTION CHOICES

When it comes to fit and comfort and withstanding wear, no part of the sock is quite as important as the heel. A close second is the toe. This extremely hardworking area of the sock needs special attention. Crocheters have been taught to use primarily two types of heel constructions and simple toe construction methods. However, these are not the only methods of making crochet sock heels, nor are they necessarily the best fitting.

>>

HEEL CONSTRUCTION TYPES

Cuff-down heel flaps and toe-up short-row heel constructions are common methods, but they may not be the best for your feet. Try, instead, these four heel construction methods: the round heel, the strong heel, the band heel, and the common heel. All of these heels have been adapted from their knitted counterparts to make a well-fitting and versatile crochet sock.

Choosing the crochet sock-heel technique that works best for you is a practice in trial and error. The heels I have included in this book work for both toe-up and cuff-down socks, and each features a heel flap and gusset construction for proper fit.

A heel flap is typically worked back and forth in rows on half of the total stitches of the sock in either single crochet (sc) or linked half double crochet (lhdc) for durability. In a top-down sock, the flap is worked back and forth on these stitches to a specific measurement; for the best fit, the flap-length measurement should be customized to your foot. If working toe-up socks, this can prove a bit tricky because the length of the heel flap is inexplicably linked to the number of stitches increased in the gusset. When the heel flap is complete, a heel turn is worked to curve the sock under and create a great fit for the bottom of the heel. In a toe-up sock, the heel turn is worked first, then the heel flap.

CUFF-DOWN ROUND HEEL

The standard round heel, also called the French heel, is the most popular heel type in cuff-down crochet socks. It can be used for toe-up socks as well. The round heel consists of a heel flap with a small trapezoid of fabric worked with decreases and short-rows to create the heel turn. Stitches are then picked up around the heel flap and incorporated into the body of the sock to form the gusset.

TOE-UP ROUND HEEL

The toe-up round heel is constructed the same as its cuff-down counterpart, just in the reverse order. The foot of the sock is worked to a designated length, then increases are worked to form the gusset on either side of the foot. The heel turn is worked and then the flap is started. The flap is worked back and forth, joining (and thus decreasing) stitches as the flap is worked up. The flap can be made shorter or longer by decreasing more (or fewer) stitches, depending on the desired length. Once the flap is done, no other decreasing needs to take place, and the stitches that remain are the stitches you began with.

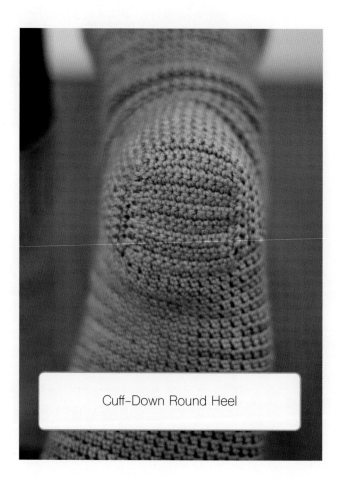

Cuff-Down Round Heel

CUFF-DOWN STRONG HEEL

The cuff-down strong heel, adapted from the knitted version, is very easy and fun to complete. The heel begins after working the leg to a desired length. Increases are then worked on either side of the leg to form the gusset increases and the heel flap at the same time. This entire heel, except for the heel turn itself, is worked in the round. Once the necessary number of stitches has been reached, a short-row heel turn is worked, which also acts as a decrease method. When the heel turn is finished, the original number of stitches remains.

TOE-UP STRONG HEEL

The toe-up strong heel is worked similarly to the top-down version, but in reverse order. The sock foot is worked to the desired length, then the heel turn is worked. Stitches are picked up around the heel turn and worked with the previously unworked stitches on the foot of the sock. Stitches are then decreased on either side of the foot while work-ing in the round to create a comfortable and fitted heel. Stitches are decreased to the original amount needed.

COMMON HEEL

The common heel is similar to the round heel flap, except there is no heel turn. Half the stitches are worked in the stitch pattern designated in the pattern until the sock flap measures the desired length. The heel is then folded in half and joined with a simple slip-stitch or sc seam. This seam sits on the bottom of the heel. The heel is worked in reverse for toe-up socks, though this is a bit more rare and not fea-tured in this book.

CUFF-DOWN DUTCH HEEL

A Dutch heel works well for both toe-up and cuff-down socks. The heel flap is worked on half the total stitches to a designated length. Once the flap is completed, one-third of the stitches in the center of the flap are used to create a band. The stitches on either side of the center band are joined by working two stitches together, which serves a dual purpose of decreasing the total number of heel flap stitches. A small number of stitches then need to be decreased in the gusset section.

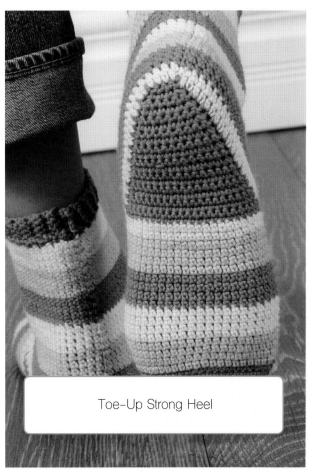

Toe-Up Strong Heel

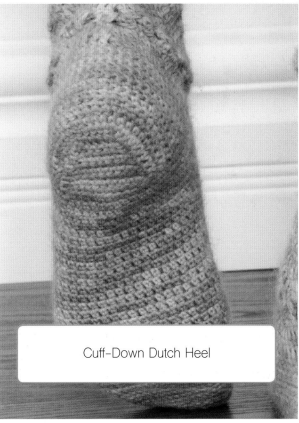

Cuff-Down Dutch Heel

TOE-UP DUTCH HEEL

In the toe-up version of this heel, the band is worked first with the heel flap forming around this small rectangle of fabric, after increasing a small number of stitches for the gusset. When the heel flap is done, the original number of stitches remains.

REINFORCED HEELS

Reinforcing heels is a popular trick worked by a lot of knitters and crocheters. It simply involves carrying a thin thread of 100 percent nylon along with your yarn while working areas of a sock that receive a lot of wear, such as the heel.

The truth is, with crochet, this isn't necessary. Crochet stitches are individual knots that reinforce themselves. However, if you want to reinforce your heels, simply crochet as normal, carrying along the nylon thread through the heel flap and turn.

A Note on Peasant and Short-Row Heels: The peasant heel, also referred to as an afterthought heel, and the short-row heel are among the more popular methods of creating heels, especially with knitters. But I didn't include any in this book. Why? The truth is, I don't like them, nor do I think they are appropriate for crochet socks.

The afterthought heel does not have a heel flap or gusset, and it is worked the same way for toe-up and cuff -down socks. It often puts strain on the top of the ankle and creates a tight fabric that isn't great for crochet socks.

The short-row heel is ill fitting and must always be customized. This customization is difficult to accomplish because the stitch counts are dependent upon each other and can be difficult for the beginner sock maker to figure out.

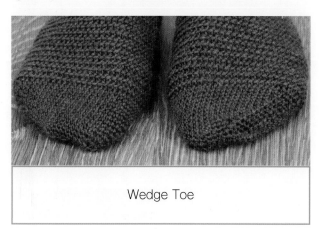

Wedge Toe

PATTERNED HEELS

I am often asked if I recommend patterning on heels, such as carrying cables down the length of the sock heel. The answer is "yes" and "no." The determining factor is whether or not the pattern will have an impact on the overall fit of the sock within the shoe.

As a general rule, cables and lace should never be carried down the heel. Lace has holes, which will ultimately rub and break. Cables are thick and bulky and won't comfortably fit in a shoe. My advice is to stay away from these. Textured stitches can be carried down the heel, but this should only be done on a trial basis.

TOE CONSTRUCTION TYPES

All sock constructions are the same in their basic structure. For a cuff-down sock, you begin with the foot stitches and decrease down to a specific number of stitches to match the gauge of the sock. For toe-up socks, you begin with a small set of numbers and increase to the needed number of foot stitches. Whether you choose a toe-up or cuff-down pattern, making a tough toe is absolutely essential to successful sock crocheting.

Although I prefer the wedge toe for both toe-up and cuff-down constructions, you can experiment with many options to create a toe that is perfectly unique for your feet. I highly recommend four of them: the wedge toe, the six-point toe, the four-point toe, and the square toe.

WEDGE TOE

The wedge toe is the most common type of toe. It's quite an easy way to shape a toe, and it has a comfortable fit. Decrease 2 stitches at either side of the foot for cuff-down socks or increase 2 stitches at either side of the foot for toe up socks until about 1" (2.5 cm) or half your original stitches remain for the foot of the sock. Finally, seam the end of the toe together.

SIX-POINT TOE

The six-point toe forms a six-pointed star at the top of the toe, which requires a number that is divisible by six to complete. The toe is simply shaped by decreasing 6 stitches every other row until just 6 stitches remain.

FOUR-POINT TOE

The four-point toe is simply a variation of the six-point toe. The number must be divisible by four to complete. The toe is shaped by decreasing 8 stitches every other row until just 8 stitches remain.

Four-Point Toe

SQUARE TOE

The square toe is my favorite alternative to the wedge toe because its comfort is unparalleled. It is best worked toe up, but it can also be completed cuff down. If working toe up, a small square of fabric is crocheted and then stitches are worked around the perimeter with increases worked at each of four points. If you're working top down, 4 decreases are made to a small number of stitches, then the decreases are worked at a much quicker rate to close the toe.

PATTERNED TOES

The toe of your sock needs to be strong and able to withstand a great amount of stress. So, I would avoid patterns that include cables and lace. While I've been tempted to add cables and lace on a toe or two, doing so will greatly shorten the life of your socks and would be incredibly uncomfortable.

Colorwork, however, can be carried through to the end of your foot, and working with the different strands can add a bit of strength. Take care not to carry the yarn along the inside of the foot, as in stranded crochet colorwork; instead, work tapestry crochet by working over the yarn. This will create a toe that has a bit more bulk. I don't recommend this toe for beginners, and therefore it is not included in this book.

When working the toe, always use sc, as you want your toe to be firm and strong and withstand the environment within your shoe. Avoid any stitches that are open or can wear rather quickly.

A Note about Short-Row Toes: Whether worked from the cuff down or toe up, short-row toes are worked the same as a short-row heel. This is where their downfall arises. Short-row toes are too bulky and can be quite uncomfortable. Plus, the differences in gauge from working flat to working in the round create fit issues. Like the short-row heel, this is an option I avoid.

CUFF CONSTRUCTION TYPES

To keep your socks from falling down, you need a cuff. It also gives the sock a finished appearance and a more traditional look and feel. Like crocheting heels and toes, I recommend using less common construction methods.

Most sock crocheters have made cuffs using the front post stitch or the back post stitch. Post stitches create only a small amount of stretch. The stretch that is there when you put the socks on in the morning is gone by the time you remove them at the end of the day—they've fallen into your shoes and turned into uncomfortable slippers.

Bulk is another issue that most crocheters run into. Because so much bulk is associated with post stitches, they make it difficult to maintain a neat and clean look.

I prefer stitches that create a firm stretch and truly helps keep the sock on the leg where it is supposed to be. This requires a different approach to traditional crochet ribbing by working it from side to side on both toe-up and cuff-down socks. These side-to-side ribbings should be worked in either single crochet or slipped stitches and always through the back loop. This juxtaposes the stitches and creates a ribbing that has a wonderful, firm stretch that draws in when released.

The length of the ribbing is up to you. Just 1" (2.5 cm) of cuff can provide enough stability to keep the sock up. Still, I recommend a ribbing of at least 2" to 3" (5 to 7.5 cm), especially for men.

SINGLE CROCHET RIB

Most crocheters are familiar with single crochet rib, whether you've made socks or not. This rib is made by working sc stitches into the back loop of each stitch. Common crochet stitches are worked into both loops. Specialty stitches, such as those worked in the front loop or back loop, create a different fabric that makes distinct lines within the fabric. By turning this work 90 degrees and seaming the ends, you create a great ribbing with a nice clean look. It works particularly well for basic socks.

Single crochet rib can be worked on any number of stitches. The number of stitches designates the length of the rib. So, if your gauge is 6 stitches per 1" (2.5 cm) and you want a rib that is 2" (5 cm) long, you would chain 13 stitches. Twelve of those stitches are for the rib itself and the extra stitch is for the foundation row. After the foundation row, you only work on the 12 sc stitches for the entire length of the rib.

The length of the rib before joining the ends will be the finished circumference of the sock leg. Because each sc stitch is the same width and height, you will work exactly as many rows as you need stitches for the leg circumference. For example, if your gauge is 6 stitches per 1" (2.5 cm) and your leg measurement is 8½" (21.5 cm), you will work a sock leg of 8" (20.5 cm) after subtracting ½" (1.3 cm) for negative ease. That means the leg will be 48 stitches around. Working a single crochet rib, you would simply crochet 48 rows in all. You would then pick up stitches around the base of the rib after seaming the ends and begin working with the proper number of crochet stitches.

SLIP-STITCH RIB

Slip-stitch rib is a lesser-known method to crochet ribbing, but it's a wonderful and stretchy option. Slip (sl) stitches are usually designated for joining in the round or moving the beginning of the round to another stitch, but when they are worked through the back loop and turned 90 degrees to form a rib, they create an incredibly comfortable and stretchy cuff.

This method does take considerably longer than the single crochet ribbing, but the end result is quite superior to anything else I have found.

Slip-stitch rib can be worked on any number of stitches. The number of stitches designates the length of the rib. So, if your gauge is 6 stitches per 1" (2.5 cm) and you want a rib that is 2" (5 cm) long, you would chain 13 stitches. Twelve of those stitches are for the rib, and the extra stitch is for the foundation row. After the foundation row, you only work on the 12 stitches for the entire length of the rib.

The length of the rib before joining the ends is the finished circumference of the sock leg. This rib is a bit more difficult to size because we are using 2 different stitches at different heights. However, the rules still apply. The nature of this rib makes it extremely stretchy, so you will work exactly as many rows as you need stitches for the leg circumference.

For example, if your gauge is 6 stitches per 1" (2.5 cm) and your leg measurement is 8½" (21.5 cm), you would work a sock leg of 8" (20.5 cm) after subtracting ½" (1.3 cm) for negative ease. That means the leg will be 48 stitches around. Working a slip-stitch rib, you would simply crochet 48 rows in all. You would then pick up stitches around the base of the rib after seaming the ends and begin working with the proper number of crochet stitches.

You can increase the stretch of the single crochet rib and spend less time working the cuff than with the slip-stitch rib by combining the 2 stitches. The result looks similar to the knit stitch and is stretchy without being bulky. Simply alternate rows of sl stitch with rows of sc for the length of the ribbing.

The only disadvantage in working slip-stitch rib in whole or in conjunction with single crochet rib is picking up stitches after seaming the ends. Seeing where to put the hook can sometimes cause a bit of confusion. This is easily fixed by placing one single crochet stitch in each row or working two single crochet stitches in the end of each single crochet row and then continuing on with the pattern stitches on the next round.

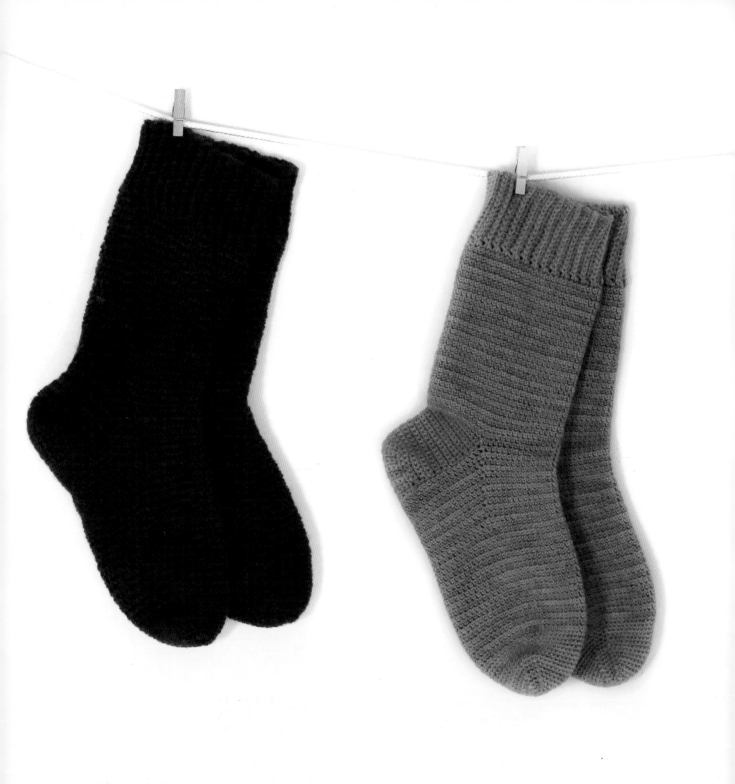

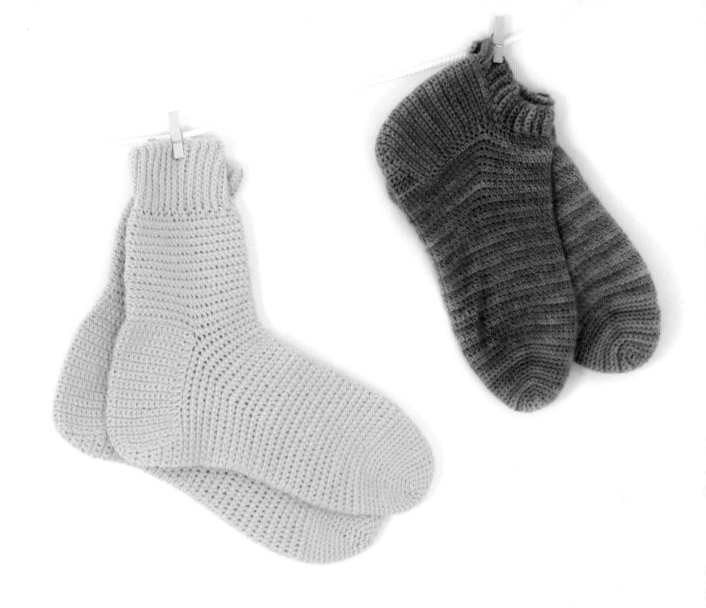

CHAPTER 5

SIMPLE SOCKS

Simple socks are the foundation of all crochet sock patterns. Learning how to customize and create socks that fit your measurements is easiest when there aren't cables or lace or textured stitch patterns to worry about. These socks are as basic as basic can get. Apply all of the lessons you've learned in this book to create custom socks with these patterns, fitted just for you!

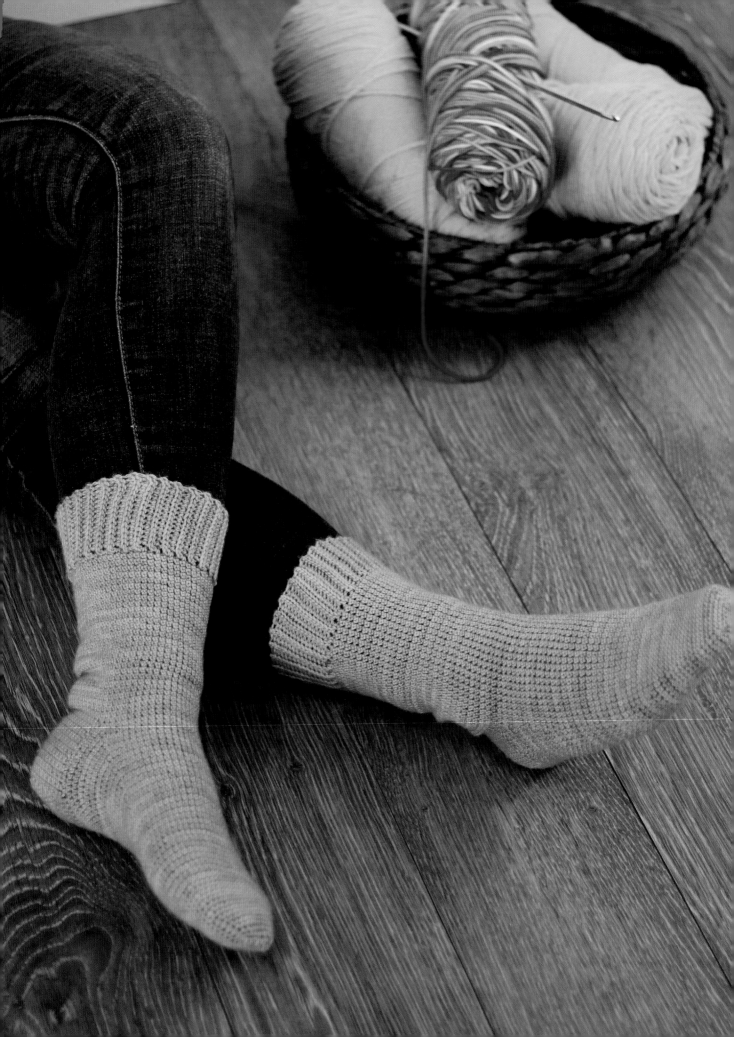

GORMAN STREET CUFF-DOWN SOCKS

These socks are just the sock you need if you want a basic sock. They are worked at a nice, tight gauge that is perfect for long-lasting crochet socks. They are a perfect recipe for the perfect basic sock. Try on the socks as you work them. Play with the fit of the toe, heel, and leg—customize each part to fit you. They are easy to modify and a joy to wear!

These socks are worked from the top down with a single crochet in the back loop (sc in blo) rib, basic heel flap, and standard wedge toe.

FINISHED SIZE

Foot length: 7½" (8½", 9½") (19 [21.5, 24] cm).
Foot circumference: 7" (7½", 8½") (18 [19, 21.5 cm).
Leg length: 1" (2.5 cm).

Sock shown measures 8½" (23 cm) long in the foot and 7½" (19 cm) in circumference.

YARN

Sock weight (#1 Super Fine).
Shown here: SweetGeorgia Yarns Tough Love Sock (80% superwash merino wool/20% nylon; 425 yd [388.6 m]/100 g): Pistachio, 1 (2, 2) skein(s).

HOOK

Size U.S. C/2.75 mm.
Adjust hook if necessary to obtain gauge.

NOTIONS

Tapestry needle.

GAUGE

28 sts and 24 rows = 4" (10 cm) in extended single crochet (exsc) worked in rnds, blocked.

STITCH GUIDE

SINGLE CROCHET IN THE BACK LOOP (SC IN BLO)
Working only in the back loop, pull up a loop in the next stitch, yarn over (yo), pull through 2 loops on hook.

CUFF

Row 1: (RS) Chain (ch) 19, single crochet (sc) in 2nd ch from hook and each ch across to last st, ch 1, turn—18 sts.

Row 2: (WS) Slip (sl) st through the back loop in each st across, ch 1, turn.

Row 3: (RS) Single crochet in the back loop (sc in blo, see Stitch Guide) in each st across to last st, ch 1, turn.

Rep Rows 2 and 3 for a total of 48 (52, 60) rows, join cuff with mattress stitch (see Techniques) to work in rnds.

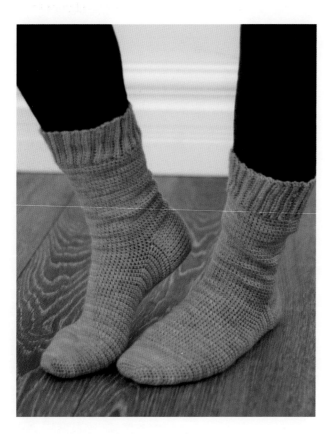

Next rnd: Sc 48 (52, 60) evenly around one edge of cuff, join with sl st to first st, being careful not to twist, ch 1.

LEG

Next rnd: Extended single crochet (exsc, see Techniques) in each st around, join with a sl st to first st, ch 1—48 (52, 60) sc.

Rep last rnd until the leg is 7" (18 cm) long or desired length from top of cuff.

HEEL FLAP

Now work in rows.

Row 1: (RS) Sc in each of first 24 (26, 30) sts, ch 1, turn.

Row 2: (WS) Sc in each st across, ch 1, turn.

Rep the last row 22 (24, 26) more times.

HEEL TURN

Now work in short-rows.

Short-row 1: (RS) Sc in each of first 16 (17, 20) sts, sc2tog (see Techniques), ch 1, turn.

Short-row 2: (WS) Sc in each of next 8 (8, 10) sts, sc2tog, ch 1, turn.

Rep Short-row 2 until all heel sts have been worked, ending having worked a WS row—10 (10, 12) sts rem.

Next row: Sc in each st across, ch 1.

GUSSET

Next rnd: With RS facing, sc 12 (13, 14) sts along the side of the heel flap, cont as est across instep, sc 12 (13, 14) sts along the other side of the heel flap, join

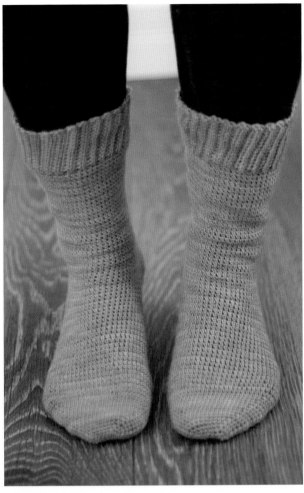

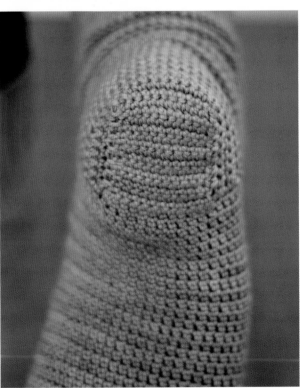

with sl st to first st, sl st into the first st of last row of heel turn, ch 1—58 (62, 68) sts (inc heel turn).

Dec rnd: Exsc in each st to 2 sts before instep, sc2tog, cont as est across instep, sc2tog, exsc in each st around, join with sl st to first st, ch 1—2 sts dec'd (56 [60, 66] sts).

Dec rnd: Exsc in each st to 1 st before previous dec, sc2tog, cont as est across instep, sc2tog, exsc in each st around, join with sl st to first st, ch 1—2 sts dec'd (54 [58, 64] sts).

Rep the last rnd until 48 (52, 56) sts rem.

FOOT

Next rnd: Exsc in each st around, join with sl st to first st, ch 1.

Rep the last rnd until foot is 2" (5 cm) less than desired length from back of heel.

TOE

Dec rnd: [Sc in first st, sc2tog, sc in each of next 19 (21, 23) sts, sc2tog] twice, join with sl st to first st, ch 1—4 sts dec'd (44 [48, 52] sts).

Next rnd: Sc in each st around, join with sl st to first st, ch 1.

Dec rnd: [Sc in first st, sc2tog, sc in each of next 17 (19, 21) sts, sc2tog] twice, join with sl st to first st, ch 1—4 sts dec'd (40 [44, 48] sts).

Next rnd: Sc in each st around, join with a sl st to first st, ch 1.

Dec rnd: [Sc in first st, sc2tog, sc in each of next 15 (17, 19) sts, sc2tog] twice, join with sl st to first st, ch 1—4 sts dec'd (36 [40, 44] sts).

Next rnd: Sc in each st around, join with sl st to first st, ch 1.

Dec rnd: [Sc in first st, sc2tog, sc in each of next 13 (15, 17) sts, sc2tog] twice, join with sl st to first st, ch 1—4 sts dec'd (32 [36, 40] sts).

Cont as est, dec'ing 4 sts every odd rnd until 24 sts rem. Then dec as est every rnd until 16 sts rem.

Fasten off. Seam toe (see Techniques).

Weave in all ends. Wash and lay flat to block.

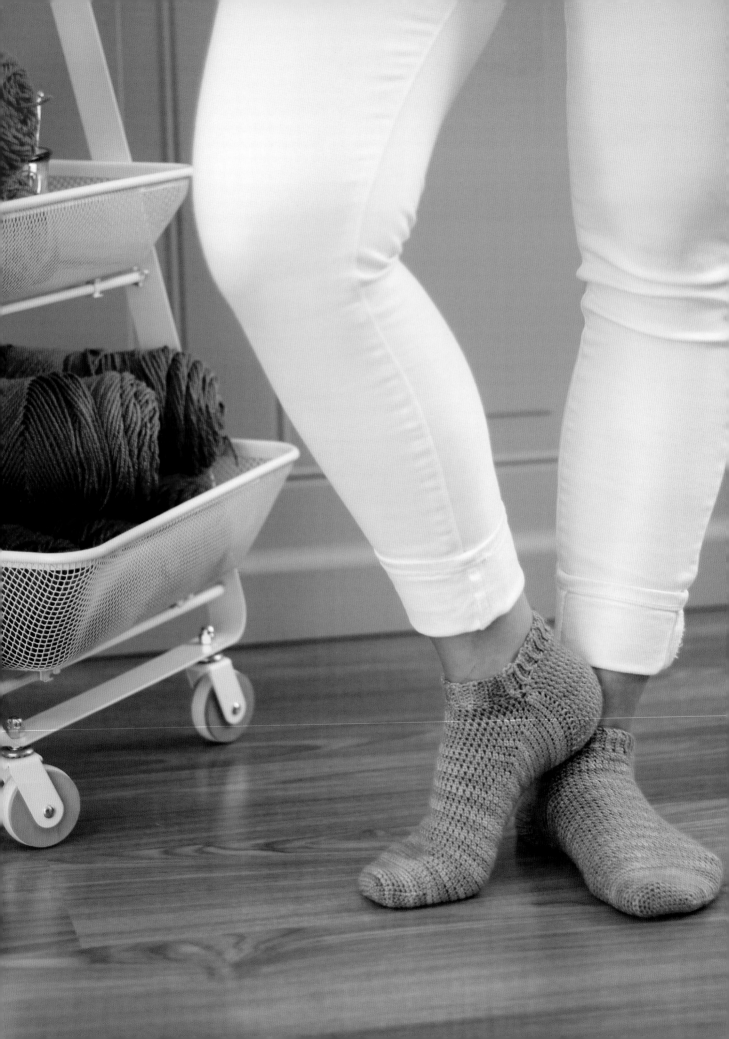

GORMAN STREET TOE-UP SOCKS

These toe-up socks are almost an exact replica of the Gorman Street Cuff-Down Socks, except for the length of the leg.

These toe-up socks are worked with a standard wedge toe, basic heel flap, and single crochet in the back loop (sc in blo) rib.

FINISHED SIZE
Foot length: 7½" (8½", 9½") (19 [21.5, 24] cm).

Foot circumference: 6½" (7", 8") (16.5 [18, 20.5] cm).
Leg length: 7" (18 cm).

Sock shown measures 8½" (21.5 cm) long in the foot and 7" (18 cm) in circumference.

YARN
Sock weight (#1 Super Fine).
Shown here: SweetGeorgia Yarns Tough Love Sock (80% superwash merino wool/20% nylon; 425 yd [389 m]/100 g): Hush, 1 skein.

HOOK
Size U.S. C (2.75 mm).
Adjust hook if necessary to obtain gauge.

NOTIONS
Split-ring stitch markers (sm), tapestry needle.

GAUGE
28 sts and 24 rows = 4" (10 cm) in extended single crochet (exsc) worked in rnds, blocked.

SINGLE CROCHET IN THE BACK LOOP (SC IN BLO)
Working in only the back loop, pull up a loop in the next stitch, yarn over (yo), pull through 2 loops on hook.

TOE

Chain (ch) 9.

Rnd 1: Single crochet (sc) in second ch from hook and in each ch across, working in opposite side of beg ch, sc in each ch across, join with slip (sl) st to first st, being careful not to twist, ch 1—16 sts.

Inc rnd: *Sc in first st, 2 sc in next st, sc in each of next 5 sts, 2 sc in next st; rep from * once more, join with sl st to first st, ch 1—4 sts inc'd (20 sts).

Inc rnd: *Sc in first st, 2 sc in next st, sc in each of next 7 sts, 2 sc in next st; rep from * once more, join with sl st to first st, ch 1—4 sts inc'd (24 sts).

Next rnd: Sc around, join with a sl st to first st, ch 1.

Inc rnd: *Sc in first st, 2 sc in next st, sc in each of next 9 sts, 2 sc in next st; rep from * once more, ch 1—4 sts inc'd (28 sts).

Next rnd: Sc around, join with sl st to first st, ch 1.

Inc rnd: *Sc in first st, 2 sc in next st, sc in each of next 11 sts, 2 sc in next st; rep from * once more, ch 1—4 sts inc'd (32 sts).

Next rnd: Sc around, join with a sl st to first st, ch 1.

Cont as est, inc'ing 4 sts on every odd rnd until there are 44 (48, 52) sts.

FOOT

Rnd 1: Ch 1, extended single crochet (exsc, see Techniques) in each st around, join with sl st to first st, ch 1.

Rep rnd until foot measures 4" (5", 6") (10 [12.5, 15] cm) long or 3½" (9 cm) less than desired foot length.

GUSSET

Inc rnd: Exsc in each of first 22 (24, 26) sts, 2 exsc in next exsc, exsc in each st around to last st, 2 exsc in last st, ch 1—2 sts inc'd (46 [50, 54] sts).

Rep last rnd until 62 (66, 72) sts have been worked.

HEEL TURN

Now work in rows.

Note: The center heel stitches are worked back and forth in short-rows while stitches along the gussets on either side of the center heel stitches are worked.

Beg with RS facing, cont as est across 22 (24, 26) sts of instep, sc in each of the next 13 (14, 15) sts, sc2tog, sc in each of the next 12 (12, 14) sts, ch 1, turn, leaving rem sts unworked.

Next row: (WS) Sc2tog, sc across, ch 1, turn, leaving rem sts unworked.

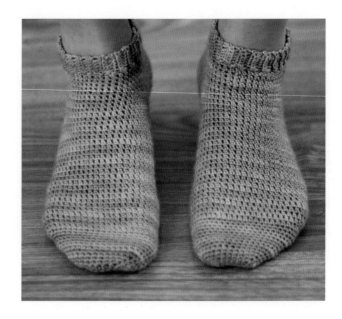

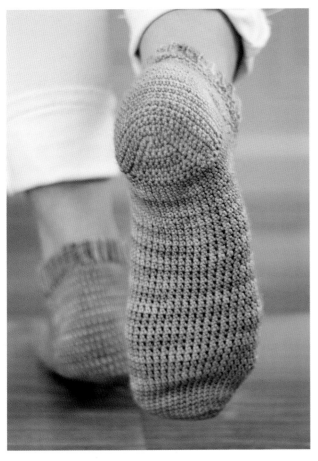

Work the last row until 4 sts rem, ending with a WS row.

HEEL FLAP

Note: This heel is particularly long to make up for the lack of stretch. If a shorter heel is desired, simply join every other row of the heel flap with the next 2 stitches as opposed to just 1 stitch.

Beg with RS facing, sc in each of the rem 4 sts, sc 10 (10, 12) sts along one side of the heel turn, ch 1, turn.

Sc across all sts to second side of the heel turn, sc 10 (10, 12) sts along one side of the heel flap—24 (24, 28) sts.

Next row: (RS) Sc in each st across heel flap to last st, sc last st with next st to the left on instep, ch 1, turn.

Next row: (WS) Sc in each st across heel flap to last st, sc last st with next st to the left on instep, ch 1, turn.

Rep the last 2 rows until all instep sts have been worked—44 (48, 52) sts.

LEG (OPTIONAL)

If desired, join to work in the rnd using either continuous rounds or joined rounds and work the optional leg in exsc to desired length, then move onto cuff directions.

CUFF

Row 1: Ch 7, sc in second ch from hook and each ch across to last st, join last st of optional leg and next 2 sts of optional leg with sc2tog, ch 1, turn—6 sts.

Row 2: Single crochet in back loop (sc in blo, see Stitch Guide) in each st across, ch 1, turn.

Row 3: Sc in blo in each st across to last st, join last st of cuff and next 1 st of leg with sc2tog, ch 1, turn.

Rep Rows 2 and 3 until all sts have been worked on the optional leg. Seam cuff using mattress stitch (see Techniques).

Weave in all ends. Wash and lay flat to block.

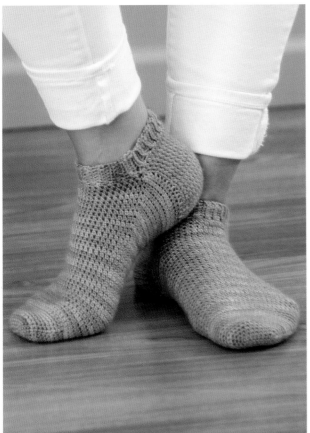

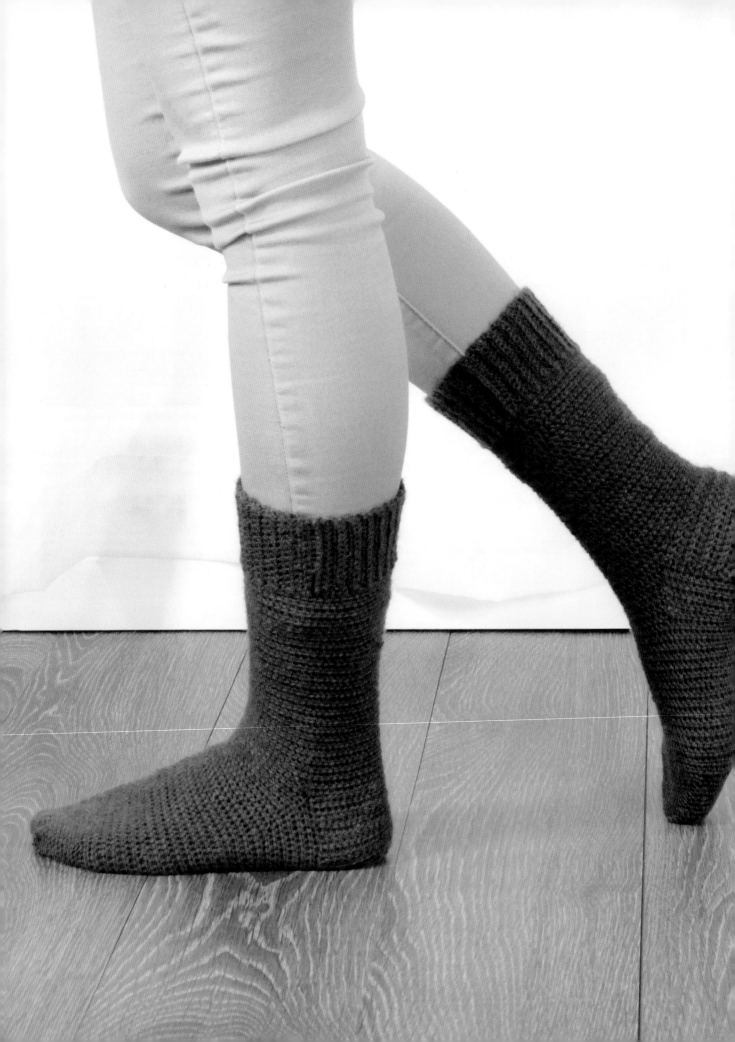

BELTLINE CUFF-DOWN SOCKS

Linked half double crochet (lhdc) is amazing. It makes a perfect sock even better. This simple sock features a great rib stitch and a basic gusset decrease section. The best part about these socks? It will fit a wide variety of sizes, is interesting to crochet, and your friends will love you forever if you make these for them.

These cuff-down socks are worked with a standard wedge toe, basic heel flap, and single crochet through the back loop (sc in blo) rib.

FINISHED SIZE
Foot length: 7½" (8½", 9½") (19 [21.5, 24] cm).
Foot circumference: 7" (7½", 8½") (18 [19, 21.5] cm).
Leg length: 7" (18 cm).

Sock shown measures 8½" (21.5 cm) long in the foot and 7½" (19 cm) in circumference.

YARN
Sock weight (#1 Super Fine).
Shown here: Regia 4-ply (75% virgin wool/25% polyamide; 230 yd [210.m]/50 g): #02205 Plum, 2 (3, 3) skeins.

HOOK
Size U.S. C (2.75 mm).
Adjust hook if necessary to obtain gauge.

NOTIONS
Split-ring stitch markers (sm), tapestry needle.

GAUGE
28 sts and 24 rows = 4" (10 cm) in linked half double crochet (lhdc), blocked.

SINGLE CROCHET IN THE BACK LOOP (SC IN BLO)
Working in only the back loop, pull up a loop in the next stitch, yarn over (yo), pull through 2 loops on hook.

CUFF

Row 1: (RS) Chain (ch) 19, single crochet (sc) in second ch from hook and each ch across to last st, ch 1, turn—18 sts.

Row 2: (WS) Single crochet in back loop (sc in blo, see Stitch Guide) in each st across, ch 1, turn.

Row 3: (RS) Sc in blo in each st across to last st, ch 1, turn.

Rep Rows 2 and 3 until 48 (52, 60) rows have been worked, join cuff to work in rnds (see Techniques).

Rnd 1: Sc 48 (52, 60) sts around one edge of cuff, join with slip (sl) st to first st, ch 2.

LEG

Next rnd: Linked half double crochet (lhdc, see Techniques) in each st around, join with a sl st to first st, ch 2—48 (52, 60) sts.

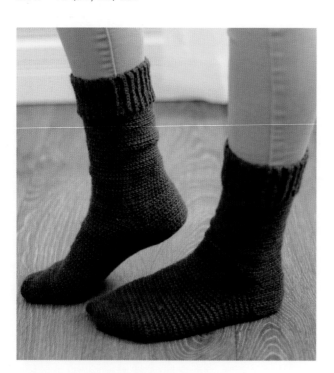

Rep the last rnd as est until leg is 7" (18 cm) or desired length from top of cuff.

HEEL FLAP

Note: The heel flap is worked in rows, joining the heel flap to the shaped instep stitches on either side of the heel.

Row 1: (RS) Lhdc in each of first 24 (26, 30) sts, ch 2, turn.

Row 2: (WS) Lhdc in each st across, ch 2, turn.

Rep the last row 8 (10, 12) more times, replacing ch 2 with ch 1 at end of last row.

HEEL TURN

Row 1: (RS) Sc in each of first 13 (14, 16) sts, sc2tog, sc in next st, ch 1, turn.

Row 2: (WS) Sc in each of first 4 sts, sc2tog, sc in next st, ch 1, turn.

Note: There will be a small gap between the working sts for the heel turn and the unworked heel stitches.

Row 3: (RS) Sc to within 1 st of gap, sc2tog, sc in next st, ch 1, turn.

Rep Row 3, working 1 additional st on each row until all side sts are worked—16 (16, 18) sts.

GUSSET

Now work in rnds.

Next rnd: Sc in each sc across bottom of heel turn, sc 12 (13, 14) sts along the side of heel flap, lhdc across instep, sc 12 (13, 14) sts along other side of heel flap, join with sl st to first st, ch 1—62 (66, 72) sts.

Dec rnd: Extended single crochet (exsc, see Techniques) in each st to 2 sts before instep, sc2tog, cont in patt across instep as est, sc2tog, exsc in each st around, join with sl st to first st, ch 1—2 sts dec'd.

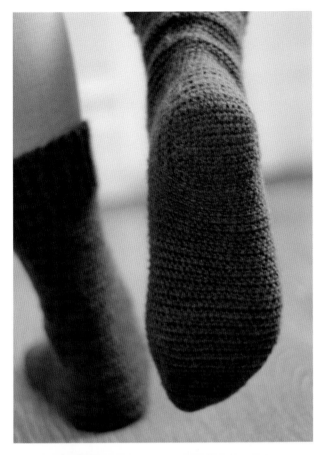

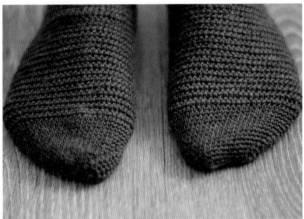

Dec rnd: Exsc cont in each st to 1 st before previous dec, sc2tog, patt across instep, sc2tog, exsc in each st around, join with sl st to first st, ch 1—2 sts dec'd.

Rep the last rnd until 48 (52, 56) sts rem.

FOOT

Rnd 1: Exsc in each st around, join with sl st to first st, ch 1.

Rep the last rnd until foot is 2" (5 cm) less than desired length from back of heel.

TOE

Dec rnd: [Sc in first st, sc2tog, sc in each of next 19 (21, 23) sts, sc2tog] twice, join with sl st to first st, ch 1—4 sts dec'd (44 [48, 52] sts).

Next rnd: Sc in each st around, join with sl st to first st, ch 1.

Dec rnd: [Sc in first st, sc2tog, sc in each of next 17 (19, 21) sts, sc2tog] twice, join with sl st to first st, ch 1—4 sts dec'd (40 [44, 48] sts).

Next rnd: Sc in each st around, join with sl st to first st, ch 1.

Dec rnd: [Sc in first st, sc2tog, sc in each of next 15 (17, 19) sts, sc2tog] twice, join with sl st to first st, ch 1—4 sts dec'd (36 [40, 44] sts).

Next rnd: Sc in each st around, join with sl st to first st, ch 1.

Dec rnd: [Sc in first st, sc2tog, sc in each of next 13 (15, 17) sts, sc2tog] twice, join with sl st to first st, ch 1—4 sts dec'd (32 [36, 40] sts).

Cont as est, dec'ing 4 sts every odd rnd until 24 sts rem. Then dec as est every rnd until 16 sts rem.

Fasten off. Seam toe (see Techniques).

Weave in all ends. Wash and lay flat to block.

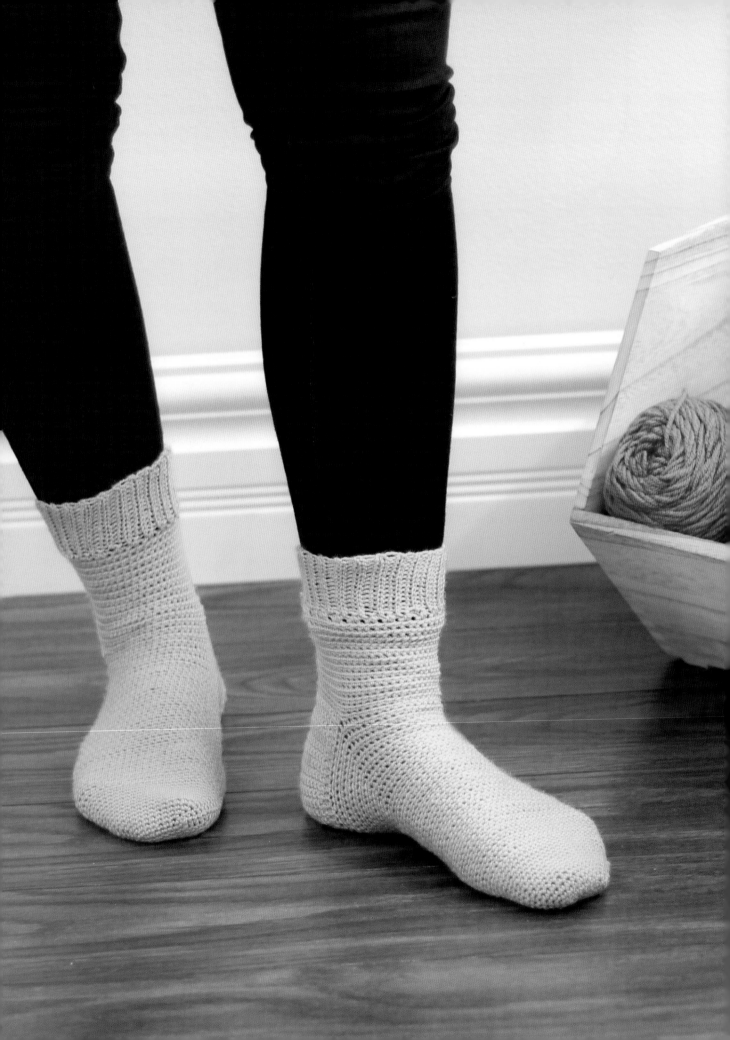

BELTLINE TOE-UP SOCKS

These socks, much like their cuff-down counterparts, are plain enough for everyone to enjoy but have a bit of extra spice. The allover linked half double crochet (lhdc) stitch gives the socks a smooth look and feel, while providing a large amount of stretch.

These toe-up socks are worked with a standard wedge toe, basic heel flap, and single crochet in the back loop (sc in blo) rib.

FINISHED SIZE
Foot length: 7½" (8½", 9½") (19 [21.5, 24] cm).
Foot circumference: 6½" (7", 8") (16.5 [18, 20.5] cm).
Leg length: 7" (18 cm).

Sock shown measures 8½" (21.5 cm) long in the foot and 7" (18 cm) in circumference.

YARN
Sock weight (#1 Super Fine).
Shown here: Louet Yarns Gems (100% merino wool; 425 yd [389 m]/100 g): Buttercup, 3 (3, 4) skeins.

HOOK
Size U.S. C (2.75 mm).
Adjust hook if size necessary to obtain gauge.

NOTIONS
Split-ring stitch markers (sm), tapestry needle.

GAUGE
28 sts and 24 rows = 4" (10 cm) in linked half double crochet (lhdc) worked in rnds, blocked.

SINGLE CROCHET IN THE BACK LOOP (SC IN BLO)
Working in only the back loop, pull up a loop in the next stitch, yarn over (yo), pull through 2 loops on hook.

TOE

Chain (ch) 9.

Rnd 1: Single crochet (sc) in second ch from hook and in each ch across, working in opposite side of beg ch, sc in each ch across, join with slip (sl) st to first st, being careful not to twist, ch 1—16 sts.

Rnd 2: *Sc in first st, 2 sc in next st, sc in each of next 5 sts, 2 sc in next st; rep from * once more, join with sl st to first st, ch 1—4 sts inc'd (20 sts).

Rnd 3: *Sc in first st, 2 sc in next st, sc in each of next 7 sts, 2 sc in next st; rep from * once more, join with sl st to first st, ch 1—4 sts inc'd (24 sts).

Rnd 4 and all following even rnds: Sc around, join with sl st to first st, ch 1.

Rnd 5: *Sc in first st, 2 sc in next st, sc in each of next 9 sts, 2 sc in next st; rep from * once more, ch 1—4 sts inc'd (28 sts).

Rnd 7: *Sc in first st, 2 sc in next st, sc in each of next 11 sts, 2 sc in next st; rep from * once more, ch 1—4 sts inc'd (32 sts).

Cont in patt as est, inc'ing 4 sts every odd rnd, until there are 44 (48, 52) sts. Do not ch 1 at end of last rnd.

FOOT

Rnd 1: Ch 2, linked half double crochet (lhdc, see Techniques) in each st around, join with sl st to first st, ch 2.

Rnd 2: Lhdc in each st around, join with sl st to first st, ch 2.

Rep Rnd 2 until foot measures 4" (5", 6") (10 [12.5, 15] cm) or 3½" (9 cm) less than desired length.

GUSSET

Inc rnd: Lhdc in each of first 22 (24, 26) sts, 2 lhdc in next lhdc, lhdc in each st around to last st, 2 lhdc in last st, ch 2—2 sts inc'd (46 [50, 54] sts).

Rep the last rnd until there are 62 (66, 72) sts.

HEEL TURN

Note: The center heel stitches are worked in short-rows while the stitches along the gussets on either side of the center heel stitches are worked.

Beg with RS facing, cont as est across instep, sc in each of next 13 (14, 15) sts, sc2tog, sc in each of next 12 (12, 14) sts, ch 1, turn, leaving rem sts unworked.

Next row: (WS) Sc2tog, sc across, ch 1, turn, leaving rem sts unworked.

Rep the last row until 4 sts rem, ending with a WS row.

HEEL FLAP

Beg with RS facing, sc in each of first 4 sts, sc 10 (10, 12) sts along one side of heel turn, ch 1, turn. Sc across all sts to second side of heel turn, sc 10 (10, 12) sts along side of heel flap, ch 1—24 (24, 28) sts.

Row 1: (RS) Sc in each st across heel flap to last st, sc2tog last st with next st to the left on instep, ch 1.

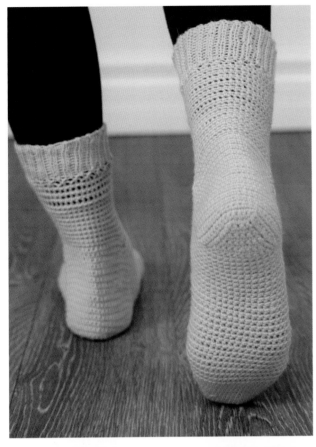

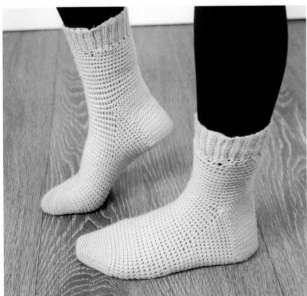

Row 2: (WS) Sc in each st across heel flap to last st, sc2tog last st with next st to left on instep.

Note: This heel is particularly long to make up for the lack of stretch. If a shorter heel is desired, simply join every other row of the heel flap with the next 2 stitches as opposed to just 1 stitch.

Rep Rows 1 and 2 until all instep sts have been worked.

LEG

Cont in rnds as est until leg is desired length. Do not ch 1 at end of last row.

CUFF

Row 1: Ch 17, sc in second ch from hook and each ch across to last st, join last st of cuff and next 2 sts of leg with sc2tog, ch 1, turn—16 sts.

Row 2: Sl st in back loop of each st across, ch 1, turn.

Row 3: Single crochet in back loop (sc in blo, see Stitch Guide) in each st across to last st, join last st of cuff and next st of leg with sc2tog, ch 1, turn.

Rep Rows 2 and 3 until all leg sts have been worked.

Fasten off. Seam cuff using mattress stitch (see Techniques).

Weave in all ends. Wash and lay flat to block.

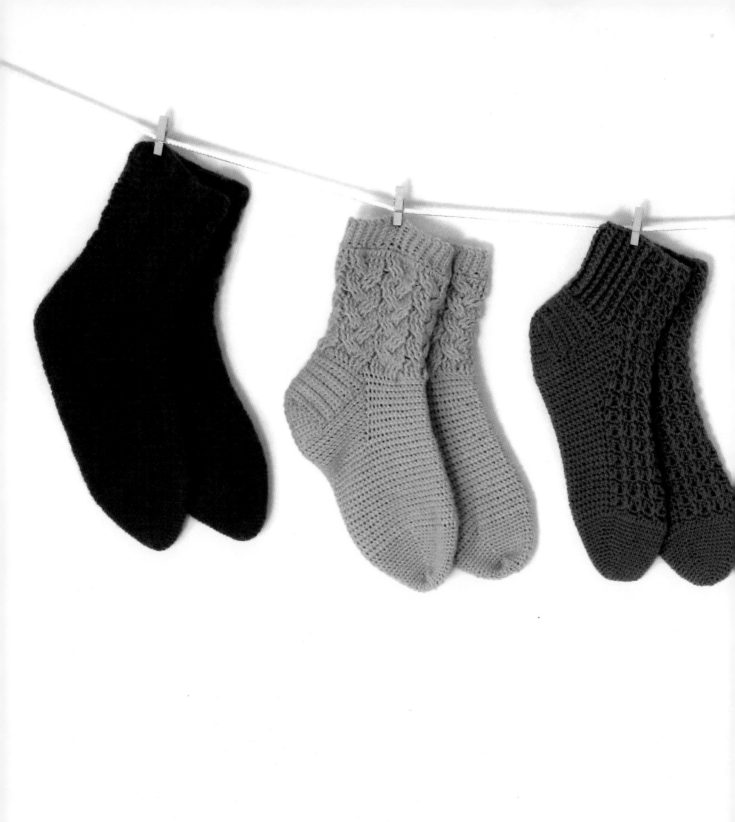

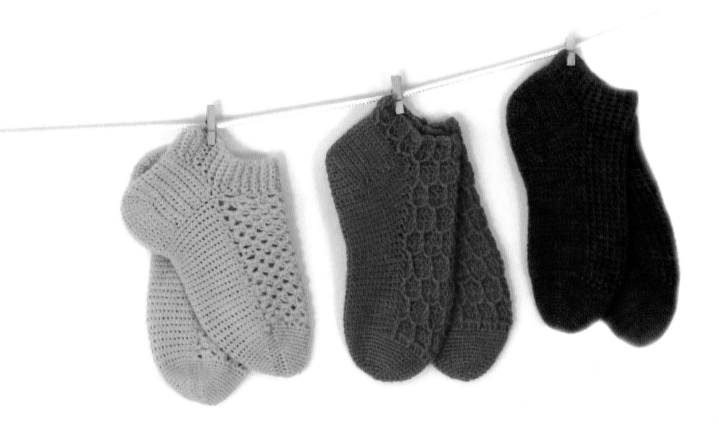

CHAPTER 6

TEXTURED AND CABLED SOCKS

Adding texture or cables to socks is a great way to break up the monotony of working rounds and rounds of plain stitches. The following socks feature texture stitches that are fun and fast to complete, while still being stretchy enough to work for socks of all shapes and sizes. I also love a good cable, especially on a pair of socks. These designs feature both faux and real crochet cables. From honeycomb allover cables to classic antler cables, these socks are made for walking in style!

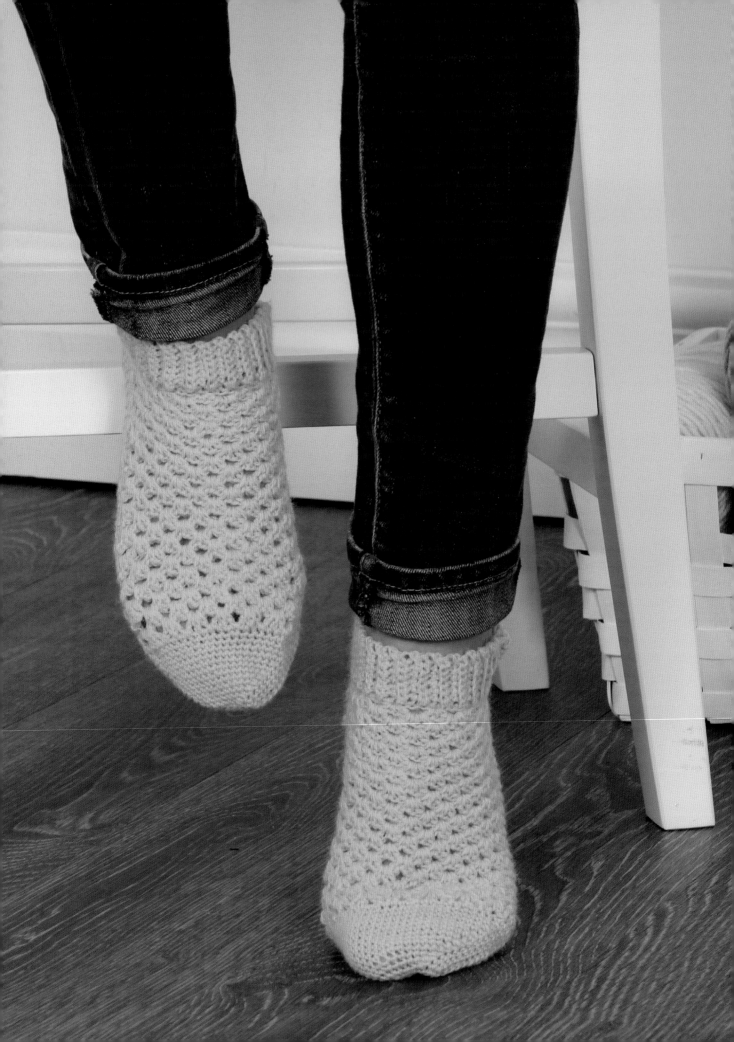

NORTH HILLS SOCKS

I just love a sweet pair of yellow socks. Call me crazy, but they remind me of walks through the French countryside on a warm summer day, eating an ice cream cone. I say this as a lactose-intolerant man who doesn't wear lace socks and has never been to France. These socks are constructed using one of my favorite heels, which provides a great fit and simple gusset construction. They work up in a flash and can be customized to fit a wide array of sizes, thanks to the super-stretchy and supportive linked half double crochet (lhdc) sole.

These cuff-down socks are worked with a standard wedge toe, basic heel flap, and single crochet in the back loop (sc in blo) rib".

FINISHED SIZE
Foot length: 7½" (8½", 9½") (19 [21.5, 24] cm).
Foot circumference: 7" (7½", 8½") (18 [19, 21.5] cm).
Leg length: 1" (2.5 cm).

Sock shown measures 8½" (21.5 cm) long in the foot and 7½" (19 cm) in circumference.

YARN
Sock weight (#1 Super Fine).
Shown here: Cascade Yarns 220 Fingering
(100% Peruvian Highland wool; 273 yd [217 m]/50 g):
#4147 Lemon Yellow, 2 (2, 2) skeins.

HOOK
Size U.S. C (2.75 mm).
Adjust hook if necessary to obtain gauge.

NOTIONS
Split-ring stitch markers (sm), tapestry needle.

GAUGE
28 sts and 24 rows = 4" (10 cm) in linked half double crochet (lhdc) worked in rnds, blocked.

STITCH GUIDE

SINGLE CROCHET IN THE BACK LOOP (SC IN BLO)
Working in only the back loop, pull up a loop in the next stitch, yarn over, pull through 2 loops on hook.

CUFF

Row 1: (RS) Chain (ch) 9, single crochet (sc) in second ch from hook and each ch across to last st, ch 1, turn—8 sts.

Row 2: (WS) Slip (sl) st through the back loop in each st across, ch 1, turn.

Row 3: (RS) Single crochet in back loop only (sc in blo, see Stitch Guide) in each st across to last st, ch 1, turn.

Rep Rows 2 and 3 for a total of 48 (52, 60) rows. Join cuff and begin working in rnds.

Rnd 1: Sc 48 (52, 60) sts along one edge of cuff. Join with sl st to first st, ch 2.

HEEL FLAP

Now work in rows.

Row 1: (RS) Linked half double crochet (lhdc, see Techniques) in each of first 24 (26, 30) sts, ch 2, turn.

Row 2: (WS) Lhdc in each st across, ch 2, turn.

Rep Row 2 eight more times, replacing last ch 2 with ch 1.

HEEL TURN

Note: Work the heel band on 8 (10, 10) sts.

Dec row: (RS) Sc in each of first 15 (17, 18) sts, sc2tog, ch 1, turn.

Dec row: (WS) Sc in each of first 7 (9, 9) sts, sc2tog, ch 1, turn.

Rep the previous row until all sts have been worked—8 (10, 10) sts rem at end of heel turn.

GUSSET

Now work in rnds.

Rnd 1: Sc across heel turn, sc 12 (13, 14) sts along one side of heel flap, sc across instep, sc 12 (13, 14) sts along other side of heel flap, join with sl st to first st, ch 2.

Dec rnd: Lhdc in each st across to 2 sts before instep, sc2tog, *half double crochet (hdc, see Techniques) in first st of instep, ch 1, skip (sk) next 3 sts, 2 hdc in next st; rep from * across instep to last

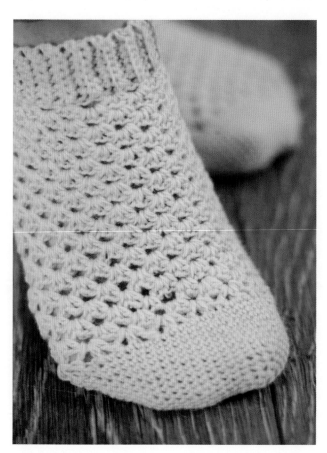

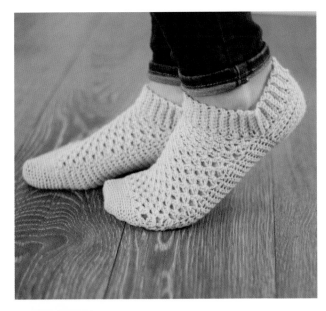

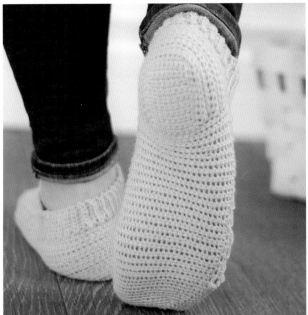

* across instep to last instep st, hdc in last st, lhdc in each rem st around, join with sl st to first st, ch 2.

Rnd 2: Lhdc in each st across to instep, *hdc in first st of instep, ch 1, sk next 3 sts, 2 hdc in next st; rep from * across instep to last instep st, hdc in last st, lhdc in each rem st around, join with sl st to first st, ch 2.

Rep Rnds 1 and 2 until foot measures 2" (5 cm) less than desired length from back of heel.

TOE

Dec rnd: [Sc in first st, sc2tog, sc in each of next 19 sts, sc2tog] twice, join with sl st to first st, ch 1—4 sts dec'd (44 [48, 56] sts).

Next rnd: Sc in each st around, join with sl st to first st, ch 1.

Dec rnd: [Sc in first st, sc2tog, sc in each of next 17 sts, sc2tog] twice, join with sl st to first st, ch 1—4 sts dec'd (40 [44, 52] sts).

Next rnd: Sc in each st around, join with sl st to first st, ch 1.

Dec rnd: [Sc in first st, sc2tog, sc in each of next 15 sts, sc2tog] twice, join with sl st to first st, ch 1—4 sts dec'd (36 [40, 48] sts).

Next rnd: Sc in each st around, join with sl st to first st, ch 1.

Dec rnd: [Sc in first st, sc2tog, sc in each of the next 13 sts, sc2tog] twice, join with sl st to first st, ch 1—4 st dec'd (32 [36, 44] sts).

Next rnd: Sc in each st around, join with sl st to first st, ch 1.

Continue in patt as est, dec'ing 4 sts every other rnd until 24 sts rem. Then dec in the same manner every rnd until 16 sts rem.

Fasten off. Seam toe, then join cuff with mattress stitch (see Techniques).

Weave in ends. Wash and lay flat to block.

instep st, hdc in last st, sc2tog, lhdc in each rem st around, join with a sl st to first st, ch 2.

Dec rnd: Lhdc in each st across to 1 st before dec on previous row, sc2tog, hdc in first st, *ch 1, 2 hdc in next chain-1 space (ch-1 sp); rep from * across instep to last instep st, ch 1, hdc in last st, sc2tog, lhdc in each rem st around, join with a sl st to first st, ch 2.

Rep both dec rnds until 48 (52, 60) sts rem.

FOOT

Rnd 1: Lhdc in each st across to instep, *hdc in first st of instep, ch 1, sk next 3 sts, 2 hdc in next st; rep from

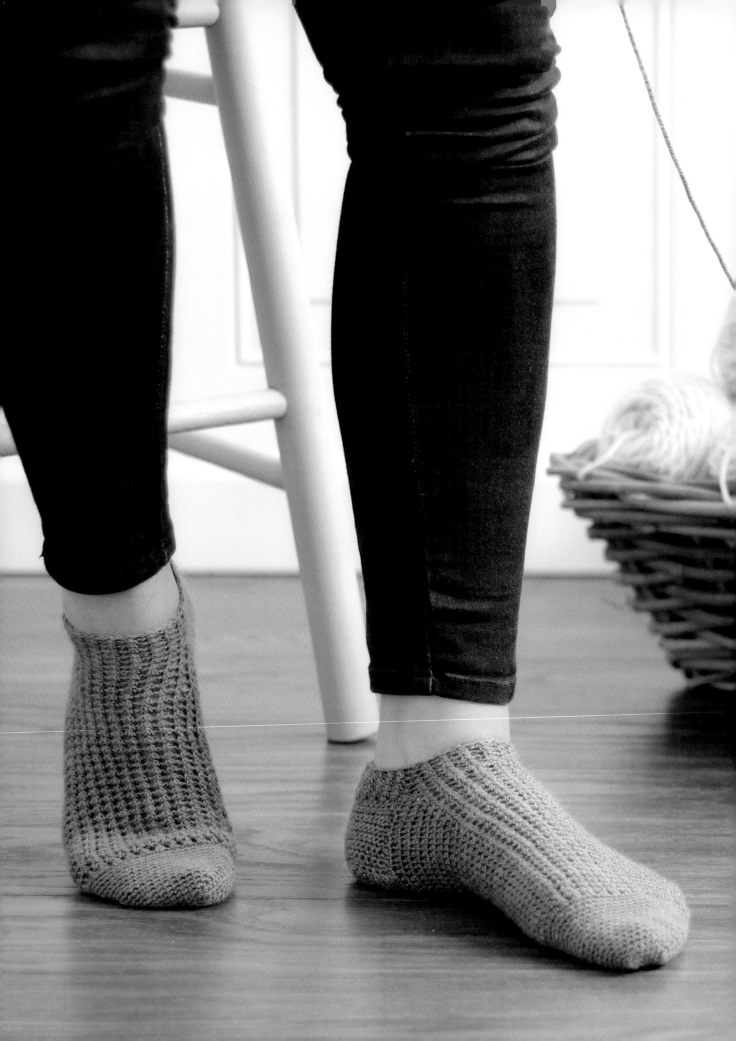

OAKWOOD SOCKS

Using basic texture is one of my favorite methods of mixing up simple crochet socks a bit. The real star is the fun and surprisingly simple textural stitch that adds a lot of stretch. Try it out with a variegated yarn! Choose a sock size about ½" (1.3 cm) smaller than what you'd usually crochet to account for the extra stretch in this stitch.

These toe-up socks are worked with a standard wedge toe and modified heel flap.

FINISHED SIZE
Foot length: 7½" (8½", 9½") (19 [21.5, 24] cm).
Foot circumference: 6½" (7", 8") (16.5 [18, 20.5] cm).
Leg length: 1" (2.5 cm)

Sock shown measures 8½" (21.5 cm) long in the foot and 7" (18 cm) in circumference.

YARN
Sock weight (#1 Super Fine).
Shown here: Rowan Yarns Fine Art Yarn (45% wool/20% mohair/10% silk/25% polyamide; 437 yd [400 m]/100 g): #006 Boar, 1 skein.

HOOK
Size U.S. C (2.75 mm).
Adjust hook size if necessary to obtain gauge.

NOTIONS
Split-ring stitch markers (sm), tapestry needle.

GAUGE
28 sts and 24 rows = 4" (10 cm) in extended single crochet (exsc) worked in rnds, blocked.

HALF DOUBLE CROCHET 2 STS TOG (HDC2TOG)
Yarn over (yo), pull up a loop in each of the next 2 stitches, yo, pull through all 4 loops on hook, chain 1.

TOE

Chain (ch) 9.

Inc rnd: Single crochet (sc) in second ch from hook and in each ch across, working in opposite side of beg ch, sc in each ch across, join with a slip (sl) st to first st, being careful not to twist, ch 1—4 sts inc'd (16 sts).

Inc rnd: *Sc in first st, 2 sc in next st, sc in each of next 5 sts, 2 sc in next st; rep from * once more, join with sl st to first st, ch 1—4 sts inc'd (20 sts).

Inc rnd: *Sc in first st, 2 sc in next st, sc in each of next 7 sts, 2 sc in next st; rep from * once more, join with sl st to first st, ch 1—4 sts inc'd (24 sts).

Next rnd: Sc around, join with sl st to first st, ch 1.

Inc rnd: *Sc in first st, 2 sc in next st, sc in each of next 9 sts, 2 sc in next st; rep from * once more, ch 1—4 sts inc'd (28 sts).

Next rnd: Sc around, join with sl st to first st, ch 1.

Inc rnd: *Sc in first st, 2 sc in next st, sc in each of the next 11 sts, 2 sc in next st; rep from * once more, ch 1—4 sts inc'd (32 sts).

Next rnd: Sc around, join with sl st to first st, ch 1.

Cont as est, inc'ing 4 sts every other rnd, until there are 44 (48, 52) sts. Do not ch 1 at end of last rnd.

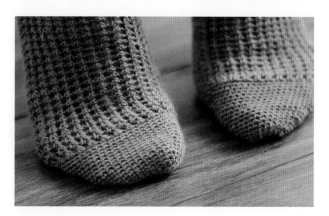

FOOT

Next rnd: Ch 2, [half double crochet 2 sts together (hdc2tog; see Stitch Guide), ch 1] 11 (12, 13) times, extended single crochet (exsc, see Techniques) in each rem st, join with sl st to first st, ch 2 (counts as first hdc of next rnd here and throughout).

Next rnd: [Hdc2tog, ch 1] 11 (12, 13) times, exsc in each rem st, join with sl st to first st, ch 2.

Rep the last rnd until foot measures 4" (5", 6") (10 [12.5, 15] cm) or 3½" (9 cm) less than desired length.

GUSSET

Inc rnd: Work in patt as est across instep, 2 exsc in first exsc, exsc in each st around to last st, 2 exsc in last st—2 sts inc'd (46 [50, 54] sts).

Rep inc rnd until there are 62 (66, 72) sts.

HEEL TURN

Note: The center heel stitches are worked in short-rows while the stitches along the gussets on either side of the center heel stitches are worked.

Beg with RS facing, cont as est across 22 (24, 26) sts of instep, sc in each of next 13 (14, 15) sts, sc2tog, sc in each of next 12 (12, 14) sts, ch 1, turn, leaving rem sts unworked.

Next row: (WS) Sc2tog, sc across, ch 1, turn, leaving rem sts unworked.

Work the last row until 4 sts rem, ending with WS row.

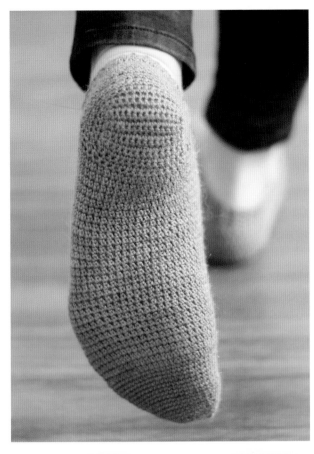

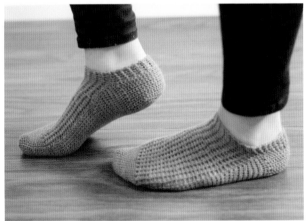

HEEL FLAP

Note: This heel is particularly long to make up for the lack of stretch. If a shorter heel is desired, simply join every other row of the heel flap with the next 2 stitches as opposed to just 1 stitch.

Beg with RS facing, sc in each of rem 4 sts, sc 10 (10, 12) sts along one side of heel turn, ch 1, turn.

Sc across all sts to second side of heel turn, sc 10 (10, 12) sts along one side of heel flap—24 (24, 28) sts.

Next row: (RS) Sc in each st across heel flap to last st, sc last st with next st to the left on instep, ch 1, turn.

Next row: (WS) Sc in each st across heel flap to last st, sc last st with next st to the left on instep, ch 1, turn.

Rep last 2 rows until all instep sts have been worked—44 (48, 52) sts.

LEG (OPTIONAL)

If desired, join to work in the rnd using either continuous rnds or joined rnds, and work optional leg in exsc to desired length, then move onto the cuff directions. If you're crocheting an ankle sock, as pictured, continue to cuff directions.

CUFF

Working across instep stitches, work [hdc2tog, ch 1] across as est, then cont with [hdc2tog, ch 1] across heel flap sts. Work in rnds of [hdc2tog, ch 1] until cuff is 1" (2.5 cm) or desired length.

Fasten off. Weave in ends.

Wash and lay flat to block.

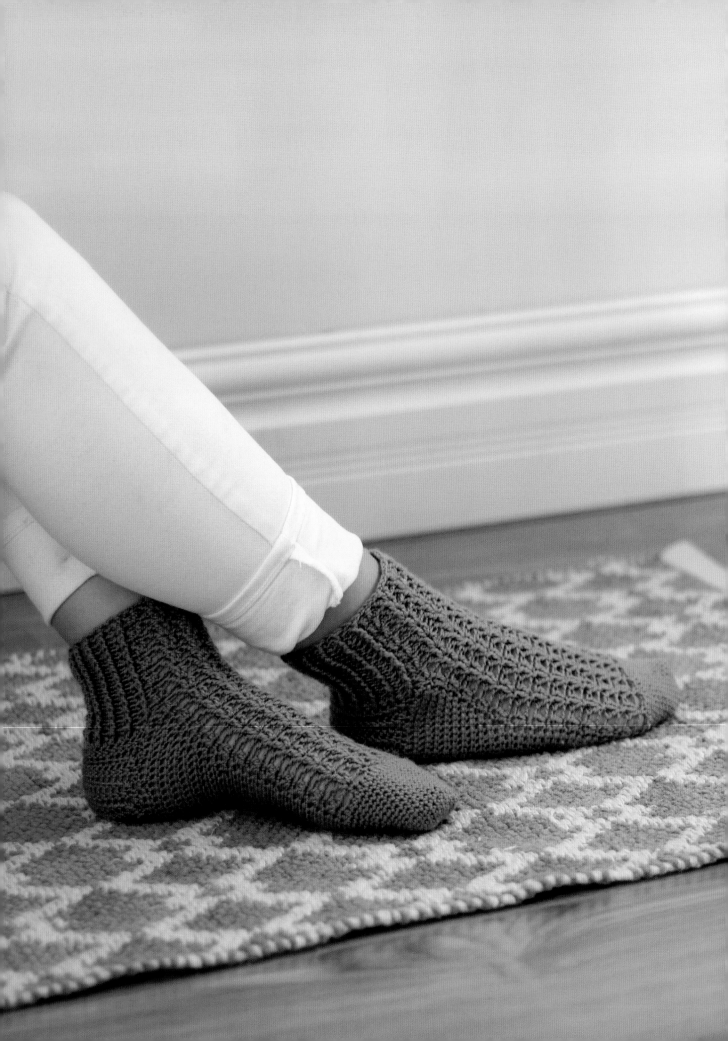

RAULSTON SOCKS

These faux-cable socks are quite reminiscent of knitted cables and make this pair an interesting and fun project. The shell cables also fit like a dream, and the cuff is built right into the leg, thanks to the super-stretchy stitch pattern! If a cuff is desired, work a side-to-side cuff, joined as you go, as in other toe-up patterns in this book. Make sure to watch your gauge on this sock; it can run bulky if you are not careful.

These toe-up socks are worked with a four-point toe, strong heel, and cuff that is part of the stitch pattern, although an additional cuff can be attached.

FINISHED SIZE
Foot length: 8½" (9½", 10½") (21.5 [24, 26.5] cm).
Foot circumference: 7" (7½", 8") (18 [19, 20.5] cm).
Leg length: 3" (7.5 cm).

Sock shown measures 9½" (24 cm) long in the foot and 7½" (19 cm) in circumference.

YARN
Sock weight (#1 Super Fine).
Shown here: Plymouth Yarn Happy Feet (90% superwash merino wool/10% nylon; 192 yd [176 m]/50 g): #13, 2 skeins.

HOOK
Size U.S. D (3.25 mm).
Adjust hook size if necessary to obtain gauge.

NOTIONS
Tapestry needle.

GAUGE
24 sts and 24 rows = 4" (10 cm) in linked half double crochet (lhdc) worked in rnds, blocked.

FRONT POST SINGLE CROCHET (FPSC)
Insert hook from back to front around the post of the next stitch to the right, yarn over (yo) and pull up a loop, yo and pull through both loops on hook.

TOE

Chain (ch) 2.

Rnd 1: 4 single crochet (sc) in second ch from hook, join with a slip (sl) st to first st, being careful not to twist, ch 1.

Do not turn.

Inc rnd: 2 sc in each sc around, join with sl st to first st, ch 1—4 sts inc'd (8 sts).

Inc rnd: 2 sc in each sc around, join with sl st to first st, ch 1—8 sts inc'd (16 sts).

Inc rnd: *2 sc in first st, sc in next st; rep from * around, join with sl st to first st, ch 1—8 sts inc'd (24 sts).

Next rnd: Sc around, join with sl st to first st, ch 1.

Inc rnd: *2 sc in first st, sc in each of next 5 sts; rep from * around, join with sl st to first st, ch 1—4 sts inc'd (28 sts).

Next rnd: Sc around, join with sl st to first st, ch 1.

Inc rnd: *2 sc in first st, sc in each of next 6 sts; rep from * around, join with sl st to first st, ch 1—4 sts inc'd (32 sts).

Next rnd: Sc around, join with sl st to first st, ch 1.

Inc rnd: *2 sc in first st, sc in each of next 7 sts; rep from * around, join with sl st to first st, ch 1—4 sts inc'd (36 sts).

Next rnd: Sc around, join with sl st to first st, ch 1.

Inc rnd: *2 sc in first st, sc in each of next 8 sts; rep from * around, join with sl st to first st, ch 1—4 sts inc'd (40 sts).

Next rnd: Sc around, join with sl st to first st, ch 1.

Cont as est, working 1 extra sc between each inc, until there are 44 (48, 54) sts.

Work even until toe measures 2" (5 cm).

FOOT

Place marker (pm) in the 21st (25th, 25th) st. Begin working the Shell Cable chart.

Rnd 1: Ch 1, sc in first st, *ch 3, skip (sk) next 3 sts, sc in next st; rep from * across to m, linked half double crochet (lhdc, see Techniques) in each st around, join with sl st to first st, ch 3—6 (7, 7) sc; 5 (6, 6) ch-sps; 23 (23, 29) lhdc.

Rnd 2: Double crochet (dc, see Techniques) in first sc, sk next ch-3 sp, *3 dc in next sc, sk next ch-3 sp; rep from * across to m, 2 dc in marked sc, lhdc in each st around, join with sl st to first st, ch 1.

Rnd 3: Sc in top of turning chain (tch), *ch 3, front post single crochet (fpsc, see Stitch Guide) around center post of next 3-dc group; rep from * across to m, sc in last dc, lhdc in each st around, join with sl st to first st, ch 3.

Rep Rnds 2 and 3 until foot measures 4" (5", 6") (10 [12.5, 15] cm) or 3½" (9 cm) less than desired length.

GUSSET

Inc rnd: Work in patt as est on instep, 2 lhdc in next lhdc, lhdc in each st around to last st, 2 lhdc in last st, ch 2—2 sts inc'd (46 [50, 54] sts).

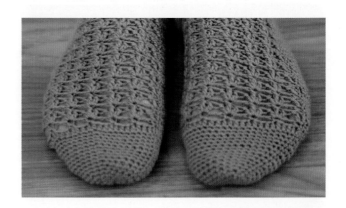

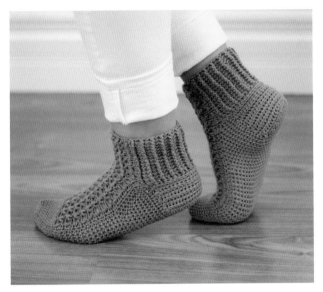

Rep rnd until there are 62 (66, 72) sts, replacing ch 2 with ch 1 at end of last rnd.

HEEL TURN

Now work in short-rows.

Row 1: Work as est across instep, sc in each of next 13 (14, 15) sts, sc2tog, sc in each of next 12 (12, 14) sts, ch 1, turn, leaving rem sts unworked.

Row 2: Sc2tog, sc across, ch 1, turn, leaving rem sts unworked.

Rep Row 2 until 4 sts rem, ending with a WS row.

HEEL FLAP

Beg with RS facing, sc in each of first 4 sts, sc 10 (10, 12) sts along one side of heel turn, ch 1, turn. Sc across all sts to second side of heel turn, sc 10 (10, 12) sts along side of heel flap, ch 2—24 (24, 28) sts.

Dec row: (RS) Lhdc in each st across heel flap to last st, lhdc2tog (see Techniques) last st with next 2 sts to the left on instep, ch 2, turn.

Dec row: (WS) Lhdc in each st across heel flap to last st, lhdc2tog last st with next 2 sts to the left on instep, ch 2.

Rep last two dec rows until all instep sts have been worked.

Cont dec'ing until 44 (48, 52) sts rem.

Pm in the 21st (25th, 25th) st.

LEG

Now work in rnds. Cont patt on instep.

Rnd 1: Sc in first st, patt in each st across to m, dc in each st around, join with sl st to first st, ch 3.

Rnd 2: Dc in first sc, patt in each st across to m, [front post double crochet (fpdc), back post double crochet (bpdc), see Techniques] across, join with sl st to first st, ch 1.

Rnd 3: Sc in first st, patt in each st across to ma, [fpdc, bpdc] across, join with sl st to first st, ch 3.

Rep Rnds 2 and 3 until leg is 3" (7.5 cm) or desired length.

Fasten off. Weave in all ends.

Wash and lay flat to block.

SHELL CABLE

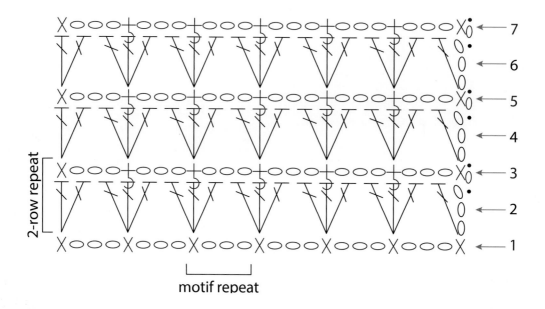

2-row repeat

motif repeat

7
6
5
4
3
2
1

KEY

- • slip stitch (sl st)
- ⬭ chain (ch)
- X single crochet (sc)
- ⴕ front post single crochet (fpsc)
- ⟙ double crochet (dc)

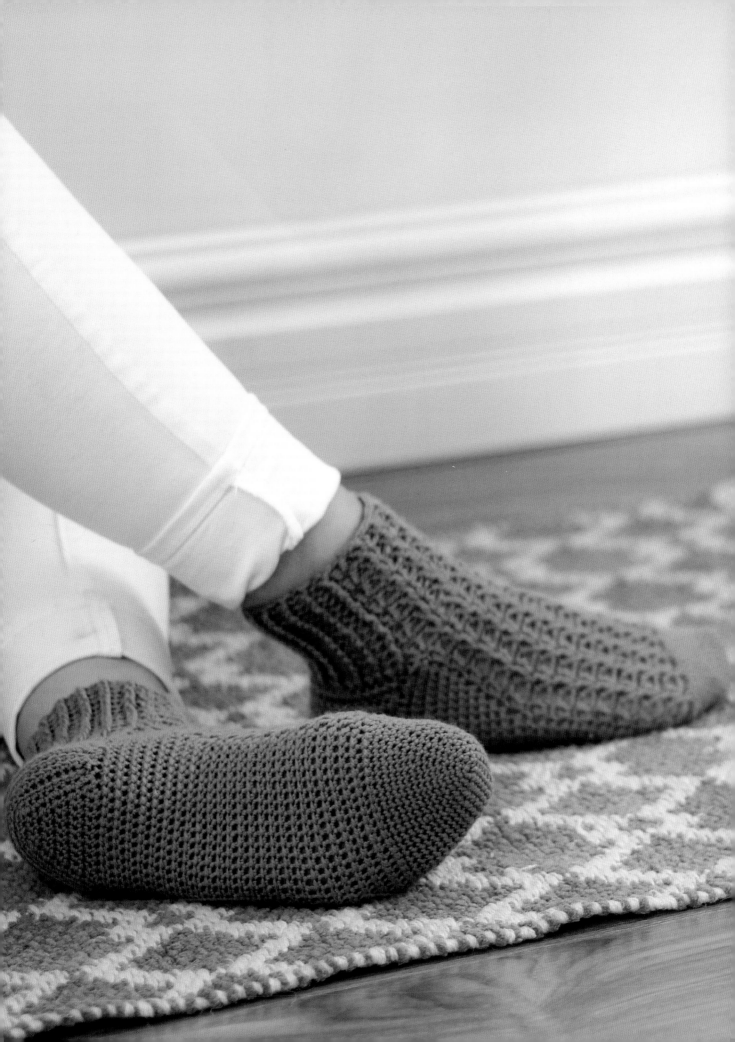

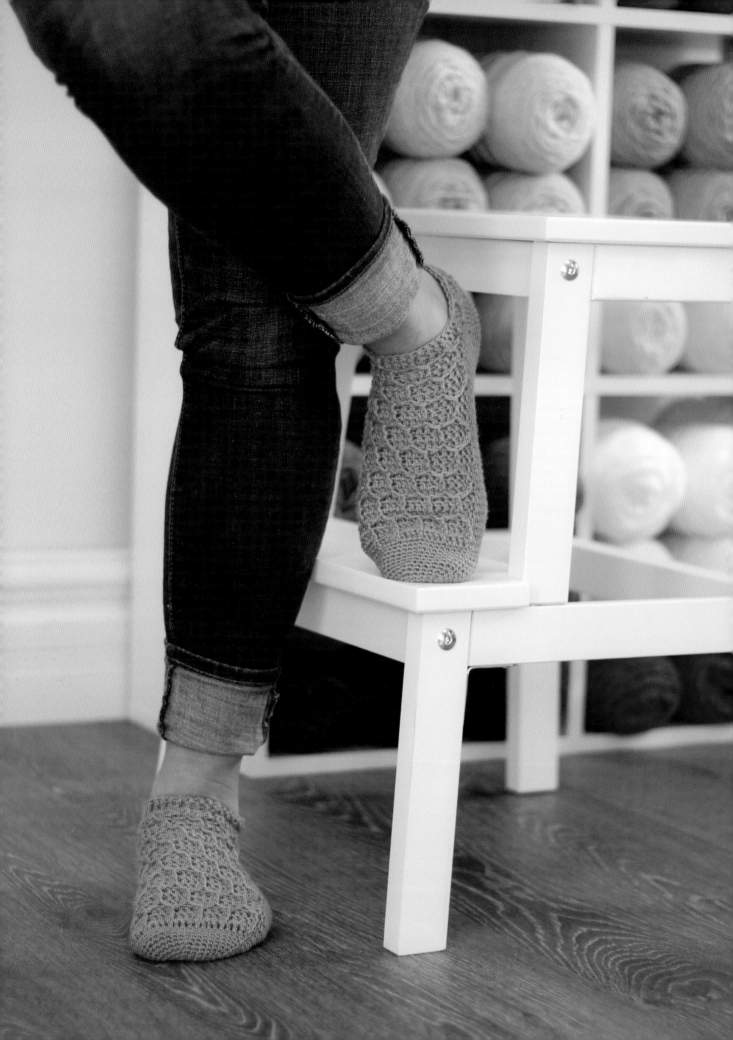

AZALEA SOCKS

Fun and fresh, my Azalea Socks are a study in crochet post stitches. The allover honeycomb cable really pops while not sacrificing any stretch at all. Joined rounds are used to keep the pattern from spiraling, which can often happen when working post stitches in continuous rounds. Although these socks are designed as ankle socks, continuing the pattern up the leg and adding a cuff would finish these off wonderfully.

These toe-up socks are worked with a six-point toe and modified strong heel.

FINISHED SIZE
Foot length: 7½" (8½", 9½") (19 [21.5, 24] cm).
Foot circumference: 7" (8", 9") (18 [20.5, 23] cm).
Leg length: 1" (2.5 cm).

Sock shown measures 8½" (21.5 cm) long in the foot and 8" (20.5 cm) in circumference.

YARN
Sock weight (#1 Super Fine).
Shown here: Spud & Chloe Fine (80% wool/20% silk; 248 yd [227 m]/65 g): #7812 Sassafras, 2 (2, 3) skeins.

HOOK
Size U.S. D (3.25 mm).
Adjust hook size if necessary to obtain gauge.

NOTIONS
Tapestry needle.

GAUGE
24 sts and 21 rows = 4" (10 cm) in extended single crochet (exsc) worked in rnds, blocked.

TOE

Chain (ch) 2.

Rnd 1: 4 single crochet (sc) in second ch from hook, join with slip (sl) st to first st, being careful not to twist, ch 1.

Do not turn.

Inc rnd: 2 sc in each sc around, join with sl st to first st, ch 1—4 sts inc'd (8 sts).

Inc rnd: 2 sc in each sc around, join with sl st to first st, ch 1—8 sts inc'd (16 sts).

Inc rnd: *2 sc in first st, sc in next st; rep from * around, join with sl st to first st, ch 1—8 sts inc'd (24 sts).

Next rnd: Sc around, join with sl st to first st, ch 1.

Inc rnd: *2 sc in first st, sc in each of next 3 sts; rep from * around, join with sl st to first st, ch 1—6 sts inc'd (30 sts).

Next rnd: Sc around, join with sl st to first st, ch 1.

Inc rnd: *2 sc in first st, sc in each of next 4 sts; rep from * around, join with sl st to first st, ch 1—6 sts inc'd (36 sts).

Next rnd: Sc around, join with sl st to first st, ch 1.

Inc rnd: *2 sc in first st, sc in each of next 5 sts; rep from * around, join with sl st to first st, ch 1—6 sts inc'd (42 sts).

Next rnd: Sc around, join with sl st to first st, ch 1.

Cont in patt as est, working 1 extra sc between each inc, until there are 42 (48, 54) sts.

Work even until toe measures 2" (5 cm).

FOOT

Begin working the Honeycomb Cable chart.

Rnd 1: Ch 3, double crochet (dc) in each of next 21 (25, 25) sts, extended single crochet (exsc, see Techniques) in each st around, join with sl st to first st, ch 2 (does not count as st here and throughout) —22 (26, 26) dc; 20 (22, 28) exsc.

Rnd 2: Back post double crochet (bpdc, see Techniques) in each of next 21 (25, 25) sts, exsc in each st around, join with sl st to first st, ch 2.

Rnd 3: Front post double crochet (fpdc, see Techniques) around post of first bpdc, dc in each of next 3 sts, fpdc around post of next bpdc; rep from * across to last bpdc, fpdc around post of last bpdc, exsc in each st around, join with sl st to first st, ch 2.

Rnd 4: Rep Rnd 3.

Rnd 5: Dc in each of first 2 sts, *fpdc around first post from previous row to the right of current stitch, fpdc around post of next post from previous row to the left of current stitch, dc in each of next 3 sts; rep from * across to last dc, exsc in each st around, join with sl st to first st, ch 2.

Rnd 6: Dc in each of first 2 sts, *fpdc around both fpdc from previous row, dc in each of next 3 sts, (if working fpdc around a post that already has been worked, work around post at slightly lower position); rep from * across to last dc, exsc in each st around, join with sl st to first st, ch 2.

Rnd 7: Rep Rnd 6.

Rnd 8: Fpdc around post 2 sts to the left of current st, dc in each of next 3 sts, *fpdc around first post from previous row to the right of current stitch, fpdc around post of next post from previous row to the left of current st, dc in each of next 3 sts; rep from * across to last dc, fpdc around last post to the right of the current st, exsc in each st around, join with sl st to first st, ch 2.

Rnd 9: Fpdc around post of first st, dc in each of next 3 sts, fpdc around post of next st; rep from * across to last st, fpdc around post of last st, exsc in each st around, join with sl st to first st, ch 2.

Rnd 10: Rep Rnd 3.

Rep Rnds 5–10 in patt as est until leg measures 4" (5", 6") (10 [12.5, 15] cm) or 3½" (9 cm) less than desired length.

GUSSET

Inc rnd: Work in patt as est on instep, 2 exsc in next exsc, exsc in each st around to last st, 2 exsc in last st—2 sts inc'd (46 [50, 54] sts).

Rep inc rnd until there are 62 (66, 72) sts.

Now work in rows.

Row 1: Ch 1, turn, exsc in each st across.

Row 2: Rep Row 1.

HEEL TURN

Dec row: Work as est across instep, sc in each of next 13 (14, 15) sts, sc2tog, sc in each of next 12 (12, 14) sts, ch 1, turn, leaving rem sts unworked.

Dec row: Sc2tog, sc across, ch 1, turn, leaving rem sts unworked.

Rep last dec row until 4 sts rem, ending with a WS row.

HEEL FLAP

Note: This heel is particularly long to make up for the lack of stretch. If a shorter heel is desired, simply join every other row of the heel flap with the next 2 stitches as opposed to just 1 stitch.

Beg with RS facing, sc in each of first 4 sts, sc 10 (10, 12) sts along one side of heel turn, ch 1, turn. Sc across all sts to second side of heel turn, sc 10 (10, 12) sts along side of heel flap, ch 1—24 (24, 28) sts.

Row 1: (RS) Sc in each st across heel flap to last st, sc last st with next st to the left on the instep, ch 1.

Row 2: (WS) Sc in each st across heel flap to last st, sc last st with next st to left on instep, ch 1.

Rep Rows 1 and 2 until all instep sts have been worked.

CUFF

Cont as est across instep and around entire cuff in cable pattern until cuff is desired length.

Fasten off. Weave in ends.

Wash and lay flat to block.

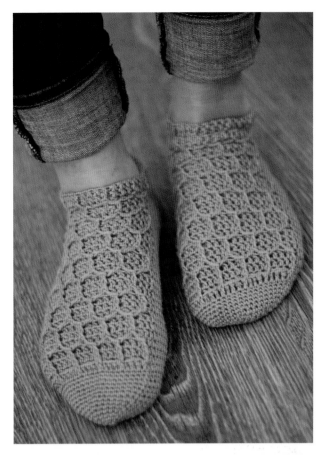

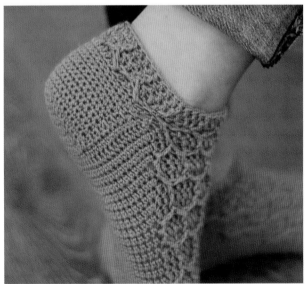

HONEYCOMB CABLE

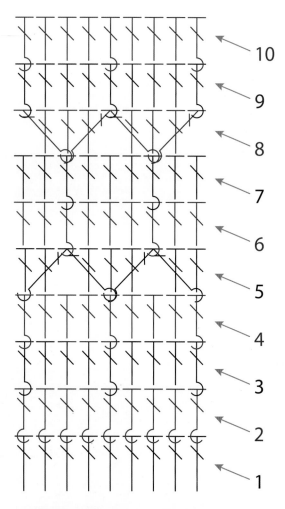

10

9

8

7

6

5

4

3

2

1

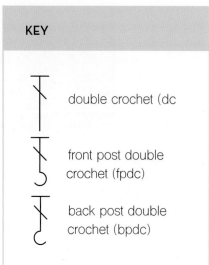

KEY	
⊤	double crochet (dc
⊤	front post double crochet (fpdc)
⊤	back post double crochet (bpdc)

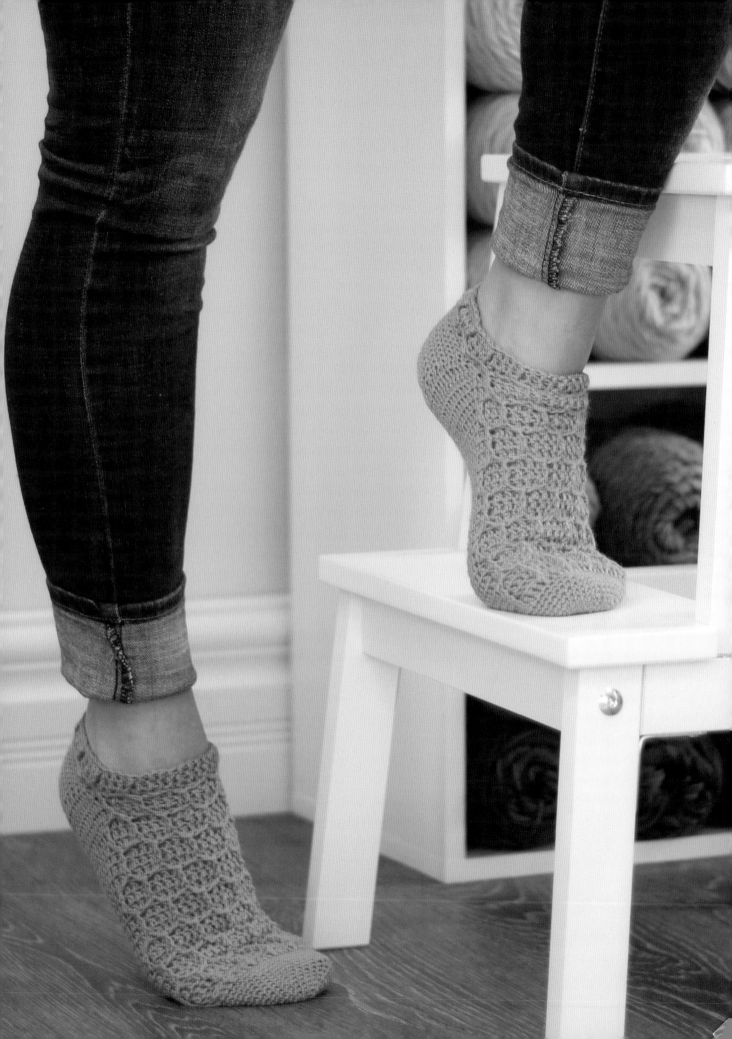

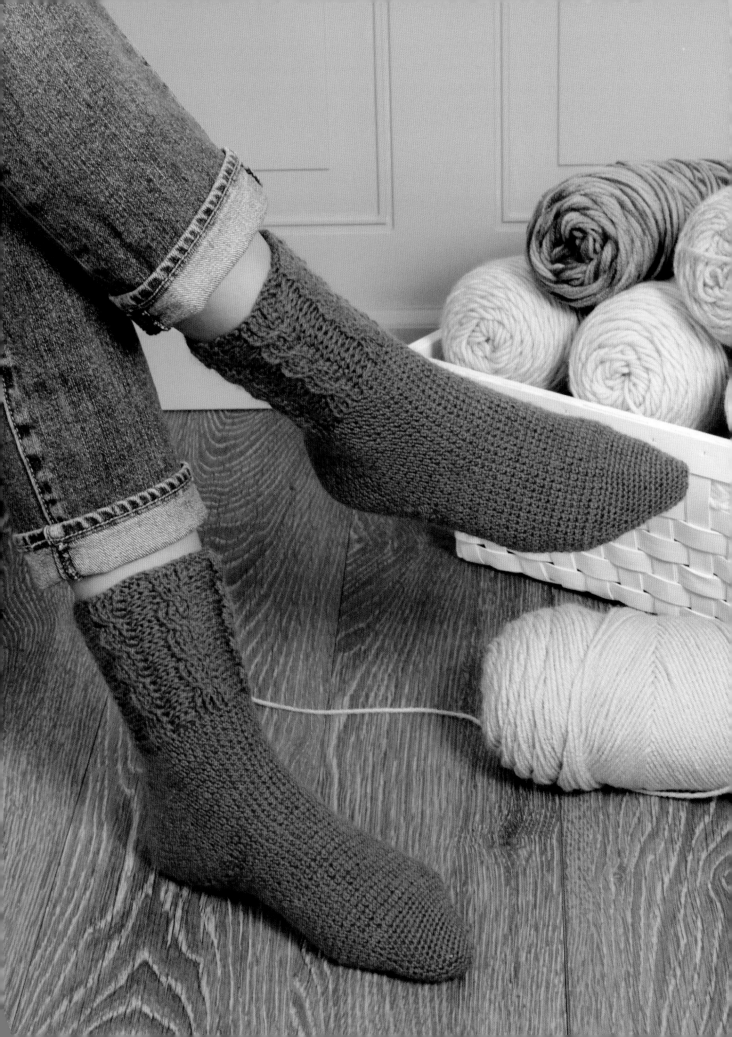

MORDECAI SOCKS

Traditional cables are just so luscious and fluffy—and, when you crochet them up (or down) a sock leg, you don't need a cuff at all. The stretchiness of the cables gives you all the stretch you need. These socks feature a simple four-stitch cable and allover extended single crochet (exsc), which gives the sock a traditional but unique look and feel.

These cuff-down socks are worked with a four-point toe, strong heel, and allover exsc foot.

FINISHED SIZE
Foot length: 7½" (8½", 9½") (19 [21.5, 24] cm).
Foot circumference: 7" (7½", 8½") (18 [19, 21.5] cm).
Leg length: 5" (12.5 cm).

Sock shown measures 8½" (21.5 cm) long in the foot
and 7½" (19 cm) in circumference.

YARN
Sock weight (#1 Super Fine).
Shown here: Lion Brand Yarns Sock Ease
(75% wool/25% nylon; 438 yd [401 m]/100 g): #240-138
Grape Soda, 1 (1, 2) skein(s).

HOOK
Size U.S. D (3.25 mm).
Adjust hook size if necessary to obtain gauge.

NOTIONS
Split-ring stitch markers (sm), tapestry needle.

GAUGE
28 sts and 24 rows = 4" (10 cm) in extended
single crochet (exsc) worked in rnds, blocked.

FOUNDATION DOUBLE CROCHET (FDC)
Chain 3. Yarn over (yo) and insert hook into third chain from hook, yo, insert hook into the loop of last double crochet made, yo, draw up loop, yo, draw through 2 loops, then draw through another 2 loops.

LEG

Work 48 (56, 64) foundation double crochet (fdc, see Stitch Guide), join to work in rnd with slip (sl) st, chain (ch) 2.

Rnds 1–3: *Front post double crochet (fpdc, see Techniques) in each of first 4 sts, back post double crochet (bpdc, see Techniques) in each of next 4 sts; rep from * around, join with sl st to first st, being careful not to twist, ch 2.

Rnd 4: *Skip (sk) next 2 sts, fpdc in each of next 2 sts, working across front of sts just worked, fpdc in each of skipped 2 sts, bpdc in each of next 4 sts; rep from * around, join with sl st to first st, ch 2.

Rep Rnds 1–4 five more times, replacing ch 2 with ch 1 at end of last rnd..

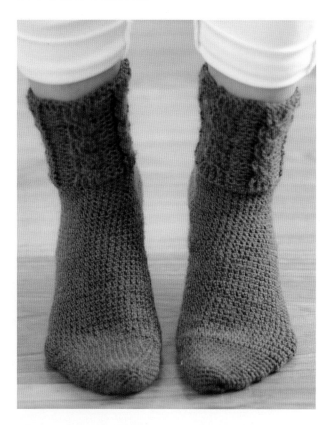

HEEL

Rnd 1: Work extended single crochet (exsc, see Techniques) in each st around, join with sl st to first st, ch 1.

Rnd 2: Exsc across first 24 (28, 32) sts, 2 exsc in next st, exsc in each rem st around to last st, 2 exsc in last st, join with sl st to first st, ch 1—2 sts inc'd (50 [58, 66] sts).

Rep Rnd 2 until there are 44 (48, 52) heel sts and 68 (76, 82) total sts.

HEEL TURN

Work the center heel sts in short-rows.

Short-row 1: (WS) Sc in each of the first 22 (24, 26) sts, sc2tog, sc in next st, turn, ch 1.

Short-row 2: (RS) Sc in each of first 4 sts, sc2tog, sc in next st, turn, ch 1.

Short-row 3: Sc in each of first 5 sts, sc2tog, sc in next st, turn, ch 1.

Short-row 4: Sc in each of next 6 sts, sc2tog, sc in next st, turn, ch 1.

Cont in patt as est, working 1 additional st each row, until all heel sts are worked. End with the same number of stitches as you began with—48 (56, 64) sts.

Rep Short-row 2 another 22 (24, 26) times.

FOOT

Now work in rnds.

Rnd 1: Exsc in each st, join with sl st to first st, ch 1.

Rep Rnd 1 until foot is desired length minus 2" (5 cm) from back of heel.

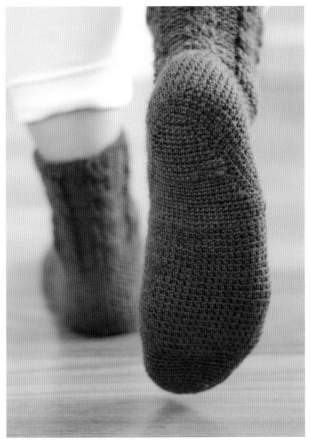

TOE

Dec rnd: [Sc in first st, sc2tog, sc in each of next 19 sts, sc2tog] twice, join with sl st to first st, ch 1—4 sts dec'd (44 [52, 60] sts).

Next rnd: Sc in each st around, join with sl st to first st, ch 1.

Dec rnd: [Sc in first st, sc2tog, sc in each of next 17 sts, sc2tog] twice, join with sl st to first st, ch 1—4 sts dec'd (40 [48, 56] sts).

Next rnd: Sc in each st around, join with sl st to first st, ch 1.

Dec rnd: [Sc in first st, sc2tog, sc in each of next 15 sts, sc2tog] twice, join with sl st to first st, ch 1—4 sts dec'd (36 [44, 52] sts).

Next rnd: Sc in each st around, join with sl st to first st, ch 1.

Dec rnd: [Sc in first st, sc2tog, sc in each of next 13 sts, sc2tog] twice, join with sl st to first st, ch 1—4 sts dec'd (32 [40, 48] sts).

Cont as est, dec'ing 4 sts every other rnd until 24 sts rem. Then dec as est every rnd until 16 sts rem.

Fasten off. Seam toe (see Techniques).

Weave in all ends. Wash and lay flat to block.

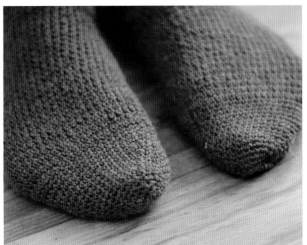

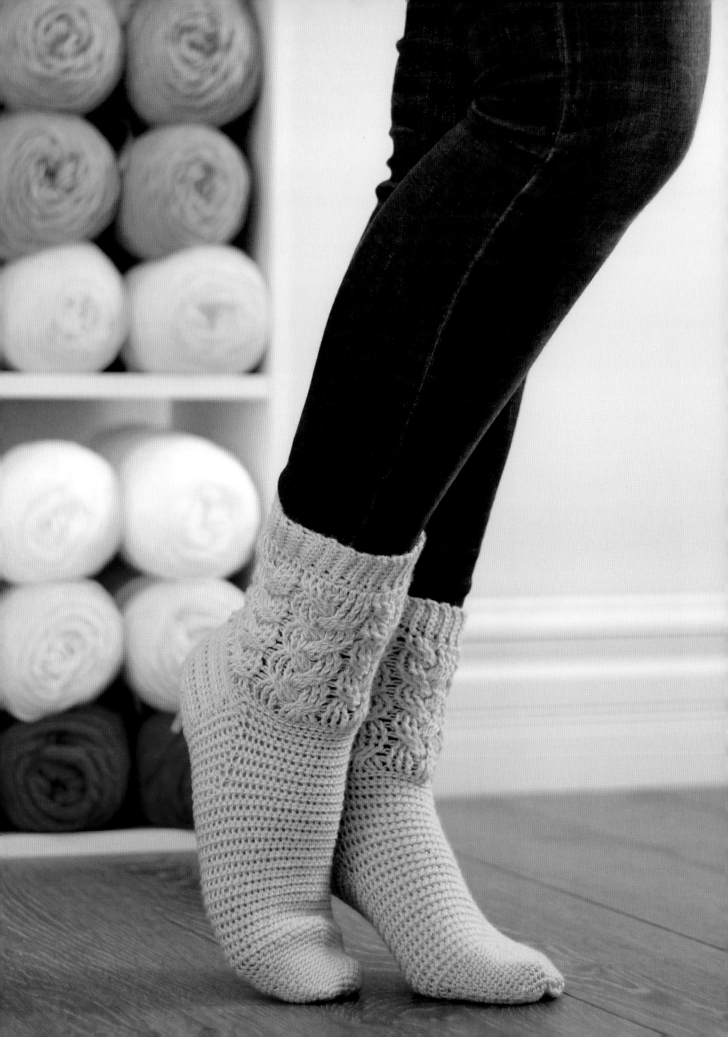

HILLSBOROUGH SOCKS

These socks are worked with a spectacular antler cable pattern that really makes a statement. Make sure to choose a tightly twisted yarn, because it will make the cabling much easier.

These cuff-down socks are worked with a four-point toe, strong heel, and an all-over linked half double crochet (lhdc) foot.

FINISHED SIZE
Foot length: 7½" (8½", 9½") (19 [21.5, 24] cm).
Foot circumference: 7½" (9", 10") (19 [23, 25.5] cm).
Leg length: 5" (7.5 cm).

Sock shown measures 8½" (21.5 cm) long in the foot and 9" (23 cm) in circumference.

YARN
Sock weight (#1 Super Fine).
Shown here: Spud & Chloe Fine (80% wool/20% silk; 248 yd [227 m]/65 g): #7812 Calypso, 2 (2, 3) skeins.

HOOK
Size U.S. D (3.25 mm).
Adjust hook size if necessary to obtain gauge.

NOTIONS
Split-ring stitch markers (sm), tapestry needle.

GAUGE
24 sts and 21 rows = 4" (10 cm) in linked half double crochet (lhdc) worked in rnds, blocked.

SINGLE CROCHET IN THE BACK LOOP (SC IN BLO)
Working in only the back loop, pull up a loop in the next stitch, yarn over (yo), pull through 2 loops on hook.

CUFF

Row 1: Chain (ch) 9, single crochet (sc) in second ch from hook and each ch across to last st, ch 1, turn—8 sts.

Row 2: Slip (sl) st in back loop only (blo) in each st across, ch 1, turn.

Row 3: Single crochet in back loop (Sc in blo, see Stitch Guide) in each st across to last st, ch 1, turn.

Rep Rows 2 and 3 until 48 (52, 60) rows have been worked. Join cuff using mattress stitch (see Techniques).

Set-up rnd: Sc 45 (54, 63) sts evenly along one edge of cuff, join with sl st to first st, being careful not to twist, ch 2 (does not count as sts here and throughout).

LEG

Now work in rnds.

Rnd 1: Double crochet (dc) in each st around, join with sl st to first st, ch 2.

Rnd 2: *Skip (sk) 3 sts, front post double crochet (fpdc, see Techniques) around next 3 sts, reaching across front of 3 sts just worked, fpdc around each of 3 skipped sts, fpdc around post of next 3 sts; rep from * around, ch 2.

Rnds 3 and 4: Fpdc in each st around, ch 2.

Rnd 5: *Fpdc around each of first 3 sts, sk next 3 sts, fpdc in each of next 3 sts, reaching behind 3 sts just worked, fpdc in each of 3 skipped sts, ch 2.

Rnds 6 and 7: Fpdc in each st around, ch 2.

Repeat Rnds 1—7 three more times. Do not ch 2 at end of last rnd.

HEEL FLAP

Now work in rows.

Row 1: Ch 2, linked half double crochet (lhdc, see Techniques) in each of the first 24 (27, 30) sts, turn.

Row 2: Ch 2, lhdc in each st across turn.

Rep Row 2 eight more times, ch 1 at end of last row.

HEEL TURN

Work center heel sts in short-rows.

Short-row 1: Sc in each of first 15 (17, 19) sts, sc2tog, ch 1, turn.

Short-row 2: Sc in each of first 7 (9, 9) sts, sc2tog, sc in next st, ch 1, turn.

Short-row 3: Sc in each of next 8 (10, 10) sts, sc2tog, sc in next st, ch 1, turn.

Short-row 4: Sc in each of next 9 (11, 11) sts, sc2tog, ch 1, turn.

Short-row 5: Sc in each of next 10 (12, 12) sts, sc2tog, ch 1, turn.

Short-row 6: Sc in each of next 11 (13, 13) sts, sc2tog, ch 1, turn.

Short-row 7: Sc in each of next 12 (14, 14) sts, sc2tog, ch 1, turn.

Cont as est until 1 st rem on either side of heel turn.

Next row: Sc in each st across to last 2 sts, sc2tog, ch 1, turn.

Rep last row once more, ch 1, turn—14 (16, 18) sts.

GUSSET

Rnd 1: Sc across heel turn, sc 12 (13, 14) sts along side of heel flap, sc across instep, sc 12 (13, 14) sts along other side of heel flap, join with sl st to first st, being careful not to twist, ch 2—62 (68, 76) sts rem.

Dec rnd: Lhdc in each st across to 1 st before instep, sc2tog, lhdc across instep, sc2tog, lhdc in each rem st around, join with sl st to first st, ch 2—2 sts dec'd (60 [66, 74] sts).

Rep dec rnd until 48 (52, 60) sts rem.

FOOT

Rnd 1: Lhdc in each st around, join with sl st to first st, ch 2.

Rep Rnd 1 until foot measures 2" (5 cm) less than desired length from back of heel, ch 1 at end of last rnd.

TOE

Dec rnd: *Sc2tog, sc in each of next 10 (11, 13) sts; rep from * around, join with sl st to first st, ch 1—4 sts dec'd (44 [48, 56] sts).

Next rnd: Sc in each st around, join with sl st to first st, ch 1.

Dec rnd: *Sc2tog, sc in each of next 9 (10, 12) sts; rep from * around, join with sl st to first st, ch 1—4 sts dec'd (40 [44, 52] sts).

Next rnd: Sc in each st around, join with sl st to first st, ch 1.

Dec rnd: *Sc2tog, sc in each of next 8 (9, 11) sts; rep from * around, join with sl st to first st, ch 1—4 sts dec'd (36 [40, 48] sts).

Next rnd: Sc in each st around, join with sl st to first st, ch 1.

Dec rnd: *Sc2tog, sc in each of next 7 (8, 10) sts; rep from * around, join with sl st to first st, ch 1—4 sts dec'd (32 [36, 44] sts).

Next rnd: Sc in each st around, join with sl st to first st, ch 1.

Cont as est, dec'ing 4 sts every other rnd until 24 sts rem. Then, dec as est every rnd until 16 sts rem.

Fasten off. Seam toe (see Techniques).

Weave in all ends. Wash and lay flat to block.

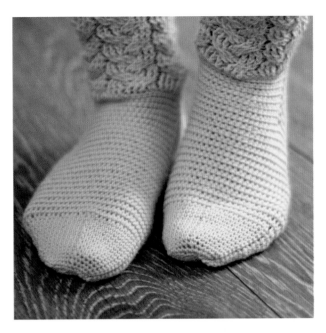

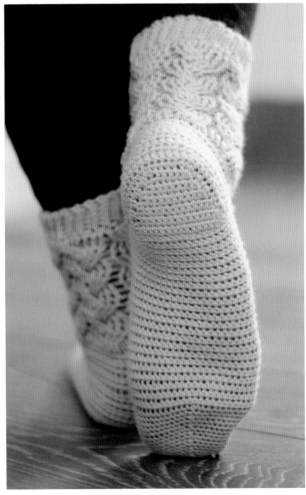

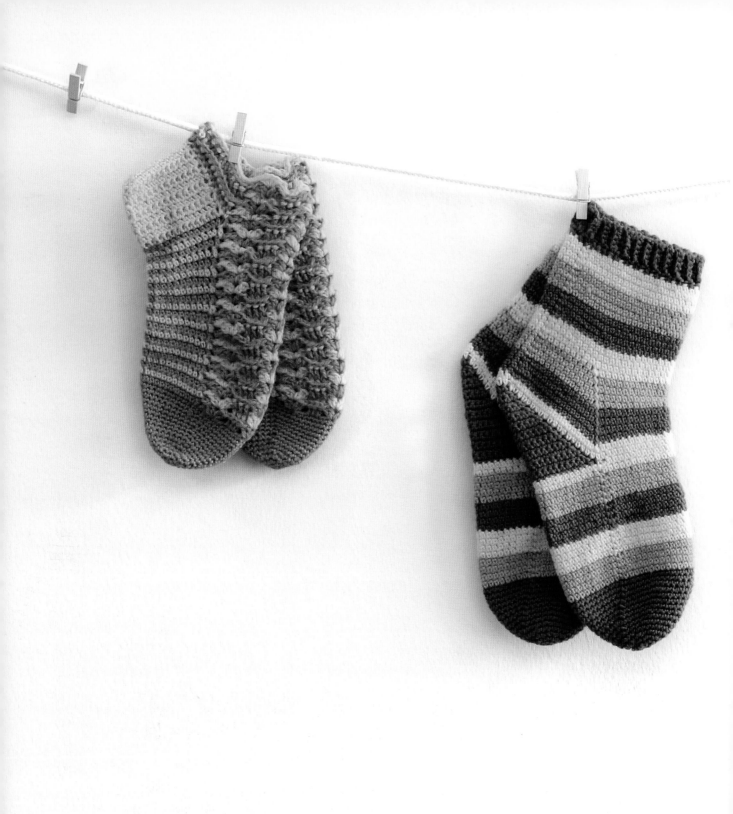

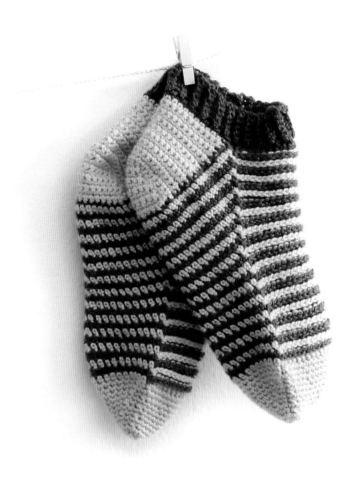

CHAPTER 7

COLORWORK SOCKS

I love designing socks that include colorwork, but many people are wary of crochet's lack of stretch in colorwork. The best way to add color and not sacrifice stretch? Textured stitch patterns and stripes. By using a combination of post stitches and varying stitch heights, we can crochet a sock that looks infinitely more difficult to make than it actually is.

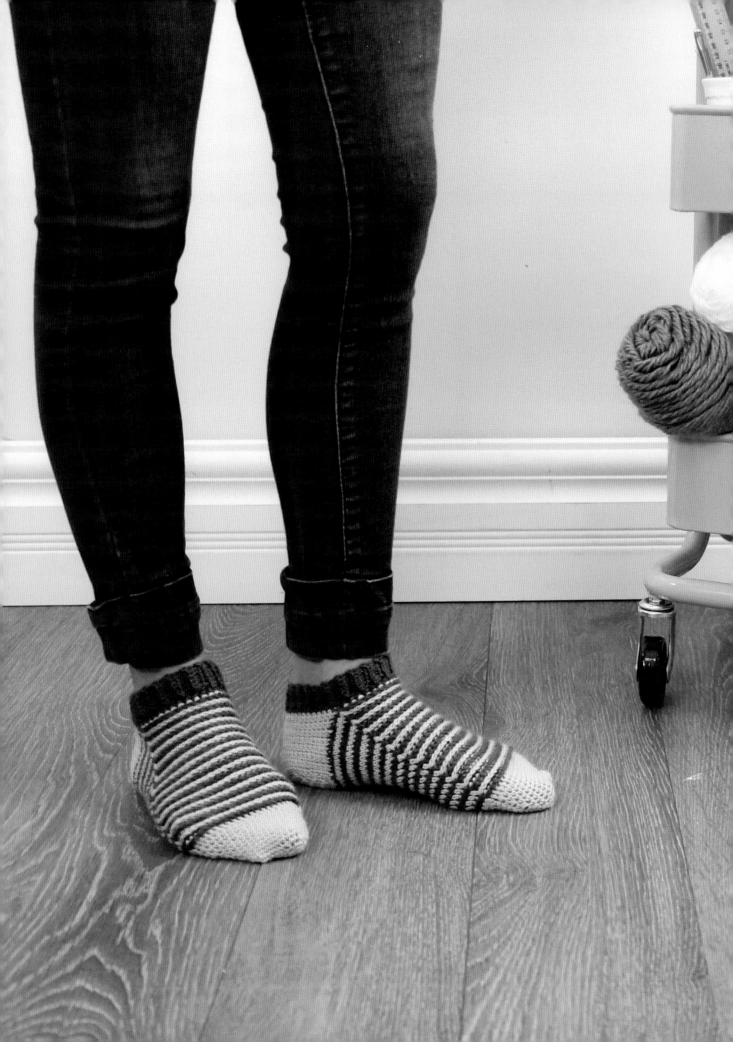

BRICKYARD SOCKS

Something about post stitches gives colorwork an extra layer of depth. The Brickyard Socks are worked in two contrasting colors of yarn to really help the rows pop. If you're nervous about working stripes and a textured stitch, try working one sock in just the textured stitches and then add in color on the second.

These toe-up socks are worked with a standard wedge toe, textured stitches, stripes, a heel flap, and a simple ribbed cuff.

FINISHED SIZE
Foot length: 7½" (8½", 9½") (19 [21.5, 24] cm).
Foot circumference: 7" (7½", 8") (18 [19, 20.5] cm).
Leg length: 1" (2.5 cm).

Sock shown measures 8½" (21.5 cm) long in the foot and 7½" (19 cm) in circumference.

YARN
Sock weight (#1 Super Fine).
Shown here: Louet Yarns Gems (100% merino wool; 425 yd [389 m]/100 g): (A) Champagne, (B) Marine Blue, 1 (1, 2) skein(s) each.

HOOK
Size U.S. C (2.75 mm).
Adjust hook size if necessary to obtain gauge.

NOTIONS
Split-ring stitch markers (sm), tapestry needle.

GAUGE
28 sts and 24 rows = 4" (10 cm) in extended single crochet (exsc) worked in rnds, blocked.

SINGLE CROCHET IN THE BACK LOOP (SC IN BLO)
Working in only the back look, pull up a loop in the next stitch, yarn over (yo), pull through 2 loops on hook.

TOE

With color A, chain (ch) 9.

Rnd 1: Single crochet (sc) in second ch from hook and in each ch across, working in opposite side of beg ch, sc in each ch across, join with slip (sl) st to first st, being careful not to twist, ch 1—16 sts.

Inc rnd: *Sc in first st, 2 sc in next st, sc in each of next 5 sts, 2 sc in next st; rep from * once more, join with sl st to first st, ch 1—4 sts inc'd (20 sts).

Inc rnd: *Sc in first st, 2 sc in next st, sc in each of next 7 sts, 2 sc in next st; rep from * once more, join with sl st to first st, ch 1—4 sts inc'd (24 sts).

Next rnd: Sc around, join with sl st to first st, ch 1.

Inc rnd: *Sc in first st, 2 sc in next st, sc in each of next 9 sts, 2 sc in next st; rep from * once more, ch 1—4 sts inc'd (28 sts).

Next rnd: Sc around, join with sl st to first st, ch 1.

Inc rnd: *Sc in first st, 2 sc in next st, sc in each of next 11 sts, 2 sc in next st; rep from * once more, ch 1—4 sts inc'd (32 sts).

Next rnd: Sc around, join with sl st to first st, ch 1.

Cont in patt as est, inc'ing 4 sts every other rnd, until there are 44 (48, 52) sts. Do not ch 1 at end of last rnd.

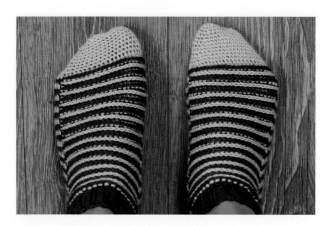

FOOT

Rnd 1: Ch 2, double crochet (dc, see Techniques) in each of first 22 (24, 26) sts, extended single crochet (exsc, see Techniques) in each st around, join with sl st to first st, ch 1.

Rnd 2: Join color B, ch 2, back post double crochet (bpdc, see Techniques) in each of first 22 (24, 26) sts, exsc in each st around, join with sl st to first st, ch 1.

Rep Rnd 2, changing color every other rnd, until leg measures 4" (5", 6") (10 [12.5, 15] cm) or 3½" (9 cm) less than desired length.

GUSSET

Inc rnd: Patt in each of first 22 (24, 26) sts, 2 exsc in next exsc, exsc in each st around to last st, 2 exsc in last st, ch 1—2 sts inc (46 [50, 54] sts).

Rep inc rnd until there are 62 (66, 72) sts.

HEEL TURN

Now work in rows.

Row 1: (RS) Join color A, work as est across instep, sc in each of next 13 (14, 15) sts, sc2tog, sc in each of next 12 (12, 14) sts, ch 1, turn, leaving rem sts unworked.

Row 2: (WS) Sc2tog, sc across to and in sc2tog from prev row, ch 1, turn, leaving rem sts unworked.

Rep Row 2 until 4 sts rem, ending with a WS row.

HEEL FLAP

Note: This heel is particularly long to make up for the lack of stretch. If a shorter heel is desired, simply join every other row of the heel flap with the next 2 stitches as opposed to just 1 stitch.

Beg with RS facing, sc in each of first 4 sts, sc 10 (10, 12) sts along one side of heel turn, ch 1, turn.

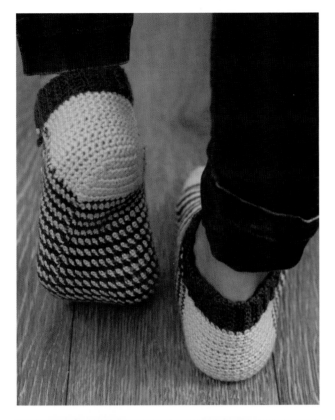

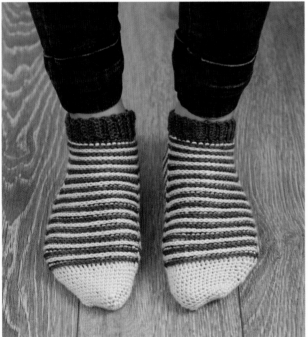

Sc across all sts to second side of heel turn, sc 10 (10, 12) sts along the side of heel flap, ch 1—24 (24, 28) sts around heel flap.

Row 1: (RS) Sc in each st across heel flap to last st, sc last st tog with next st to the left on instep, ch 1, turn.

Row 2: (WS) Sc in each st across heel flap to last st, sc last st tog with next st to left on instep, ch 1, turn.

Rep Rows 1 and 2 until all instep sts have been worked—44 (48, 52) sts.

Cont on to cuff or, if desired, continue working leg in bpdc patt as est until desired length.

Fasten off color A.

CUFF

Row 1: Join color B, ch 9, sc in second ch from hook and each ch across to last st, join last st of cuff and next 2 sts of leg with sc2tog, ch 1, turn.

Row 2: Single crochet in the back loop (sc in blo, see Stitch Guide) in each st across, ch 1, turn.

Row 3: Sc in blo in each st across to last st, join last st of cuff and next 1 st of leg with sc2tog, ch 1, turn.

Rep Rows 2 and 3 until all leg sts have been worked.

Fasten off. Seam cuff using mattress st (see Techniques).

Weave in all ends. Wash and lay flat to block.

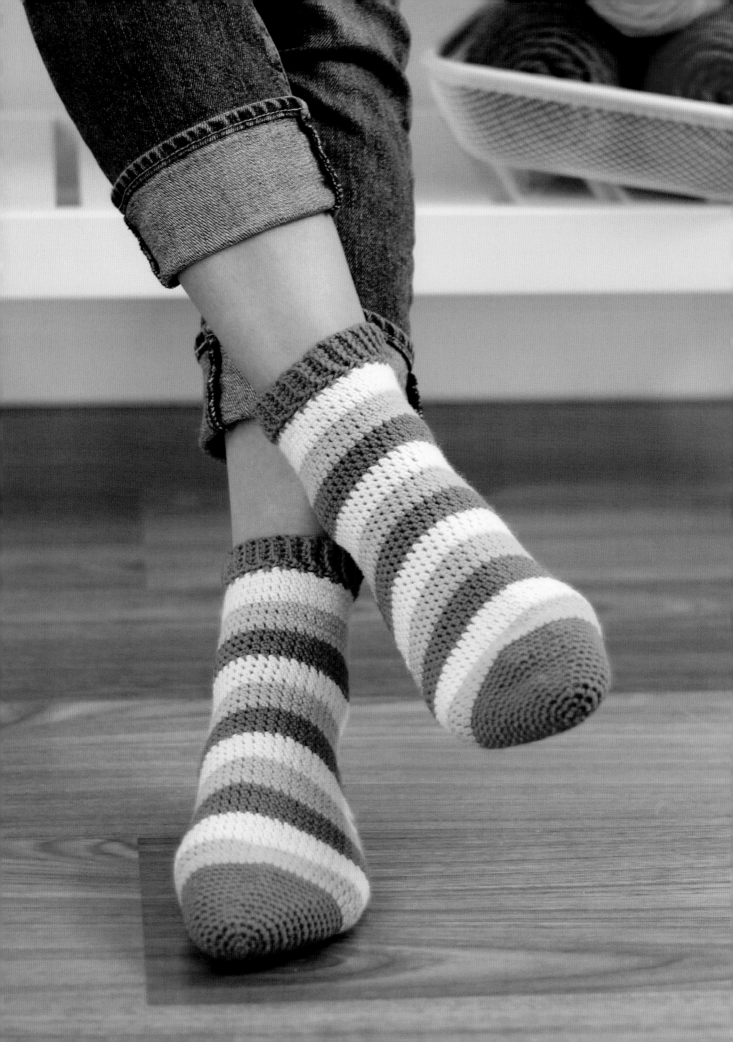

LAKE LYNN SOCKS

Striped sock yarns don't always work for crochet socks, so most of us crochet sock lovers avoid them for fear of blotchy colors. The best solution is to work what I like to call "intentional stripes," which use a single slip (sl) stitch join to hide the color changes and avoid jogs. Try as many color changes as you can think of! These socks are also wonderful for using up old sock yarn scraps to make your own special colorway.

These toe-up socks are worked with a four-point toe, strong heel, and simple ribbed cuff.

FINISHED SIZE
Foot length: 7½" (8½", 9½") (19 [21.5, 24] cm).
Foot circumference: 7" (7½", 8") (18 [19, 20.5] cm).
Leg length: 5" (12.5 cm).

Sock shown measures 8½" (21.5 cm) long in the foot and 7½" (19 cm) in circumference.

YARN
Sock weight (#1 Super Fine).
Shown here: Made in America Yarns Wayfarer (100% wool; 382 yd [349 m]/100 g): (A) Harbor, (B) Hot Spring, (C) Natural, 1 skein each.

HOOK
Size U.S. D (3.25 mm).
Adjust hook size if necessary to obtain gauge.

NOTIONS
Split-ring stitch markers (sm), tapestry needle.

GAUGE
25½" sts and 21 rows = 4" (10 cm) in extended single crochet (exsc) worked in rnds, blocked.

STITCH GUIDE

SINGLE CROCHET IN THE BACK LOOP (SC IN BLO)
Working in only the back look, pull up a loop in the next stitch, yarn over (yo), pull through 2 loops on hook.

TOE

With color A, chain (ch) 2.

Set-up rnd: 4 single crochet (sc) in second ch from hook, join with slip (sl) st to first st, being careful not to twist, ch 1. Do not turn—4 sts inc'd (4 sts).

Inc rnd: 2 sc in each sc around, join with sl st to first st, ch 1—4 sts inc'd (8 sts).

Inc rnd: 2 sc in each sc around, join with sl st to first st, ch 1—8 sts inc'd (16 sts).

Inc rnd: *2 sc in first st, sc in next st; rep from * around, join with sl st to first st, ch 1—8 sts inc'd (24 sts).

Next rnd: Sc around, join with sl st to first st, ch 1.

Inc rnd: *2 sc in first st, sc in each of next 3 sts; rep from * around, join with sl st to first st, ch 1—6 sts inc'd (30 sts).

Next rnd: Sc around, join with a sl st to first st, ch 1.

Inc rnd: *2 sc in first st, sc in each of next 4 sts; rep from * around, join with sl st to first st, ch 1—6 sts inc'd (36 sts).

Next rnd: Sc around, join with sl st to first st, ch 1.

Inc rnd: *2 sc in first st, sc in each of next 5 sts; rep from * around, join with sl st to first st, ch 1—6 sts inc'd (42 sts).

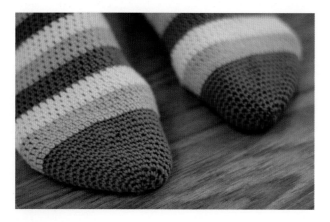

Cont as est, working 1 extra sc between each inc, until there are 42 (48, 54) sts.

Work even until toe measures 2" (5 cm).

FOOT

Rnds 1–4: Join color B, extended single crochet (exsc, see Techniques) in each st around, join with sl st to first st, ch 1.

Rnds 5–8: Join color C, exsc in each st around, join with a sl st to first st, ch 1.

Rnds 9–12: Join color A, exsc in each st around, join with sl st to first st, ch 1.

Rep this stripe sequence, changing colors every 4 rnds, until leg measures 4" (5", 6") (10 [12.5, 15] cm) or 3½" (9 cm) less than desired length.

Note: My sample sock measured the right length in the middle of a stripe sequence, so, to finish the stripes, I worked the heel as instructed in color A and rejoined color C when beginning the leg.

HEEL

Now work in rows for heel turn.

Dec row: (RS) Join color A, sc2tog, sc in each of next 19 (22, 25) sc, ch 1, turn, leaving rem sts unworked.

Dec row: (WS) Sc2tog, sc in each st across, ch 1, turn.

Rep Rnd 2 until 3 (4, 5) sts rem, ending on a WS row.

Break yarn and join the next color in the stripe sequence.

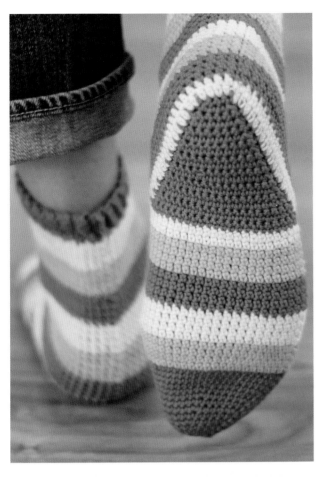

HEEL FLAP

With RS facing, sc in each of next 3 (4, 5) sts, turn work 90 degrees and sc 18 (20, 22) sts along side of heel turn, work in patt as est across the 21 (24, 27) instep sts, sc 18 (20, 22) sts along other side of heel turn, join with sl st to first st, being careful not to twist, ch 1—60 (68, 76) sts.

Place marker (pm) in first and last instep sts.

Note: The first decrease will be 1 st before the previous increase to account for the spiral of crochet rounds. The second decrease will be stacked on top of the decrease in the previous round.

Now work in rnds.

Set-up rnd: Exsc in each st around to 2 sts before first, sc2tog, exsc across instep to next, sc2tog, exsc to end of rnd, join with sl st to first st, ch 1.

Dec rnd: Exsc in each st around to 1 st before first dec, sc2tog, exsc across instep to next dec, sc2tog, exsc to end of rnd, join with sl st to first st, ch 1.

Rep dec rnd until 44 (48, 52) sts rem.

LEG

Changing colors as needed, cont working leg until it is desired length, minus length of cuff.

CUFF

Now work in rows.

Row 1: Fasten off last color. Join color C in first st, ch 6, sc in second ch from hook and each ch across to last st, join last st of cuff and next 2 sts of leg with sc3tog, ch 1, turn.

Row 2: Single crochet in the back loop (sc in blo, see Stitch Guide) in each st across, ch 1, turn.

Row 3: Sc in blo in each st across to last st, join last st of cuff and next 2 sts of leg with sc3tog, ch 1, turn.

Cont working around leg until all sts have been joined to cuff.

Fasten off. Seam cuff using mattress st (see Techniques).

Weave in all ends. Wash and lay flat to block.

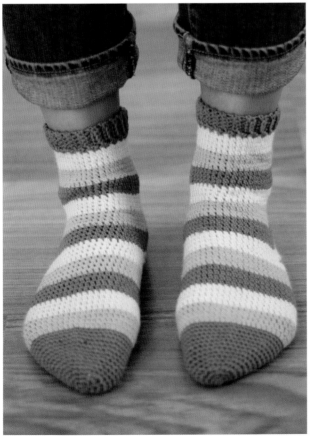

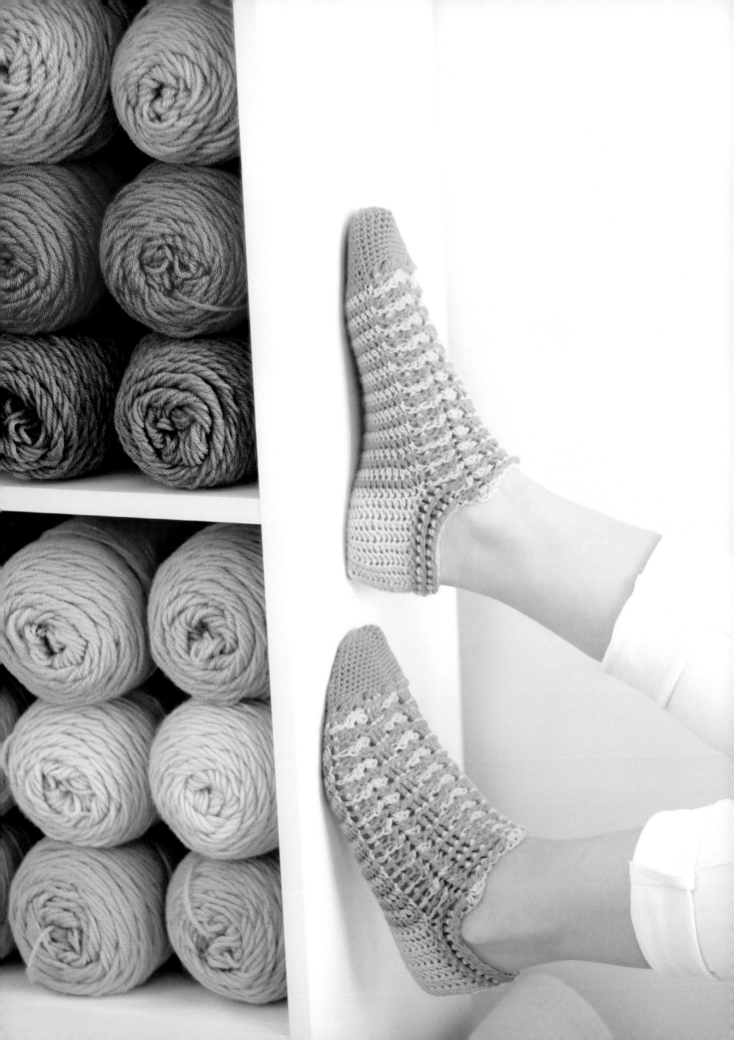

PULLEN SOCKS

There are a few socks in this world that I finish, then sit back, take a deep breath, and feel completely satisfied. This is one of those pairs of socks. This textured colorwork sock is completely fun and a great way to test your crochet skills. With lace, cables, colorwork, and increasing and decreasing, the Pullen Socks are the ultimate test of your adventurous spirit.

These toe-up socks are worked with a common heel, four-point toe, and in allover extended single crochet (exsc).

FINISHED SIZE
Foot length: 7½" (8½", 9½") (19 [21.5, 24] cm).
Foot circumference: 7" (7½", 8½") (18 [19, 21.5] cm).
Leg length: 1" (2.5 cm).

Sock shown measures 8½" (21.5 cm) long in the foot and 7½" (19 cm) in circumference.

YARN
Sock weight (#1 Super Fine).
Shown here: Cascade Yarns 220 Fingering (100% Peruvian Highland wool; 273 yd [240 m]/50 g): (A) #4147 Lemon Yellow, 1 skein; (B) #8891 Cyan Blue, 1 skein.

HOOK
Size U.S. C (2.75 mm).
Adjust hook size if necessary to obtain gauge.

NOTIONS
Split-ring stitch markers (sm), tapestry needle.

GAUGE
28 sts and 24 rows = 4" (10 cm) in extended single crochet (exsc) worked in rnds, blocked.

TOE

With color B, chain (ch) 9.

Inc rnd: Single crochet (sc) in second ch from hook and in each ch across, working in opposite side of beg ch, sc in each ch across, join with slip (sl) st to first st, being careful not to twist, ch 1—7 sts inc'd (16 sts).

Inc rnd: *Sc in first st, 2 sc in next st, sc in each of next 5 sts, 2 sc in next st; rep from * once more, join with sl st to first st, ch 1—4 sts inc'd (20 sts).

Inc rnd: *Sc in first st, 2 sc in next st, sc in each of next 7 sts, 2 sc in next st; rep from * once more, join with sl st to first st, ch 1—4 sts inc'd (24 sts).

Next rnd: Sc around, join with sl st to first st, ch 1.

Inc rnd: *Sc in first st, 2 sc in next st, sc in each of next 9 sts, 2 sc in next st; rep from * once more, ch 1—4 sts inc'd (28 sts).

Next rnd: Sc around, join with sl st to first st, ch 1.

Inc rnd: *Sc in first st, 2 sc in next st, sc in each of next 11 sts, 2 sc in next st; rep from * once more, ch 1—4 sts inc'd (32 sts).

Next rnd: Sc around, join with sl st to first st, ch 1.

Cont in patt as est, inc'ing 4 sts every other rnd, until there are 44 (48, 52) sts.

FOOT

Rnd 1: Ch 3, *skip (sk) 2 sts, (2 double crochet (dc, see Techniques), ch 1, 2 dc) in next st, sk 2 sts, dc in each next 3 sts; rep from * once more, sk 2 sts, (2 dc, ch 1, 2 dc) in next st, sk 2 sts, dc in last st, extended single crochet (exsc, see Techniques) in each of rem sts around, join with a sl st to first st, ch 3.

Rnd 2: *(2 dc, ch 1, 2 dc) in first chain-1 space (ch-1 sp), back post double crochet (bpdc, see Techniques) in each of next 3 dc; rep from * across to last shell, (2 dc, ch 1, 2 dc) in final ch-1 sp, dc in last dc, exsc in each of rem sts around, join with sl st to first st, ch 3.

Rep Rnd 2, changing color every other round, until foot measures 4" (5", 6") (10 [12.5, 15] cm) or 3½" (9 cm) less than desired length, replacing ch 3 with ch 1 at end of last rnd.

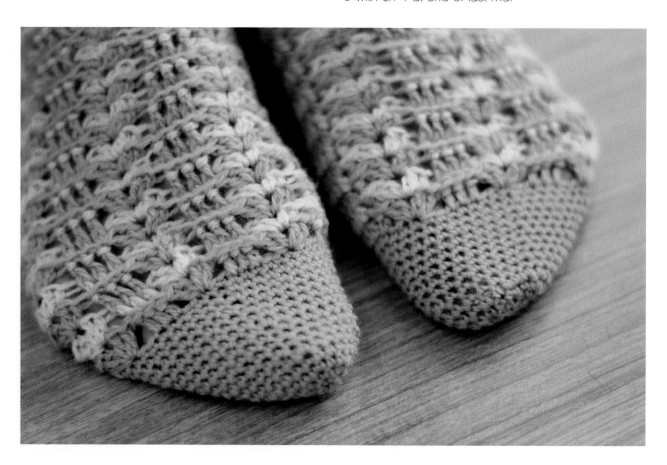

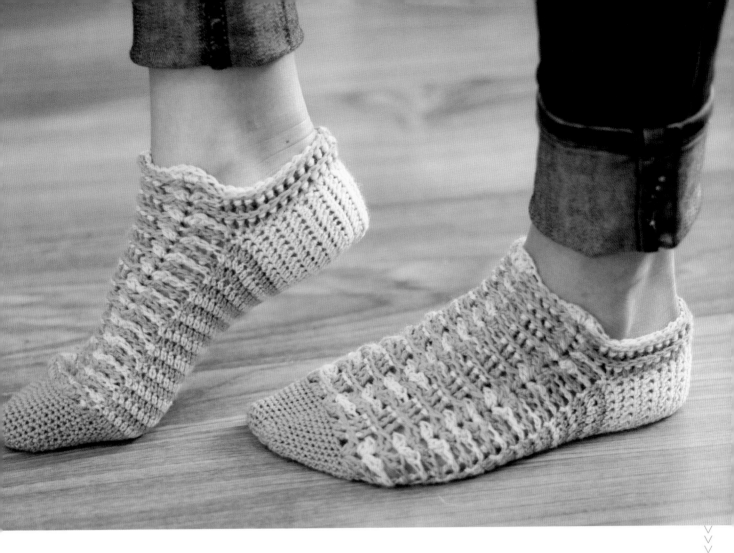

GUSSET

Inc rnd: Work in patt as est across, 2 exsc in next exsc, exsc in each st around to last st, 2 exsc in last st, ch 1—2 sts inc (46 [50, 54] sts).

Rep inc rnd 2 more times.

HEEL FLAP

Now work in rows.

Row 1: (RS) Work patt as est across instep, exsc in each st across to end of rnd, ch 1, turn.

Row 2: (WS) Exsc in each st across to end of sole, ch 1, turn.

Rep Row 2 until heel flap measures 3" (7.5 cm) long.

Fasten off. Seam back of heel using mattress st (see Techniques).

CUFF

With RS facing, join color B and work patt as est across instep, dc in each st around heel, join with sl st to first st, ch 3.

Now work in rnds.

Next rnd: Work in patt as est across instep, bpdc in each dc around, join with sl st to first st, ch 3.

Rep last rnd until optional leg is desired length.

Fasten off. Weave in all ends.

Wash and lay flat to block.

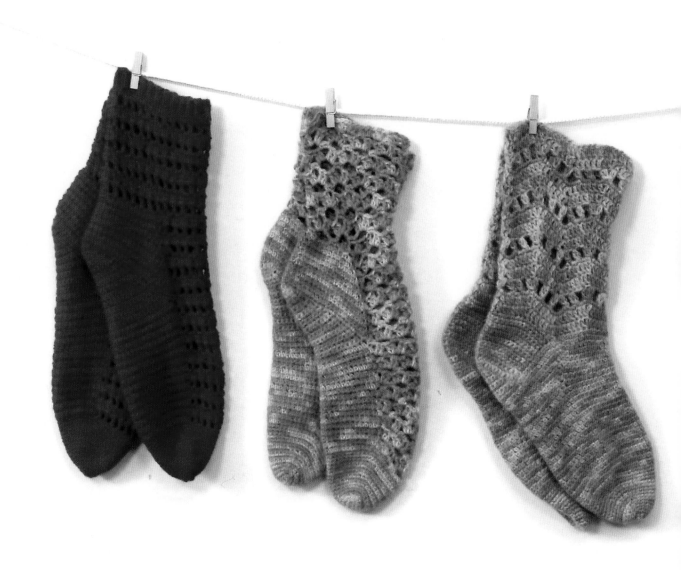

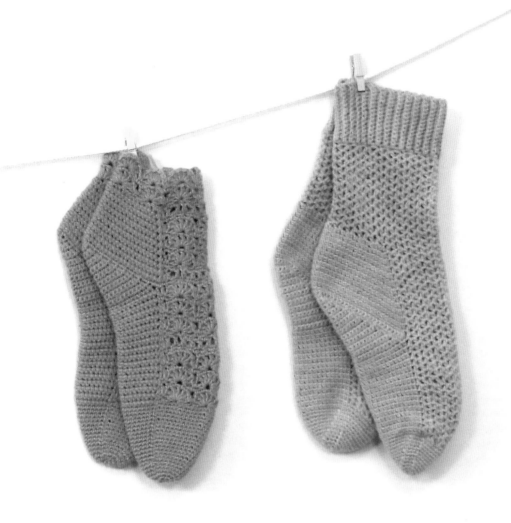

CHAPTER 8

LACE SOCKS

Crochet lace is delicate, lacy, and perfect for crochet socks. The designs in this chapter feature a wide variety of lace stitch patterns that range from simple to intermediate. The patterns included are great for customization and feature stitch patterns that are easy to fit to your feet.

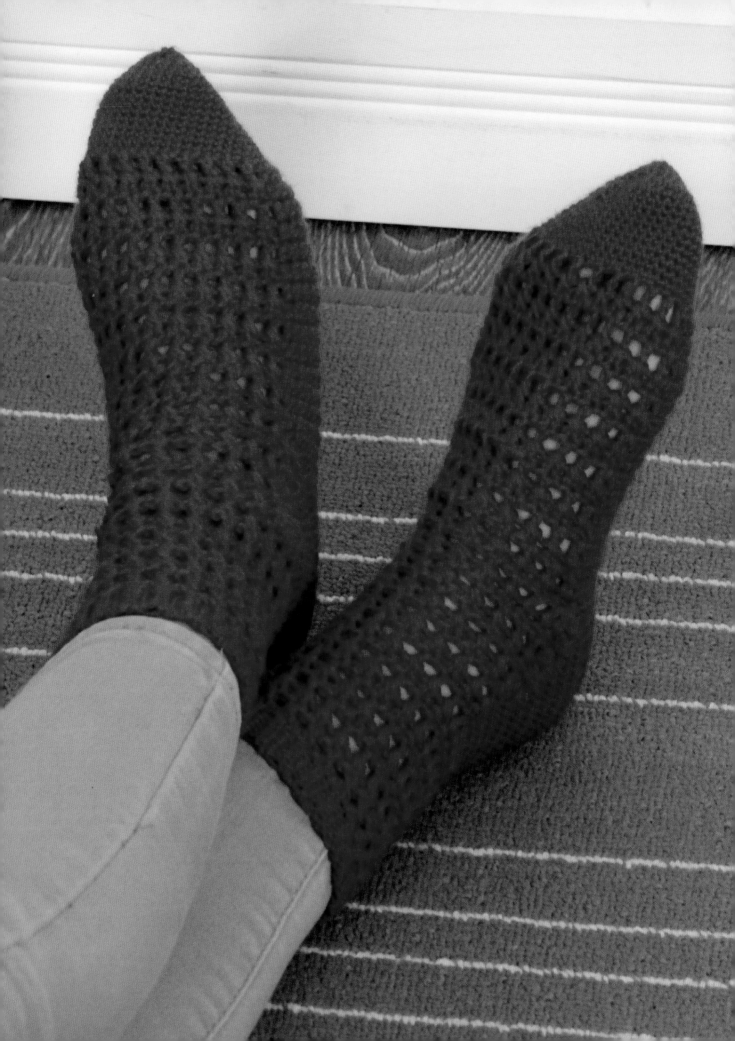

MEREDITH SOCKS

Crocheters shouldn't have to shy away from lace in their socks. The trick is making it work. This often means pairing the lace pattern with an extra-stretchy stitch such as linked half double crochet (lhdc). These socks feature a two-row lace stitch with a small repeat, which means they are perfect for customizing to your feet. I also used my favorite cuff, the single crochet through the back loop ribbed cuff, to give the lace a bit of structure and staying power on the leg. Make the leg as long as you want, maybe even creating a chic knee sock.

These toe-up socks are worked with a modified wedge toe and strong heel.

FINISHED SIZE
Foot length: 8½" (9½", 10½") (21.5 [24, 26.5] cm).
Foot circumference: 7" (7½", 8") (18 [19, 20.5] cm).
Leg length: 7" (18 cm).

Sock shown measures 9½" (24 cm) long in the foot and 7½" (19 cm) in circumference.

YARN
Sock weight (#1 Super Fine).
Shown here: Cascade Yarns 220 Fingering
(100% Peruvian Highland wool; 273 yd [250 m]/50 g):
#5616 Fuchsia, 2 skeins.

HOOK
Size U.S. D (3.25 mm).
Adjust hook size if necessary to obtain gauge.

NOTIONS
Split-ring stitch markers (sm), tapestry needle.

GAUGE
24 sts and 24 rows = 4" (10 cm) in linked half double crochet (lhdc) worked in rnds, blocked.

SINGLE CROCHET IN THE BACK LOOP (SC IN BLO)
Working only in the back loop, pull up a loop in the next stitch, yarn over (yo), pull through 2 loops on hook.

TOE

Chain (ch) 9.

Inc rnd: Single crochet (sc) in second ch from hook and in each ch across, working in opposite side of beg ch, sc in each ch across, join with slip (sl) st to first st, ch 1—7 sts inc'd (16 sts).

Inc rnd: *Sc in first st, 2 sc in next st, sc in each of next 5 sts, 2 sc in next st; rep from * once more, join with sl st to first st, ch 1—4 sts inc'd (20 sts).

Inc rnd: *Sc in first st, 2 sc in next st, sc in each of next 7 sts, 2 sc in next st; rep from * once more, join with sl st to first st, ch 1—4 sts inc'd (24 sts).

Next rnd: Sc around, join with sl st to first st, ch 1.

Inc rnd: *Sc in first st, 2 sc in next st, sc in each of next 9 sts, 2 sc in next st; rep from * once more, ch 1—4 sts inc'd (28 sts).

Next rnd: Sc around, join with sl st to first st, ch 1.

Inc rnd: *Sc in first st, 2 sc in next st, sc in each of next 11 sts, 2 sc in next st; rep from * once more—4 sts inc'd (32 sts).

Next rnd: Sc around, join with sl st to first st, ch 1.

Cont as est, inc'ing 4 sts every other rnd, until there are 44 (48, 52) sts.

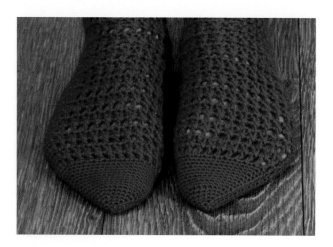

FOOT

Place marker (pm) in 21st (25th, 25th).

Begin working the Crossed Lace with Joins chart.

Rnd 1: Ch 4, skip (sk) 1 st, *double crochet (dc, see Techniques) in next st, ch 1; rep from * across to m, linked half double crochet (lhdc) in each st around, join with sl st to first st, ch 3 (counts as first dc)—20 (24, 24) dc; 20 (24, 24) chain-1 spaces (ch-1 sps); 22 (22, 26) lhdc.

Rnd 2: *Sk next ch-sp, dc in second ch-1 sp, dc in skipped ch-1 sp; rep from * across to m, lhdc in each st around, join with sl st to first st, ch 3—9 (11, 11) crossed pairs; 1 dc; 22 (22, 26) lhdc.

Rnd 3: Sk 1 dc, *dc in next dc, ch 1; rep from * across to marked st, lhdc in each st around, join with sl st to first st, ch 3.

Rep Rnds 2 and 3 until foot measures 4" (5", 6") (10 [12.5, 15] cm) or 3½" (9 cm) less than desired length, ch 1 at end of last rnd.

HEEL

Now work in rows.

Dec row: (RS) Work in patt across instep sts, sc2tog, sc in each of next 20 (22, 24) sc, ch 1, turn, leaving rem sts unworked.

Dec row: Sc2tog, sc in each st across, ch 1, turn.

Rep dec row until 4 sts rem, ending with WS row facing.

With RS facing, sc in each of next 4 sts, turn work 90 degrees and sc 18 (20, 22) sts along one side of the heel turn, work in patt as est across 20 (24, 24) instep sts, sc 18 (20, 22) sts along second side of heel turn, join with sl st to first st, ch 2—60 (68, 72) sts.

Pm in first and last instep sts.

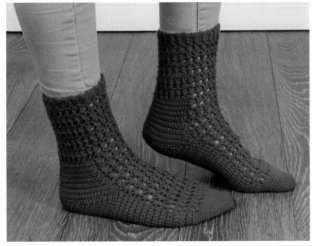

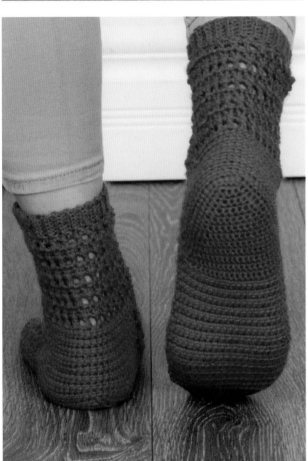

Set-up rnd: Lhdc in each st around to 2 sts before first, sc2tog, lhdc across instep to next, sc2tog, lhdc to end of rnd, join with sl st to first st, ch 2.

Dec rnd: Lhdc in each st around to 2 sts before first dec, hdc3tog (see Techniques), lhdc across instep to next dec, hdc3tog, lhdc to end of rnd, join with sl st to first st, ch 2—4 sts dec'd (56 [64, 68] sts).

Note: The first decrease will be 1 stitch before the previous increase to account for the spiral of crochet rounds. The second decrease will be stacked on top of the decrease in the previous round.

Rep dec rnd until 44 (48, 52) sts rem.

LEG
Now work in rnds.

Work in est lace patt until leg is 5" (12.5 cm) long or desired length.

CUFF
Now work in rows.

Row 1: Ch 8, sc in second ch from hook and each ch across to last st, join last st of cuff and next 1 st of leg with sc2tog, ch 1, turn.

Row 2: Single crochet in the back loop (sc in blo, see Stitch Guide) in each st across, ch 1, turn.

Row 3: Sc in blo in each st across to last st, join last st of cuff and next 1 st of leg with sc2tog, ch 1, turn.

Cont working around leg until all sts have been joined to cuff.

Fasten off. Seam cuff using mattress st (see Techniques). Weave in all ends.

Wash and lay flat to block.

CROSSED LACE WITH JOINS

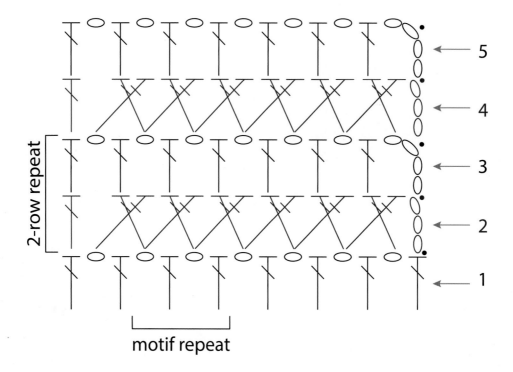

motif repeat

KEY	
•	slip stitch (sl st)
⬭	chain (ch)
⊤	double crochet (dc)

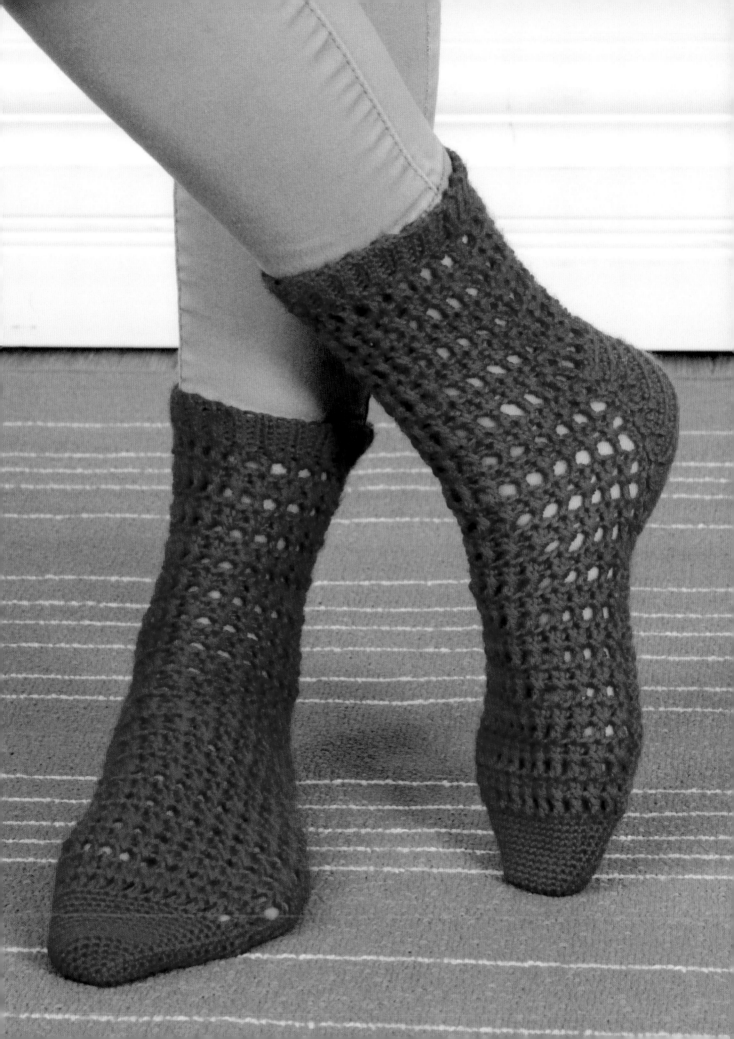

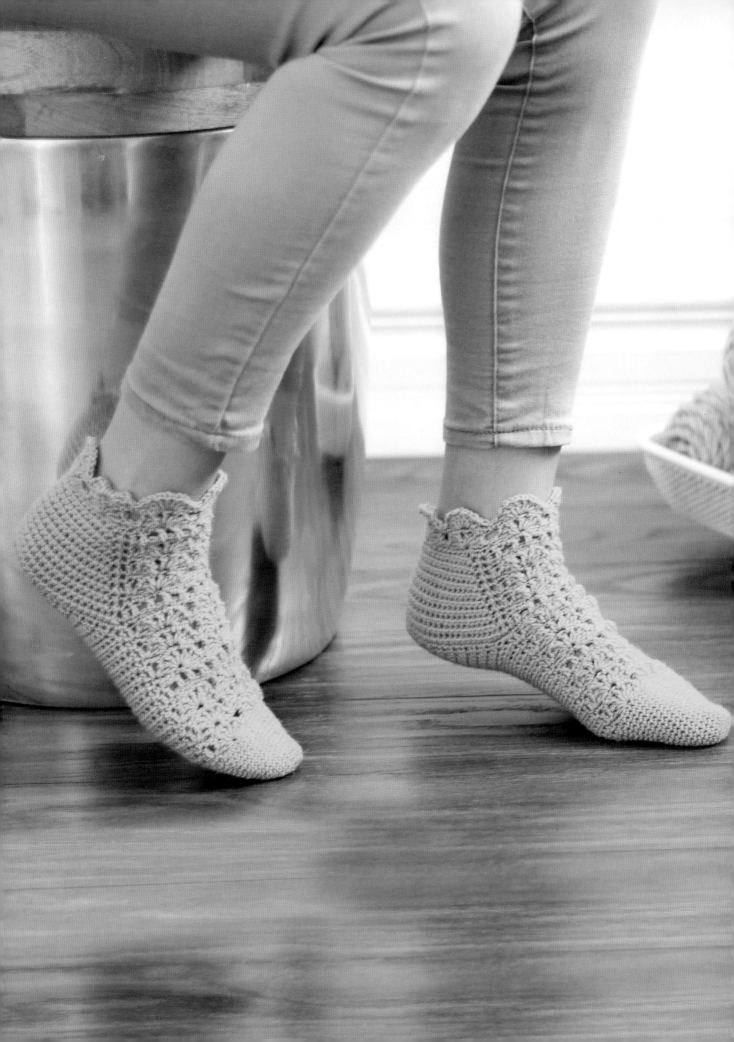

UMSTEAD SOCKS

These socks are funky and just a little loud. I adore crochet lace patterns that give socks a pop of personality. Even though the stitch pattern does make customizing length a bit more difficult, you can add rows at the heel or work the toe a bit longer to adjust the fit. If a wider circumference is needed, work a few extra stitches on the instep or try going up a hook size, which will accommodate a larger foot without having to sacrifice the lace pattern. Instead of a traditional cuff, the lace pattern finishes the socks.

These toe-up socks are worked with a modified square toe and strong heel.

FINISHED SIZE
Foot length: 8" (9", 10") (20.5 [23, 25.5] cm).
Foot circumference: 7" (7½", 8") (18 [19, 20.5] cm).
Leg length: 2" (5 cm).

Sock shown measures 9" (23 cm) long in the foot and 7½" (19 cm) in circumference.

YARN
Sock weight (#1 Super Fine).
Shown here: Spud & Chloe Fine (80% wool/20% silk; 248 yd [227 m]/65 g): #7812 Lizard, 2 (2, 3) skeins.

HOOK
Size U.S. D (3.25 mm).
Adjust hook size if necessary to obtain gauge.

NOTIONS
Split-ring stitch markers (sm), tapestry needle.

GAUGE
24 sts and 24 rows = 4" (10 cm) in linked half double crochet (lhdc) worked in rnds, blocked.

TOE

Chain (ch) 2.

Rnd 1: 6 single crochet (sc) in second ch from hook, join with slip (sl) st to first st, ch 1. Do not turn—6 sts.

Inc rnd: 2 sc in each sc around, join with sl st to first st, ch 1—6 sts inc'd (12 sts).

Inc rnd: *2 sc, sc; rep from * around, join with sl st to first st, ch 1—6 sts inc'd (18 sts).

Inc rnd: *2 sc in first st, sc in next 2 sts; rep from * around, join with sl st to first st, ch 1—6 sts inc'd (24 sts).

Next rnd: Sc around, join with sl st to first st, ch 1.

Inc rnd: *2 sc in first st, sc in each of next 3 sts; rep from * around, join with sl st to first st, ch 1—6 sts inc'd (30 sts).

Next rnd: Sc around, join with sl st to first st, ch 1.

Inc rnd: *2 sc in first st, sc in each of next 4 sts; rep from * around, join with sl st to first st, ch 1—6 sts inc'd (36 sts).

Next rnd: Sc around, join with sl st to first st, ch 1.

Inc rnd: *2 sc in first st, sc in each of next 5 sts; rep from * around, join with sl st to first st, ch 1—6 sts inc'd (42 sts).

Next rnd: Sc around, join with sl st to first st, ch 1.

Cont as est, working 1 extra sc between each inc, until there are 42 (48, 54) sts.

Work even until toe measures 2" (5 cm).

FOOT

Begin following Citrus Lace Chart.

Rnd 1: Ch 3, *skip (sk) next 3 sts, double crochet (dc, see Techniques) (ch 1, dc) 6 times in next st, sk next 3 sts, sc in next st; rep from * 3 times, sc in last sc, linked half double crochet (lhdc see Techniques) in each st around, join with sl st to first st, ch 3.

Rnds 2, 4, and 6: *Sc in second chain-1 space (ch-1 sp) of shell, ch 1, sc in next ch-1 sp, ch 3, sc in next ch-1 sp, ch 1, sc in next ch-1 sp, ch 1; rep from * 3 times, dc in last sc, join with sl st to first st.

Rnds 3 and 5: *Sk next 3 sts, dc, (ch 1, dc) 6 times in next st, sk next 3 sts, sc in next st; rep from * 3 times, sc in last sc, lhdc in each st around, join with sl st to first st, ch 3.

Rnd 7: Sc in each st and ch-sp across, lhdc in each st around, join with a sl st to first st, ch 3.

Rnd 8: *Sk next dc, dc in next dc, ch 1; rep from * across 11 more times, lhdc in each st around, join with sl st to first st, ch 1.

Rnd 9: *Sc in second ch-1 sp of shell, ch 1, sc in next ch-1 sp, ch 3, sc in next ch-1 sp, ch 1, sc in next ch-1 sp, ch 1; rep from * 3 times, dc in last sc, join with sl st to first st.

Rep Rnds 1–9 until sock measures 3½" (9 cm) less than desired length.

HEEL

Now work in rows.

Set-up row: Work Citrus Lace chart across instep sts.

Row 1: (RS) Sc2tog, sc in each st across, ch 1, turn.

Row 2: (WS) Sc2tog, sc in each st across, ch 1, turn.

Rep Row 2 until 4 sts rem, ending on a WS row.

With RS facing, sc in each of next 4 sts, turn work 90 degrees and sc 18 (20, 22) sts along one side of heel turn, work in patt as est across instep, sc 18 (20, 22) sts along other side of the heel turn, join with sl st to first st, ch 2.

Place marker (pm) in first and last instep sts.

Now work in rnds.

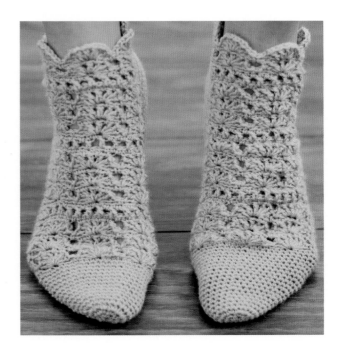

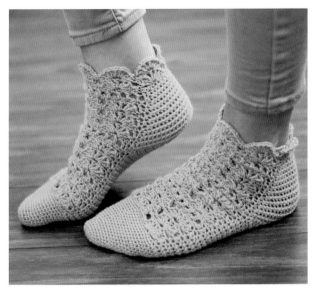

Set-up rnd: Lhdc in each st around to 2 sts before first, sc2tog, work in Citrus Lace patt across instep to next m, sc2tog, lhdc to end of rnd, join with sl st to first st, ch 1.

Dec rnd: Work in Citrus Lace patt across instep in each st around to first dec, sc2tog, lhdc across instep to next dec, sc2tog, lhdc to end of rnd, join with sl st to first st, ch 1.

Note: The first decrease will be 1 stitch before the previous increase to account for the spiral of crochet rounds. The second decrease will be stacked on top of the decrease in the previous round.

Rep dec rnd until 44 (48, 52) sts rem.

Cont working leg until it is 2" (5cm) or desired length minus length of lace cuff.

Instead of working a ribbed cuff, cont working sock in lace patt as est across instep and across heel.

Fasten off. Weave in all ends.

Wash and lay flat to block.

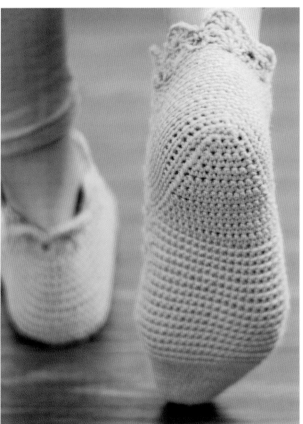

CITRUS LACE

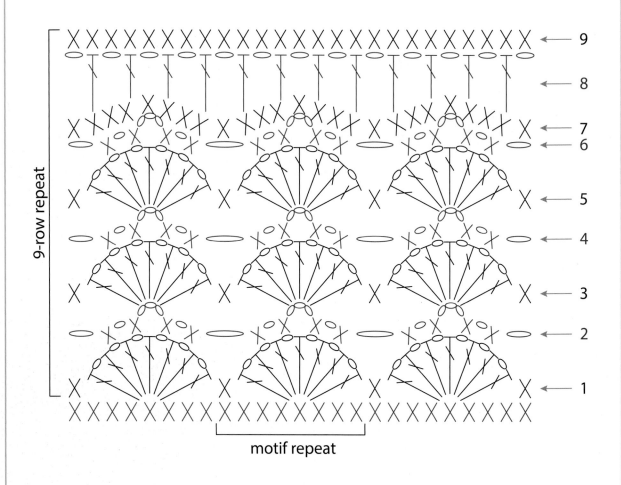

9-row repeat

motif repeat

← 9
← 8
← 7
← 6
← 5
← 4
← 3
← 2
← 1

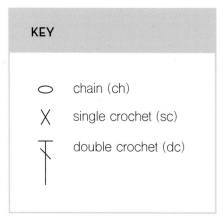

KEY

◯ chain (ch)

✕ single crochet (sc)

⊤ double crochet (dc)

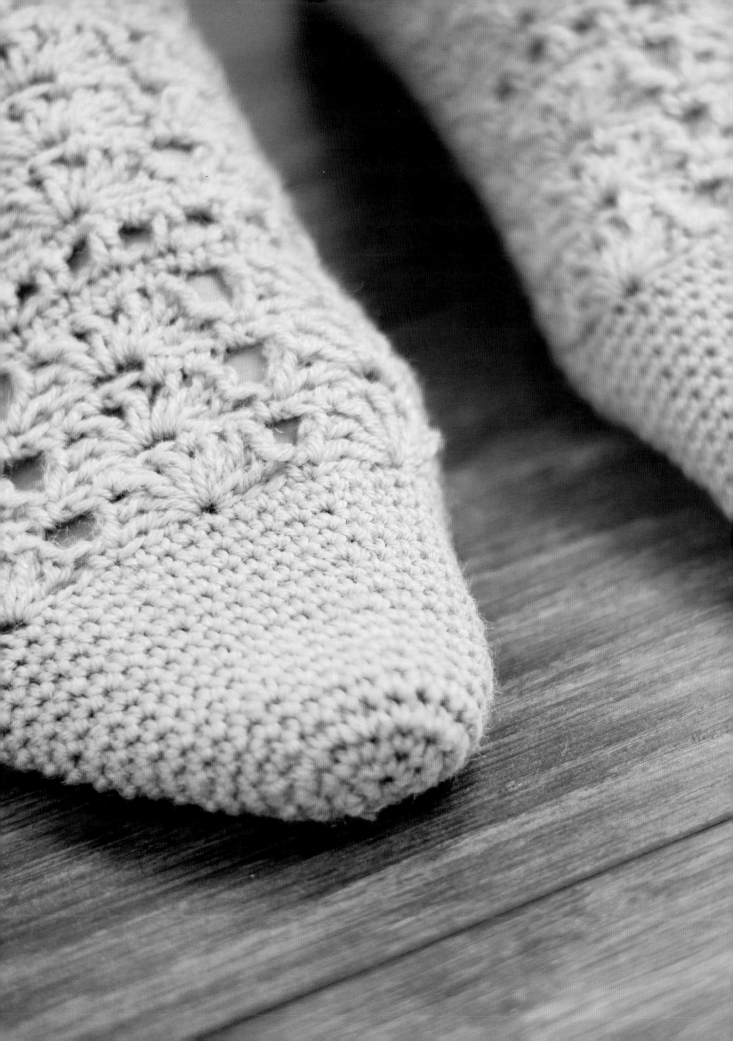

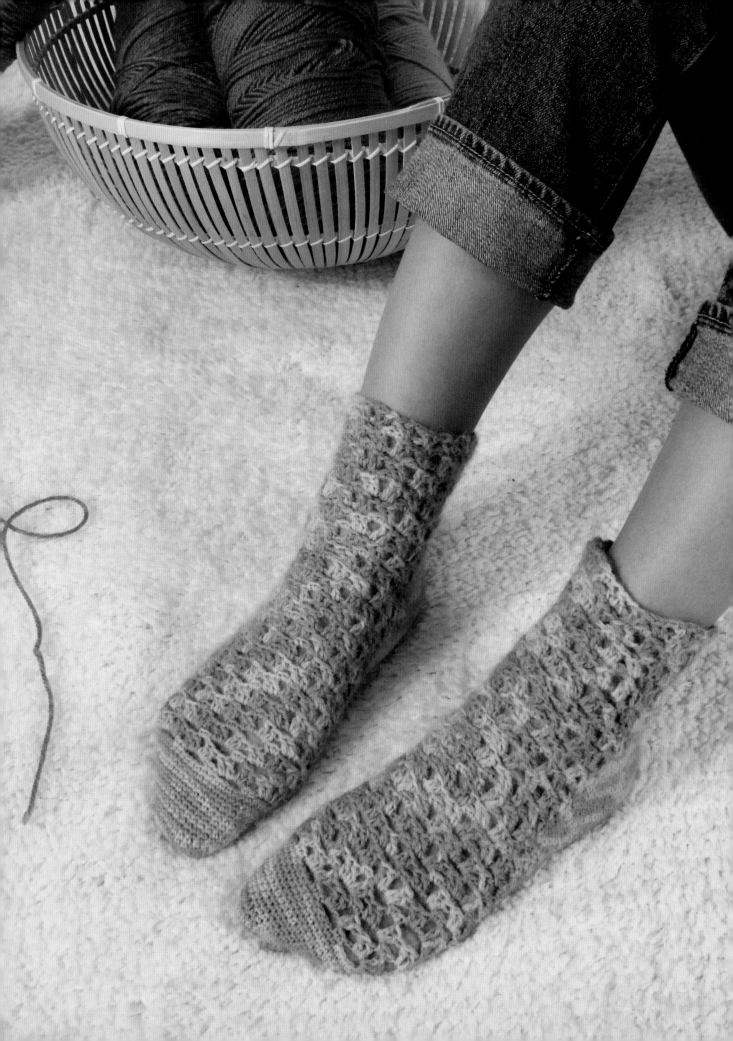

CENTENNIAL SOCKS

Crochet lace is one of my favorite techniques, but it can sometimes be difficult to work in socks because of crochet's lack of stretch. To make up for it, these socks feature a simple lace pattern with the extra stretch of the extended single crochet (exsc). A strong heel adds a bit more room in the heel, and a short leg makes the sock perfect for women with all calf sizes.

These toe-up socks are worked with a modified square toe and strong heel.

FINISHED SIZE
Foot length: 8" (9", 10") (20.5 [23, 25.5] cm).
Foot circumference: 7" (8", 9") (18 [20.5, 23] cm).
Leg length: 7" (17.5cm)

Sock shown measures 9" (23 cm) long in the foot and 8" (20.5 cm) in circumference.

YARN
Sock weight (#1 Super Fine).
Shown here: Classic Elite Yarns Alpaca Sox
(60% alpaca/20% merino wool/20% nylon;
450 yd [412 m]/100 g): #1846 Aquamarine,
1 (1, 2) skein(s).

HOOK
Size U.S. C (2.75 mm).
Adjust hook size if necessary to obtain gauge.

NOTIONS
Split-ring stitch markers (sm), tapestry needle.

GAUGE
24 sts and 21 rows = 4" (10 cm) in extended single crochet (exsc) worked in rnds, blocked.

TOE

Chain (ch) 9.

Inc rnd: Single crochet (sc) in second ch from hook and in each ch across, working in opposite side of beg ch, sc in each ch across, join with slip (sl) st to first st, being careful not to twist, ch 1—7 sts inc'd (16 sts).

Inc rnd: *Sc in first st, 2 sc in next st, sc in each of next 5 sts, 2 sc in next st; rep from * once more, join with sl st to first st, ch 1—4 sts inc'd (20 sts).

Inc rnd: *Sc in first st, 2 sc in next st, sc in each of next 7 sts, 2 sc in next st; rep from * once more, join with sl st to first st, ch 1—4 sts inc'd (24 sts).

Next rnd: Sc around, join with sl st to first st, ch 1.

Inc rnd: *Sc in first st, 2 sc in next st, sc in each of next 9 sts, 2 sc in next st; rep from * once more, ch 1—4 sts inc'd (28 sts).

Next rnd: Sc around, join with sl st to first st, ch 1.

Inc rnd: *Sc in first st, 2 sc in next st, sc in each of next 11 sts, 2 sc in next st; rep from * once more, ch 1—4 sts inc'd (32 sts).

Next rnd: Sc around, join with sl st to first st, ch 1.

Cont in patt as est, inc'ing 4 sts every other rnd, until there are 44 (48, 52) sts.

FOOT

Place marker (pm) in 19 (25, 25)th st. Begin working Shell Lace with Joins chart.

Rnd 1: Sc in each of first 2 sts, ch 4, skip (sk) 4 sts, sc in each of next 2 sts; rep from * across to, extended single crochet (exsc, see Techniques) in each st around, join with sl st to first st, ch 3.

Rnd 2: (2 double crochet (dc, see Techniques), ch 2, 2 dc) in each chain-4 space (ch-4 sp) across to 1 st before m, dc in marked st, exsc in each st around, join with sl st to first st, ch 5.

Rnd 3: *2 sc in ch-2 sp, ch 4; rep from * across ending last rep with ch 2, dc in dc, exsc in each st around, join with sl st to first st, ch 4.

Rnd 4: 2 dc in first ch-2 sp, (2 dc, ch 2, 2 dc) in each ch-4 sp across to last ch-2 sp, 2 dc in last ch-2 sp, ch 1, dc in dc, exsc in each st around, join with sl st to first st, ch 1.

Rnd 5: Sc in each of first 2 sts, ch 4, sk 4 sts, sc in each of next 2 sts; rep from * across to m, exsc in each st around, join with sl st to first st, ch 3.

Rep Rnds 2–5 as est until foot measures 4" (5", 6") (10 [12.5. 15] cm) or 3½" (9 cm) less than desired length.

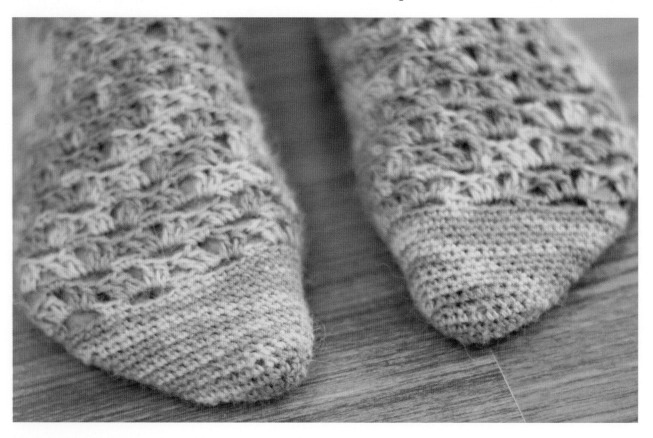

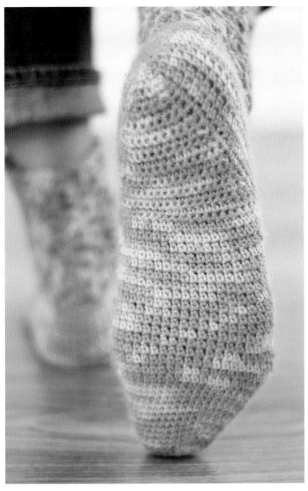

HEEL

Now work in rows.

Row 1: (RS) Sc2tog, sc in each of next 20 (22, 24) sc, ch 1, turn, leaving rem sts unworked.

Row 2: (WS) Sc2tog, sc in each st across, ch 1, turn.

Rep Row 2 until 4 sts rem, ending on WS row.

With RS facing, sc in each of next 4 sts, turn work 90 degrees and sc 18 (20, 22) sts along one side of heel turn, work in patt as est across instep, sc 18 (20, 22) sts along other side of heel turn, join with sl st to first st, ch 1.

Pm in first and last instep stitches.

Now work in rnds, following the Shell Lace with Joins chart.

Set-up rnd: Exsc in each st around to 2 sts before first, sc2tog, exsc across instep to next m sc2tog, exsc to end of rnd, join with a sl st to first st, ch 1.

Dec rnd: Exsc in each st around to 1 st before first dec, sc2tog, exsc across instep to next dec, sc2tog, exsc to end of rnd, join with sl st to first st, ch 1.

Note: The first decrease will be 1 st before the previous increase to account for the spiral of crochet rounds. The second decrease will be stacked on top of the decrease in the previous round.

Rep dec rnd until 42 (48, 54) sts rem.

LEG

Rnd 1: Ch 1, sc in each of first 2 sts, ch 4, sk 4 sts, sc in each of next 2 sts; rep from * around, join with sl st to first st, ch 3.

Rnd 2: [2 dc, ch 2, 2 dc] in each ch–4 sp around to last st, dc in last st, join with sl st to first st, ch 5.

Rnd 3: *2 sc in ch–2 sp, ch 4; rep from * around ending last rep with ch 2, dc in dc, join with sl st to first st, ch 4.

Rnd 4: 2 dc in first ch–2 sp, [2 dc, ch 2, 2 dc] in each ch–4 sp across to last ch–2 sp, 2 dc in last ch–2 sp, ch 1, dc in dc, join with sl st to first st, ch 1.

Rnd 5: *Sc in each of first 2 sts, ch 4, sk 4 sts, sc in each of next 2 sts; rep from * around, join with sl st to first st, ch 3.

Rep Rnds 2–5 until leg is desired length. End after working a Rnd 5 rnd.

Fasten off. Weave in ends.

Wash and lay flat to block.

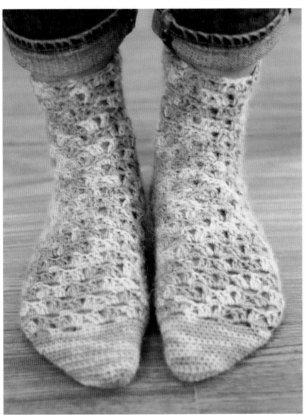

SHELL LACE WITH JOINS

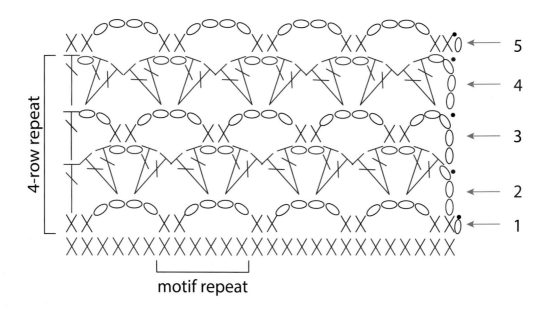

KEY

•	slip stitch (sl st)
⬭	chain (ch)
✗	single crochet (sc)
🕇	double crochet (dc)

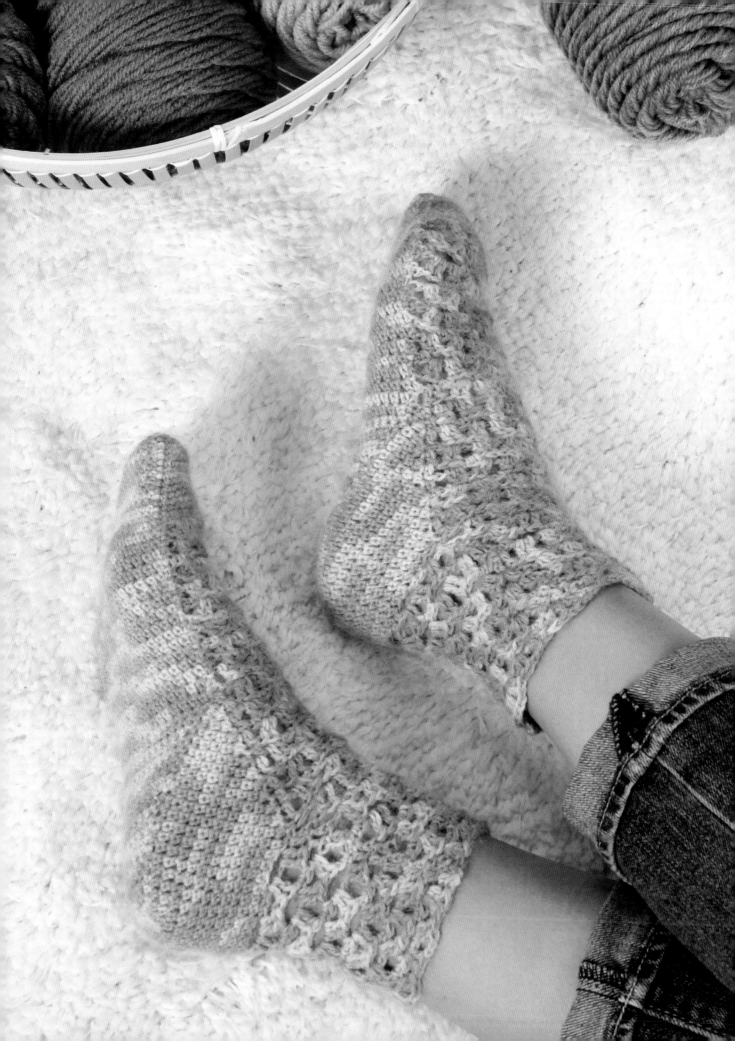

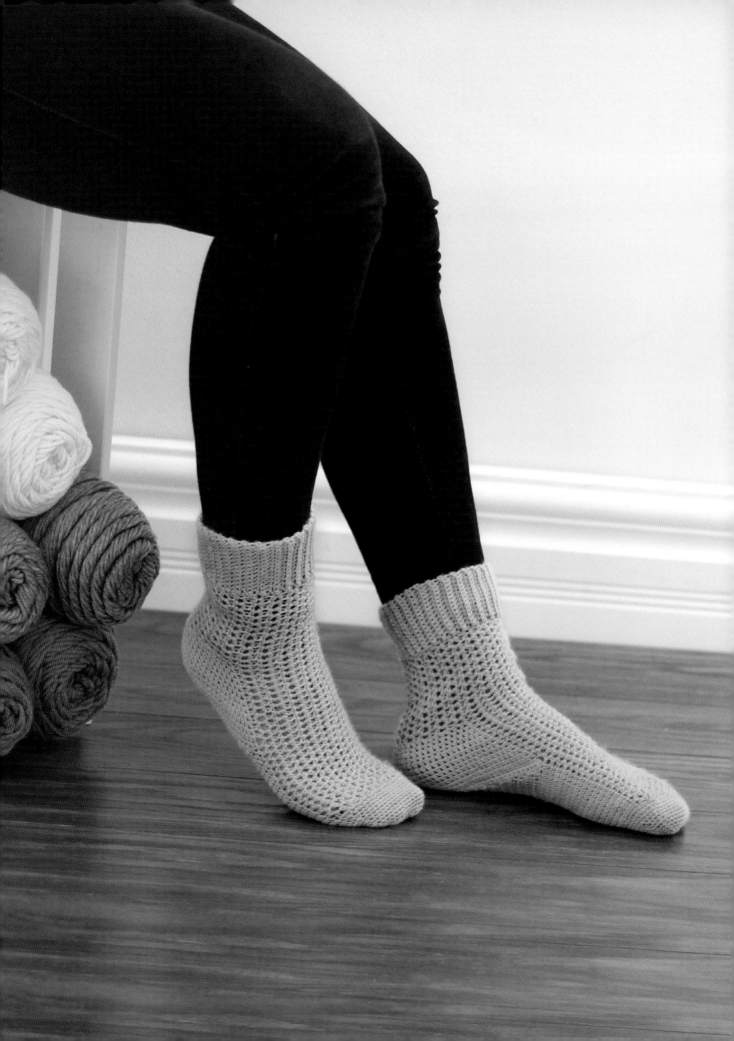

YATES MILL SOCKS

Simple, stretchy, and stunning lace is the main feature of these socks. The lace isn't obtrusive or overbearing—it is just as perfect as can be. A simple ribbed cuff and strong heel make these socks unbelievably comfortable. The allover extended single crochet (exsc) really makes these socks fit like a dream.

These cuff-down socks are worked with a strong heel and wedge toe.

FINISHED SIZE

Foot length: 7½" (8½", 9½") (19 [21.5, 24] cm).
Foot circumference: 7" (7½", 8½") (18 [19, 21.5] cm).
Leg length: 5" (12.5 cm).

Sock shown measures 8½" (21.5 cm) long in the foot and 7½" (19 cm) in circumference.

YARN

Sock weight (#1 Super Fine).
Shown here: YOTH Yarns Little Brother
(80% merino wool/10% cashmere/10% nylon;
435 yd [398 m]/100 g): Oyster, 1 (2, 2) skein(s).

HOOK

Size U.S. C (2.75 mm).
Adjust hook size if necessary to obtain gauge.

NOTIONS

Split-ring stitch markers (sm), tapestry needle.

GAUGE

28 sts and 24 rows = 4" (10 cm) in extended single crochet (exsc) worked in rnds, blocked.

STITCH GUIDE

SINGLE CROCHET IN THE BACK LOOP (SC IN BLO)
Working in only the back loop, pull up a loop in the next stitch, yarn over (yo), pull through 2 loops on hook.

CUFF

Row 1: (RS) Chain (ch) 19, single crochet (sc) in second ch from hook and each ch across to last st, ch 1, turn—18 sts.

Inc row: Single crochet in the back loop (sc in blo, see Stitch Guide) in each st across, ch 1, turn.

Rep inc row until there are 48 (52, 60) rows.

Join cuff using mattress st (see Techniques).

Now work in rnds.

Rnd 1: Sc 50 (53, 62) sts evenly around one edge of cuff, join with slip (sl) st to first st, ch 1.

LEG

Follow the Simple Lace with Joins chart.

Rnd 1: Sc in first st, skip (sk) next st, *[half double crochet (hdc, see Techniques), ch 2, hdc], sk 2 sts; rep from * across, join with a sl st to first st, ch 1—16 (17, 20) st motifs.

Rnd 2: Sc in first st, sk next st, *[hdc, ch 2, hdc] in next chain-2 space (ch-2 sp); rep from * across, join with sl st to first st, ch 1.

Rep Rnd 2 until leg is 5" (12.5 cm) or desired length.

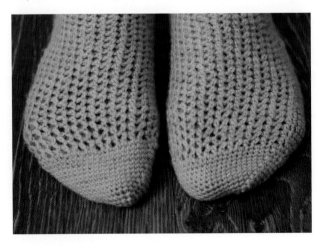

HEEL

Rnd 1: Work extended single crochet (exsc, see Techniques) in each hdc and in each ch-sp across first 8 (9, 10) motifs, work in est patt across rem sts, join with sl st to first st, ch 1—24 (27, 30) exsc; 8 (8, 10) motifs.

Inc rnd: 2 exsc in next st, exsc in each rem st around to last exsc, 2 exsc in last st, work patt as est across rem sts, join with sl st to first st, ch 1—2 sts inc'd (26 [29, 32] heel sts).

Rep inc rnd until there are 44 (49, 52) heel stitches.

HEEL TURN

Now work in rows.

Row 1: (WS) Sc in each of first 22 (25, 26) sts, sc2tog, sc in next st, turn, ch 1.

Row 2: (RS) Sc in each of first 4 sts, sc2tog, sc in next st, turn, ch 1.

Row 3: (WS) Sc in each of first 5 sts, sc2tog, sc in next st, turn, ch 1.

Row 4: (RS) Sc in each of next 6 sts, sc2tog, sc in next st, turn, ch 1.

Cont as est, working 1 additional st each row, until all sts are worked—48 (51, 60) sts.

FOOT

Rnd 1: Exsc across bottom of foot, work lace patt as est across instep, join with sl st to first st, ch 1.

Rep Rnd 1 until foot is desired length minus 2" (5 cm) from back of heel.

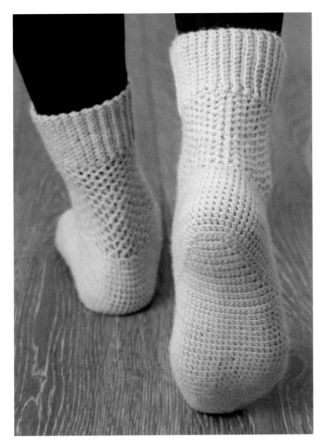

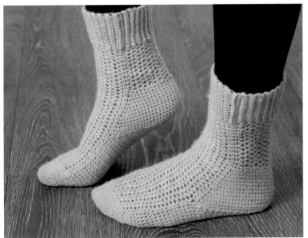

TOE

Dec rnd: [Sc in first st, sc2tog, sc 19 (21, 25) evenly across half of foot sts, sc2tog] twice, join with sl st to first st, ch 1—4 sts dec'd (44 [48, 56] sts).

Next rnd: Sc in each st around, join with sl st to first st, ch 1.

Dec rnd: [Sc in first st, sc2tog, sc in each of next 17 (19, 23) sts, sc2tog] twice, join with sl st to first st, ch 1—4 sts dec'd (40 [44, 52] sts).

Next rnd: Sc in each st around, join with sl st to first st, ch 1.

Dec rnd: [Sc in first st, sc2tog, sc in each of next 15 (17, 21) sts, sc2tog] twice, join with sl st to first st, ch 1—4 sts dec'd (36 [40, 48] sts).

Next rnd: Sc in each st around, join with sl st to first st, ch 1.

Dec rnd: [Sc in first st, sc2tog, sc in each of next 13 (15, 19) sts, sc2tog] twice, join with sl st to first st, ch 1—4 sts dec'd (32 [36, 44] sts).

Next rnd: Sc in each st around, join with sl st to first st, ch 1.

Cont in patt as est, dec'ing 4 sts every other rnd until 24 sts rem. Then dec in same manner every rnd until 16 sts rem.

Fasten off. Seam toe (see Techniques). Weave in all ends.

Wash and lay flat to block.

SIMPLE LACE WITH JOINS

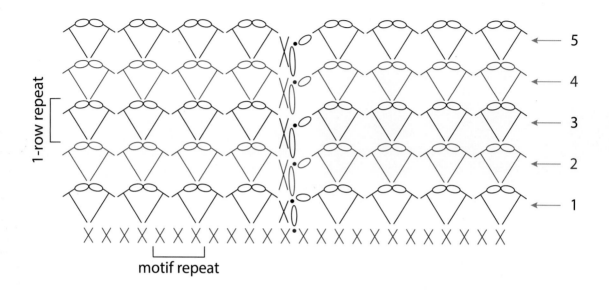

KEY

•	slip stitch (sl st)
◯	chain (ch)
✕	single crochet (sc)
T	half double crochet (dc)

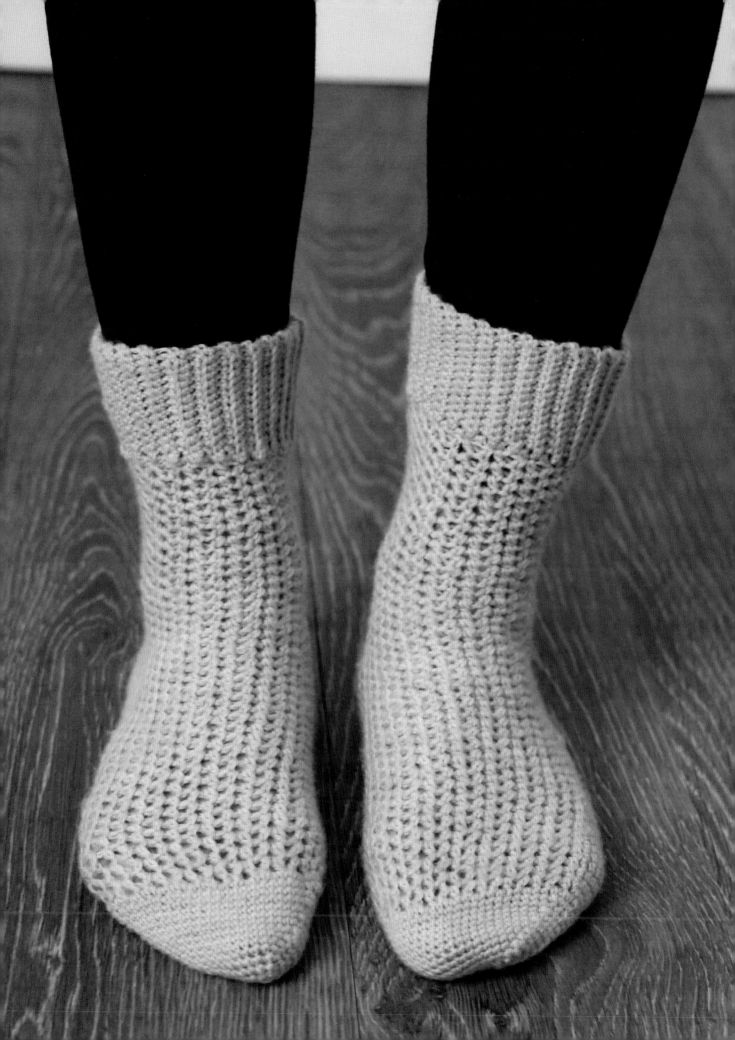

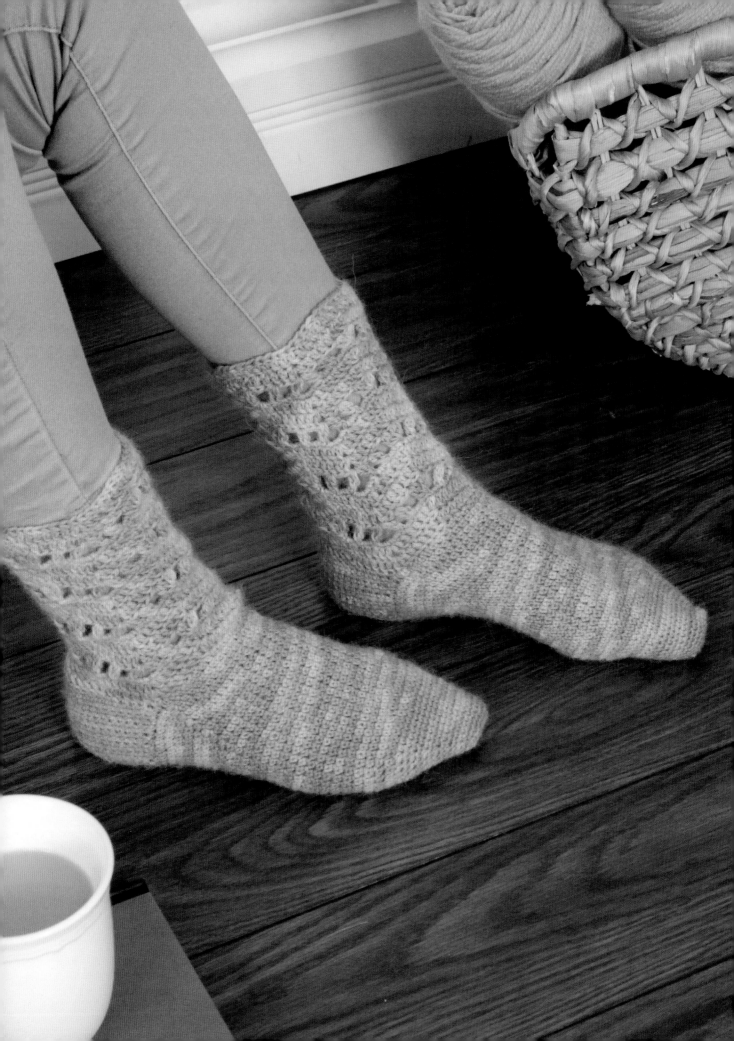

LITTLE ROSE GARDEN SOCKS

You'll notice the numbers for the leg and the foot of the sock vary a bit because of the large stitch repeat on the leg. If you have issues fitting the leg of the sock (or it won't stay up when you try it on), simply work a small ribbing before the first row of the chevron lace pattern. Even though only two sizes are offered, don't be deterred! Use the skills you've learned to adjust and customize these socks to fit your feet if necessary.

These cuff-down socks are worked with a round heel, all over extended single crochet (exsc), and wedge toe.

FINISHED SIZE
Foot length: 8½" (9½") (21.5, 24 cm)
Foot circumference: 7½" (8½")
(19, 21.5 cm)
Leg length: 7" (17.5 cm)

Sock shown measures 9½" (24 cm) long in the foot and 7½" (19 cm) in circumference.

YARN
Sock weight (#1 Super Fine).
Shown here: Classic Elite Yarns, Alpaca Sox (60% alpaca/20% merino wool/20% nylon; 450 yds [411.5 m]/100 g): Tea Rose 1822, 1 (1, 2) skeins.)

HOOK
Size U.S. C (2.75 mm).
Adjust hook size if necessary to obtain gauge.

NOTIONS
Split-ring stitch markers (sm), tapestry needle.

GAUGE
28 sts and 21 rows = 4" (10 cm) in extended single crochet (exsc) worked in rnds, blocked.

LEG

Work a foundation of 56 foundation double crochet (fdc, see Stitch Guide), join to work in the rnd, chain (ch) 4 (counts as first double crochet [dc, see Techniques] and chain space [ch-sp]).

Follow the Chevron Lace with Joins chart.

Rnd 1: Dc in same st as join, *dc in each of next 5 sts, dc2tog, dc in each of next 5 sts, (dc, ch 1, dc) in next st; rep from * around, join with slip (sl) st to first st, sl st in first ch sp, ch 4. 56 dc, 4 ch–1 sps.

Rnd 2: Rep Rnd 1.

Rnd 3: Double crochet cluster (dc cluster, see Stitch Guide) in same st as join, *ch 2, skip (sk) 2 sts, dc cluster in next st, ch 2, sk next st, dc cluster in next st tog with dc cluster in second st from last dc cluster made, ch 2, sk next 2 sts, dc cluster in next st, ch 2 sts, ch 2, (dc cluster**, ch 3, dc cluster) in next ch sp, rep from * around, ending final rep at **, ch 1, sl st in third ch of beg ch-4, ch 1—24 dc clusters.

Rnd 4: Sc in same st as join, 2 sc in next ch–1 sp, *2 sc in each of next ch-2 sps**, 5 sc in next ch–3 sp, 2 sc in each of next 2 ch-sps, sc in next st; rep from * around, ending final rep at **, 2 sc in next ch–1 sp, sl st in first st to join. (56, 56) sc.

Rep Rnds 1–4 until leg measures 7" (18 cm) or desired length.

HEEL FLAP

Beg working in rows.

Row 1: (RS) Linked half double crochet (lhdc, see Techniques) in each of first 26 (30) sts, ch 2, turn.

Row 2: (WS) Lhdc in each st across, ch 2, turn.

Rep Row 2 eight more times, replacing ch 2 with ch 1 at end of last rnd.

HEEL TURN

Note: Work the heel band on 10 sts.

Row 1: (RS) Sc in each of first 17 (18) sts, sc2tog, ch 1, turn.

Row 2: (WS) Sc in each of first 9 sts, sc2tog, ch 1, turn.

Rep Row 2 until all sts have been worked—10 sts rem at end of heel turn.

GUSSET

Now work in rnds.

Rnd 1: Sc across heel turn, sc 13 (14) sts along one side of heel flap, sc across instep, sc 13 (14) sts along other side of heel flap, join with sl st to first st, ch 2—66 (64 sts).

Dec rnd: Work extended single crochet (exsc, see Techniques) in each st across to 2 sts before instep, sc2tog, *exsc across instep to last instep st, exsc in last st, sc2tog, exsc in each rem st around, join with a sl st to first st, ch 2—2 sts dec'd (64 [62] sts).

Rep Rnd 2 until 52 (60) sts rem.

FOOT

Next rnd: Exsc in each st around, ch 1.

Rep last rnd until foot measures 6.5 (7.5)" (16.5 [19] cm) or 2" (5 cm) less than desired length from back of heel.

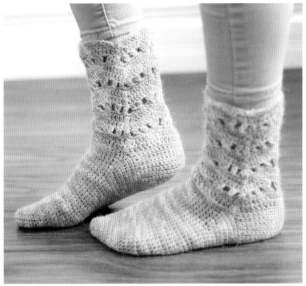

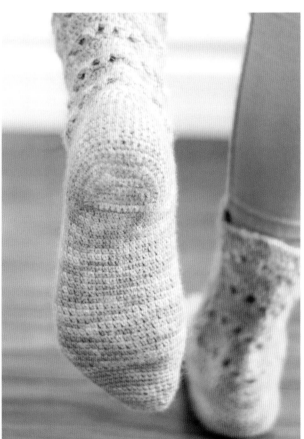

TOE

Dec rnd: [Sc in first st, sc2tog, sc in each of next 22 (26) sts, sc2tog] twice, join with sl st to first st, ch 1—4 sts dec'd (48, 56 sts).

Next rnd: Sc in each st around, join with sl st to first st, ch 1.

Dec rnd: [Sc in first st, sc2tog, sc in each of next 20 (24) sts, sc2tog] twice, join with sl st to first st, ch 1—4 sts dec'd (44, 52 sts).

Next rnd: Sc in each st around, join with sl st to first st, ch 1.

Dec rnd: [Sc in first st, sc2tog, sc in each of next 18 (22) sts, sc2tog] twice, join with sl st to first st, ch 1—4 sts dec'd (40, 48 sts).

Next rnd: Sc in each st around, join with sl st to first st, ch 1.

Dec rnd: [Sc in first st, sc2tog, sc in each of next 16 (20) sts, sc2tog] twice, join with sl st to first st, ch 1—4 sts dec'd (36, 44 sts).

Cont in patt as est, dec'ing 4 sts every other rnd until 24 sts rem. Then dec same manner every rnd until 16 sts rem.

Seam toe in mattress stitch (see Techniques). Weave in all ends.

Wash and lay flat to block.

CHEVRON LACE WITH JOINS

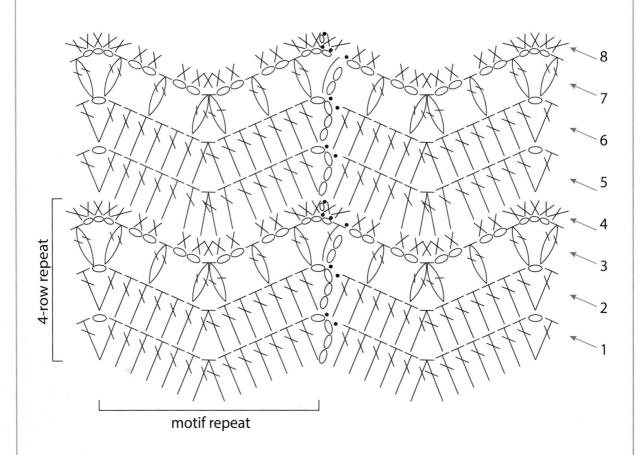

4-row repeat

motif repeat

KEY	
•	slip stitch (sl st)
⬭	chain (ch)
X	single crochet (sc)
†	double crochet (dc)
	dc cluster
	double crochet 2 together (dc2tog)

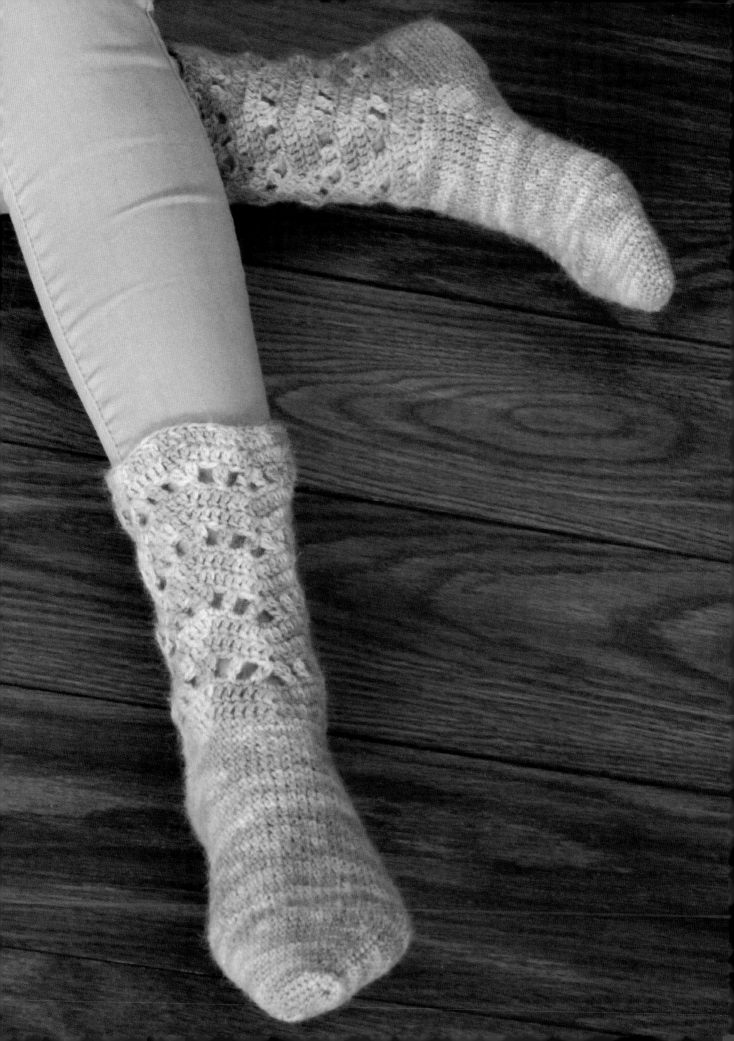

ABBREVIATIONS

beg	begin; beginning
bpdc	back post double crochet
cm	centimeter
ch-sp	chain space (X ch-sp(s): X number of chain spaces)
cont	continue; continued
dc	double crochet
dc2tog	double crochet 2 stitches together
dec	decrease
dec'ing	decreasing
est	established
exsc	extended single crochet
g	gram
inc	increase
inc'ing	increasing
lhdc	linked half double crochet
lhdc2tog	linked half double crochet 2 stitches together
m	marker
patt	pattern
pm	place marker
prev	previous
rem	remain; remains; remaining
rep	repeat
rnd	round
RS	right side
sc	single crochet
sc2tog	single crochet 2 stitches together
sc in blo	single crochet through back loop only
s-dc	single-double crochet
sh	shell
sk	skip

sl st	slip stitch
st	stitch
tch	turning chain
tog	together
WS	wrong side
yd	yard
yo	yarn over
*	repeat instructions following asterisk as directed
**	repeat all instructions between asterisks as directed
()	alternate measurements and/or instructions
[]	work bracketed instructions specified number of times

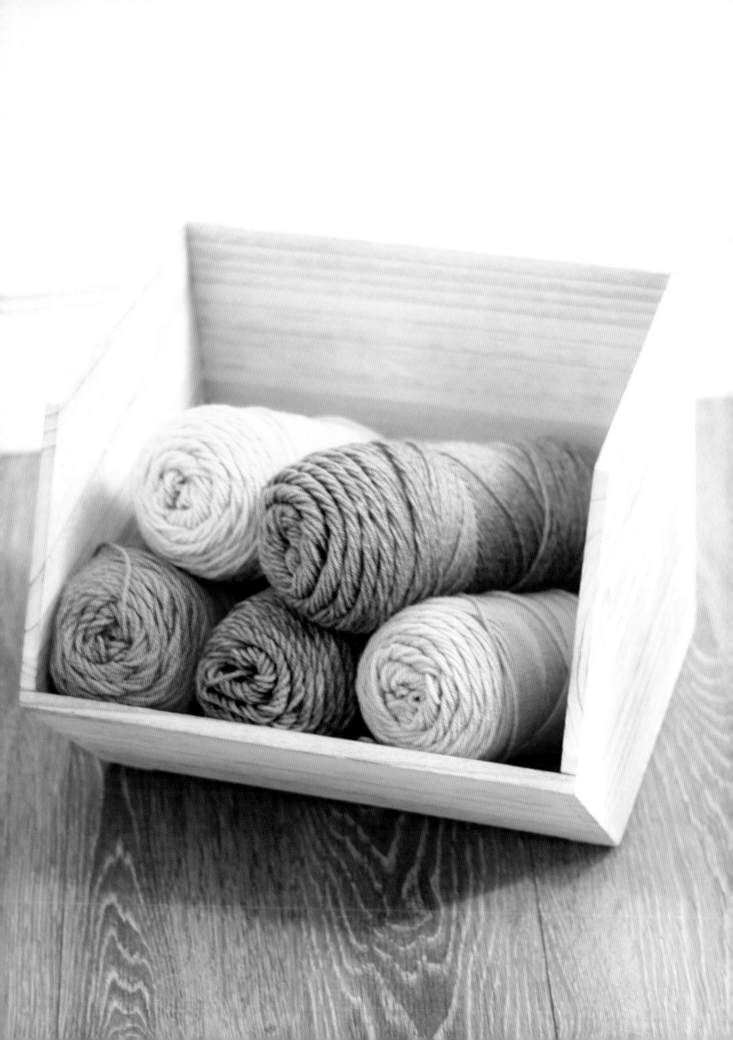

TECHNIQUES

CROCHET CHAIN (CH)

Make a slipknot and place it on crochet hook. *Yarn over hook and draw through loop on hook. Repeat from * for desired number of sts.

SINGLE CROCHET (SC)

Insert hook into st, yarn over (yo) hook and draw up a loop, yo hook and draw it through both loops on hook.

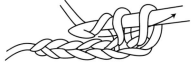

SLIP STITCH (SL ST)

*Insert hook into st, yarn over (yo) hook and draw loop through st and loop on hook. Repeat from *.

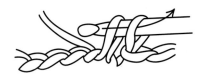

SINGLE CROCHET 2 TOGETHER (SC2TOG)

[Insert hook into next st, yarn over (yo) hook and draw up a loop (Figure 1)] 2 times, yo hook, draw through all loops on hook (Figure 2)—1 st dec'd (Figure 3).

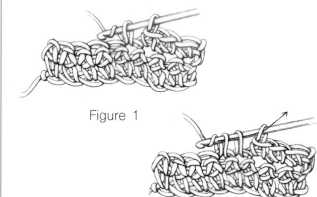

Figure 1

Figure 2

Figure 3

DOUBLE CROCHET (DC)

*Yarn over (yo) hook, insert hook into st, yo over hook and draw up a loop (Figure 1), yo hook and draw through 2 loops (Figure 2), yo hook and draw through remaining 2 loops on hook (Figure 3). Repeat from *.

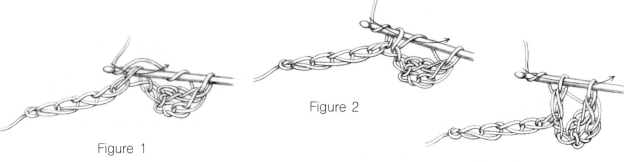

Figure 1

Figure 2

Figure 3

DOUBLE CROCHET 2 TOGETHER (DC2TOG)

[Yarn over (yo), insert hook in next st, yo and pull up loop (Figure 1), yo, draw through 2 loops] 2 times (Figure 2), yo, draw through all loops on hook (Figure 3)—1 st decreased (Figure 4).

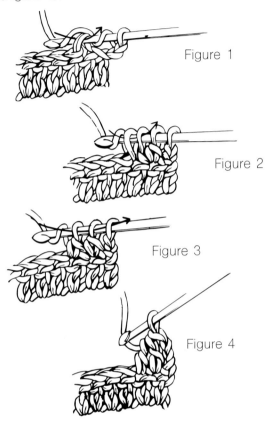

Figure 1

Figure 2

Figure 3

Figure 4

HALF DOUBLE CROCHET (HDC)

*Yarn over (yo) hook, insert hook into st, yo hook and draw up a loop, yo hook and draw it through all 3 loops on hook (Figures 1 and 2). Repeat from *.

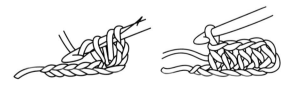

Figure 1 Figure 2

HALF DOUBLE CROCHET 2 TOGETHER (HDC2TOG)

[Yarn over (yo) hook, insert hook into next st, yo hook and draw up a loop] 2 times (Figures 1 and 2), yo hook and draw yarn through all loops on hook (Figure 3)—1 st dec'd.

Figure 1

Figure 2

Figure 3

HALF DOUBLE CROCHET 3 TOGETHER (HDC3TOG)

[Yarn over (yo), insert hook in next st, yo and pull up loop] 3 times, yo and draw through all loops on hook—2 sts dec'd.

LINKED HALF DOUBLE CROCHET (LHDC)

Insert hook in second chain (ch) from hook, yarn over (yo), draw loop through (Figure 1), insert hook in next ch or stitch (st), yo, draw a loop through (Figure 2), yo, draw through all 3 loops on hook, insert hook into single vertical thread at left hand side of previous st, yo, draw loop through (Figure 4), insert hook into next ch or st, yo, draw loop through (Figure 5), yo, draw through all 3 loops on hook (Figure 6).

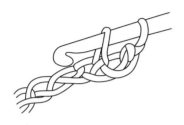

Figure 1

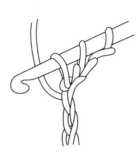

Figure 2

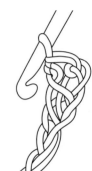

Figure 3

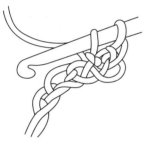

Figure 4

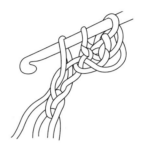

Figure 5

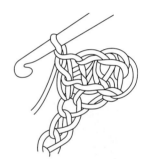

Figure 6

FRONT POST DOUBLE CROCHET (FPDC)

Yarn over (yo), insert hook from front to back to front, yo, pull up a loop, yo, draw through 2 loops on hook, yo, draw through last 2 loops on hook.

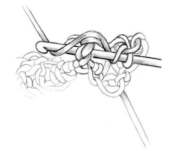

BACK POST DOUBLE CROCHET (BPDC)

Yarn over (yo), insert hook from back to front to back, yo, pull up a loop, yo, draw through 2 loops on hook, yo, draw through last 2 loops on hook.

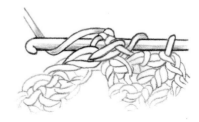

EXTENDED SINGLE CROCHET (EXSC)

Pull up a loop in next st, yarn over (yo), pull through 1 loop on hook, yo, pull through final 2 loops on hook.

X-NUMBER OF TIMES DOU-BLE CROCHET CLUSTER (XDC-CL)

[Yarn over (yo) hook, insert hook into st, yo hook, draw up loop, yo hook, draw through 2 loops on hook] x-number of times, yo hook, draw through remaining loops on hook.

MATTRESS STITCH

With right side facing, use threaded needle to *bring the needle through the center of the first st or post on one piece, then through the center of the corresponding st or post of the other piece (Figures 1 and 2). Repeat from *.

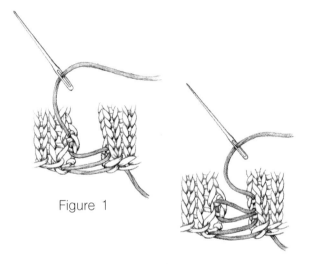

Figure 1

Figure 2

SEAM TOE

With right side of sock facing, fold the toe so that the top and bottom sts are aligned and seam will lie horizontal on the foot. Using mattress st, seam the toe closed. Alternatively, the toe can be sc'd together, through both thicknesses of fabric, to close; however, this will make a more noticeable seam.

RESOURCES

BOOKS AND MEDIA

Atherley, Kate. *Custom Socks*. Loveland, Colorado: Interweave, 2015.
I learned to appreciate the science of socks from Kate Atherley. Without her, this book, quite literally, would not have been written.

Budd, Ann. *Sock Knitting Master Class*. Loveland, Colorado: Interweave, 2011.
The queen of sock knitting, Ann Budd, is a wealth of knowledge. This book introduces several construction methods for heels, toes, and combinations of such that can be translated and applied to crochet.

Merrow, Anne. *Sockupied: 10 Knit Projects to Satisfy Your Sock Obsession*. Loveland, Colorado: Interweave, 2014.
Sockupied is a tremendous resource for sock knitters, and this collection of patterns is incredibly packed with useful information from some of the best designers we've ever seen.

Schurch, Charlene, and Beth Parrott. *The Sock Knitter's Handbook*. Bothell, Washington: Martingale, 2012.
A handbook for every sock enthusiast. It's written for knitters, but the information can be applied to both knit and crochet socks.

YARN SOURCES

BLUE SKY FIBERS
Attn: Spud & Chloe
PO Box 88
Cedar, MN 55011
spudandchloe.com

CASCADE YARNS
cascadeyarns.com

CLASSIC ELITE YARNS
16 Esquire Road. Unit 2
North Billerica, MA 01862
classiceliteyarns.com

LION BRAND YARNS
135 Kero Rd.
Carlstadt, NJ 07072
lionbrand.com

LOUET NORTH AMERICA
3425 Hands Rd.
Prescott, ON
Canada K0E 1TO
louet.com

MADE IN AMERICA YARNS
3114 E. Thompson St.
Philadelphia, PA 19134
madeinamericayarns.com

MISS BABS HAND-DYED YARNS AND FIBERS
P.O. Box 78
Mountain City, TN 37683
missbabs.com

SWEETGEORGIA YARNS
110–408 E. Kent Ave. S
Vancouver, BC
Canada V5X 2X7
sweetgeorgiayarns.com

WESTMINSTER FIBERS/ REGIA/ROWAN
165 Ledge St.
Nashua, NH 03060
westminsterfibers.com

YOTH YARNS
yothyarns.com

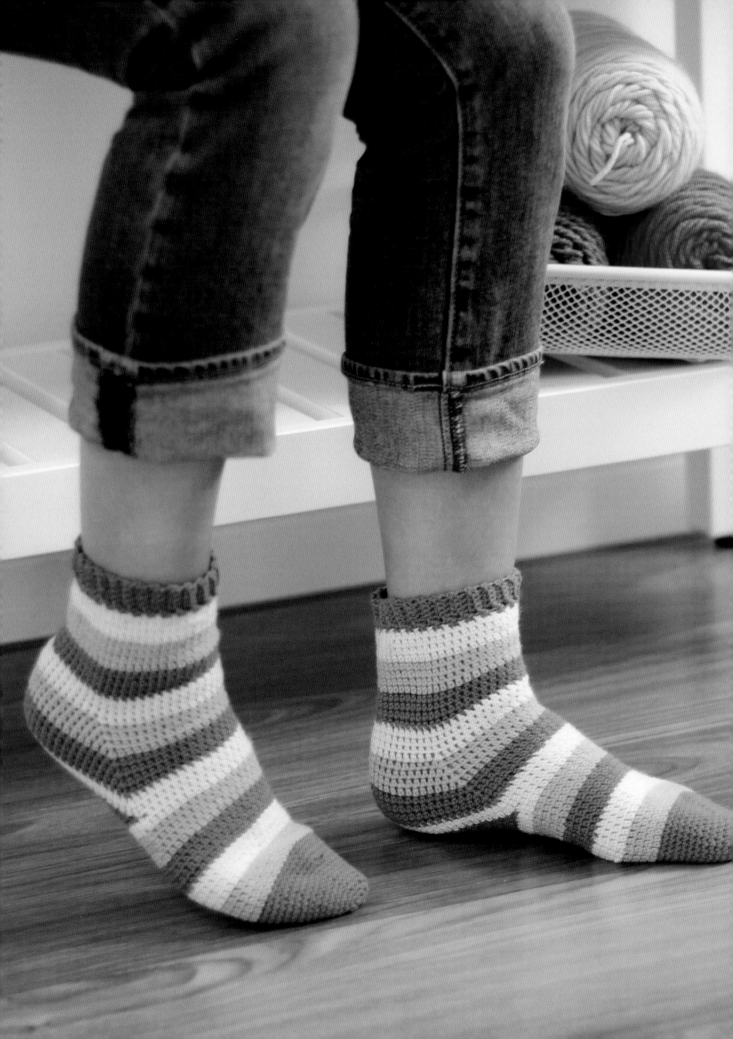

ABOUT THE AUTHOR

Rohn Strong is an accomplished crochet designer with more than 200 designs and many books to his credit, including the best-selling *New Methods for Crochet Socks*. Rohn teaches at crochet and craft festivals around the country, and his popular classes can be found online at Craftsy and Annie's, which showcase his clear and easy-to-understand teaching style.

Rohn's designs and articles have been featured in *Interweave Crochet, Crochet!, Crochet World, Love of Crochet, Happily Hooked,* and *Piecework* as well as publications from various yarn companies. Rohn can also be seen on the *Knit and Crochet Now!* TV show, which airs on PBS.

ACKNOWLEDGMENTS

Throughout the process of writing this book I had more help, advice, and encouragement than I ever thought I would need, from my mother who has never picked up a crochet hook to the seasoned designers I'm proud to call my peers.

Step Into Crochet was a team effort and I have to give the biggest thanks to the entire team at F&W/Interweave. Also to:

- Kerry Bogert for helping develop this idea the way a start editor does.
- Leslie O'Neill for making me sound clear and concise and for making this process easy as Sunday morning.
- Charles Voth for being the best technical editor I have ever worked with.

Many thanks to my fiber friends—you all have helped in individual ways, and I thank you for your friendship and advice.

Lastly, for their support, love, kindness, and constant encouragement, I want to thank my family. It was your support that carried me through the long nights.

INDEX

METRIC CONVERSION CHART		
TO CONVERT	TO	MULTIPLY BY
Inches	Centimeters	2.54
Centimeters	Inches	0.4
Feet	Centimeters	30.5
Centimeters	Feet	0.03
Yards	Meters	0.9
Meters	Yards	1.1